Stories in Stone
NEW YORK

A Field Guide to
New York City
Area Cemeteries
& Their Residents

DOUGLAS KEISTER

GIBBS SMITH
TO ENRICH AND INSPIRE HUMANKIND

To Sandy—friend, wife, inspiration
and queen of the boneyard buddies.
And to those who preserve the
past to better the future. DK

First Edition
16 15 14 13 12 11 5 4 3 2 1

Published by
Gibbs Smith
P.O. Box 667
Layton, Utah 84041
1.800.835.4993 orders
www.gibbs-smith.com

Cover designed by Blackeye Design
Interiors designed by Melissa Dymock
Printed and bound in Hong Kong

Gibbs Smith books are printed on paper produced
from sustainable PEFC-certified forest/controlled
wood source. Learn more at: www.pefc.org.

Library of Congress Cataloging-in-Publication Data

Keister, Douglas.
Stories in stone New York : a field guide to New York City
cemeteries & their residents / Douglas Keister. — 1st ed.
 p. cm.
Includes bibliographical references and index.
ISBN 978-1-4236-2102-7 (alk. paper)
1. Cemeteries—New York (State)—New York—Guidebooks. 2.
Sepulchral monuments—New York (State)—New York—Guidebooks.
3. Inscriptions—New York (State)—New York—Guidebooks.
4. Architecture—New York (State)—New York—Guidebooks. 5.
New York (N.Y.)—Buildings, structures, etc.—Guidebooks. 6. New
York (N.Y.)—Biography. 7. New York (N.Y.)—History. I. Title.
 F128.61.A1K45 2011
 363.7'509747—dc22
 2011014093

CONTENTS

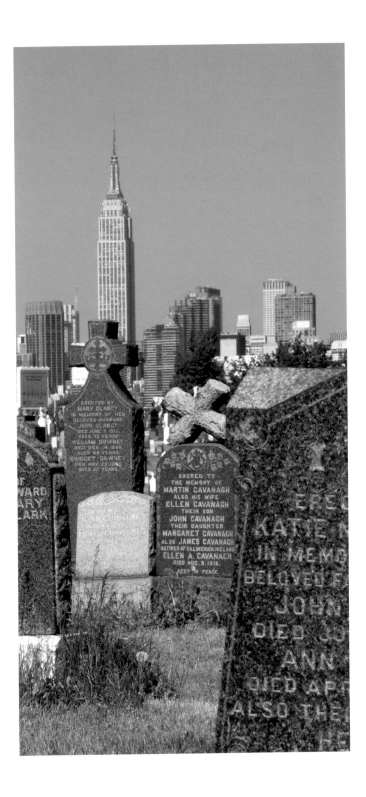

4

ABOUT NEW YORK

New York. The Big Apple. The city that never sleeps. The Naked City. Grand Central City. Gotham. Millions of people call New York City home. For millions more, it's their permanent home. Each year, some 60,000 New Yorkers reach the end of their personal line. Death. It's the price we pay for life. No one escapes. Now what? About a quarter of expired New Yorkers are cremated. The rest wind up in mausoleums or in the ground.

When New Amsterdam was founded, most of the dead were buried in churchyards that surrounded the early churches. These churchyards, known as God's Acres, also served as mini-parks. They were often used as gathering places for farmers markets and social activities. But as the city expanded, the wee churchyards rapidly filled up. There was a certain tyranny of the dead: they had much of the good property and they weren't selling or moving. Responding to a looming burial crunch, a group of forward-looking citizens formed a committee that established Green-Wood Cemetery in Brooklyn as a vast landscaped burial ground. At the time, Green-Wood was called a rural cemetery since it was located out of town. Other communities followed suit and, one after another, large rural cemeteries were developed in outlying areas. As the decades ticked on, the rural cemeteries as well as the smaller graveyards and churchyards were gradually surrounded by the burgeoning metropolis. Today, these cemeteries are oases of tranquility—a buffer of the bucolic contrasting against the cold steel and stone.

There are hundreds of cemeteries in the five New York City boroughs of Bronx, Brooklyn, Manhattan, Queens, and Staten Island. *Stories in Stone New York* also contains a selection of cemeteries in Westchester County, where New Yorkers started opting for burial sites at the beginning of the twentieth century. A cemetery complex was developed in an area that spanned the communities of Hawthorne and Valhalla. It was made easily accessible by a special funeral train. Westchester County also contains Sleepy Hollow Cemetery.

This guide is by no means comprehensive. It does, however, cover some of the most historic and tourist-friendly cemeteries, from the petite to the magnificent, and encourages you to go out and discover others on your own. The guide to cemetery symbolism applies to almost all the cemeteries, as does the guide to secret societies. It has often been said that you only have one chance to make a first impression. Conversely, you only have one chance to make a last impression. Explore these pages and you'll find some grand, stylish, simple, and thought-provoking last impressions.

Halloran Mausoleum, Calvary Cemetery, Woodside, Queens

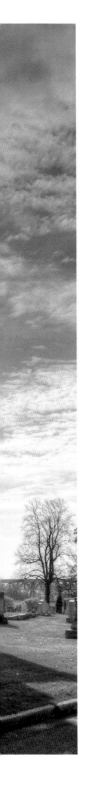

ARCHITECTURE—
GOING OUT
IN STYLE

Cemeteries are a vast treasure trove of art and architecture. The fact is, cemeteries are America's most unspoiled resource of historic architecture. It would take many hours of strolling around New York City to find the number of styles of architecture that can be found in a few minutes' walk in one of New York's historic cemeteries.

Most cemetery architecture is a mirror of the urban architecture of the time. Gothic cathedrals, Classical Revival city halls, Art Deco theaters, and rustic cast-iron garden furniture can all find their counterpart in the cemetery. And there are some styles of architecture that can be found only in cemeteries; we'll call this architecture "uniquely funerary."

Up until the Reformation in the sixteenth century, most cemeteries consisted primarily of randomly placed headstones. Wealthy folks purchased their way into being buried within the walls and floors of their church. But a series of edicts and a slowdown of church construction during the Reformation essentially put an end to burial within the church. Moneyed types started looking outside the walls of the church to erect a suitable memorial to themselves and their families. Elaborate statuary, tombs, and monuments slowly began to find their way into formerly stark churchyards and city cemeteries. When garden and rural cemeteries with vast landscaped expanses began to be developed in the early nineteenth century, they became a new architectural frontier for America's architects, artists, designers, and builders.

Most major architectural styles are represented in New York City's larger historic cemeteries in the form of mausoleums, chapels, and monuments. As a rule of thumb, the older the cemetery, the more diverse the architectural styles.

Architectural Styles

TUMULUS AND GROTTOS

The tumulus is one of mankind's oldest burial monuments, dating back 4,000 to 5,000 years BC. There are also a number of rock assemblages in cemeteries known as grottos. These tumulus-like monuments are miniature cave-like chapels containing small altars and religious statuary. Grottoes are often seen in large Catholic cemeteries. Most of them are an homage to the most famous grotto in the world, the Grotto of Lourdes in France.

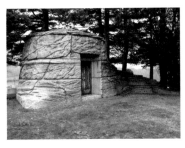

Mayer Tumulus,
Kensico Cemetery, Valhalla

EGYPTIAN REVIVAL

While it's debatable if grottos and tumuli can really be called architecture, another tomb style of antiquity, Egyptian, is perhaps the most funerary of all architecture. After all, almost all architecture in ancient Egypt had something to do with death and the afterlife.

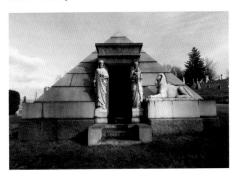

Egyptian Revival, Van Ness Parsons Mausoleum,
Green-Wood Cemetery, Brooklyn

American cemeteries have often had a schizophrenic attitude toward Egyptian Revival architecture because of its pagan roots. However, in the New York City area with its diverse population, there doesn't seem to be any particular aversion to the Egyptian Revival Style.

Almost every Egyptian Revival tomb is adorned with a pair of vulture wings sprouting from a circle (symbolizing the sun) and flanked by twin cobras (symbolizing death). Often, a pair of male sphinxes (female sphinxes are Greek) guards the entry to the tomb. Above the entry to the tomb, and usually circling the entire tomb, is an architectural element called a "cavetto cornice" (flared with curve). Other hallmarks of Egyptian Revival architecture are the tapered (battered) entry and hieroglyphics. Since Egyptian architecture doesn't make use of the strength of arches or tapering columns, its dimensions are quite massive. To provide strength, the walls of the Egyptian temple-style mausoleums taper in at about 70 degrees.

To soften the pagan demeanor, designers of Egyptian Revival tombs often add selected Christian symbols and statues in front of or on the tomb as well as religious-themed stained glass windows.

OBELISK

Another very popular form of Egyptian architecture in the cemetery is the obelisk, which is representative of a ray of sunlight. They were typically erected in pairs in front of selected temples as part of a celebration of a Royal Jubilee. The sides of the obelisk were often inscribed, and the pyramidal top was sheathed in gold to radiate the light of the sun.

CLASSICAL REVIVAL

The most common type of cemetery architecture is Classical Revival. It is easy to identify by its columns and column capitals, which are classified into "orders," generally recognized as Doric, Tuscan, Ionic, Corinthian, and Composite. Doric architecture can be divided into Grecian Doric and Roman Doric.

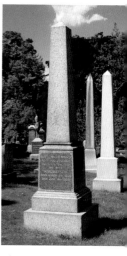

Obelisks, Moravian Cemetery, Staten Island

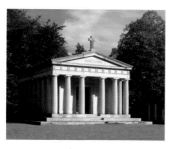

Greek Revival, Paterno Mausoleum, Woodlawn Cemetery, Bronx

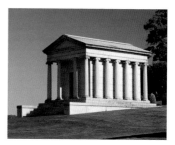

Classical Revival with Ionic Capitals, Webber Mausoleum, Kensico Cemetery, Valhalla

BYZANTINE REVIVAL

Byzantine architecture is at times difficult to plumb since it borrows from other styles such as Romanesque and Classical. Look for effervescent domes and intricate mosaics. The Hagia Sophia in Istanbul is the hallmark of Byzantine architecture.

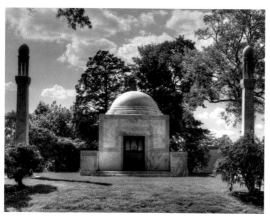

Byzantine Revival, Gordon Mausoleum, Kensico Cemetery, Valhalla

ISLAMIC

Developed in Arabia, the architecture spread to North Africa, Spain, India, and much of the rest of Asia. Even though there was not a very large Islamic population when many of America's large mausoleums were built, many fine examples can be found in our cemeteries. Look for onion domes, horseshoe arches, and surfaces adorned with mosaics, carvings, and inlays.

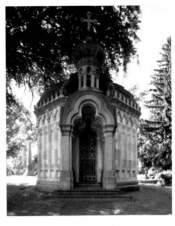

Eclectic Islamic Revival, Garrison Mausoleum, Green-Wood Cemetery, Brooklyn

MODERN ECLECTICISM

Starting in the 1930s, architectural styles essentially became devoid of ornament. However, clever architects who wanted to put their individualized stamp on their designs often blended some of the emerging styles and sometimes borrowed from the past. This mausoleum blends neo-Gothic forms with neo-Classical forms.

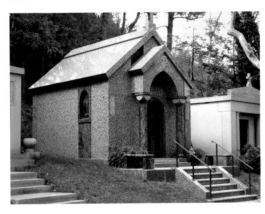

Modern Eclecticism, Moravian Cemetery, Staten Island

ROMANESQUE

Romanesque architecture is most widely characterized by rounded arches and intricately carved but judiciously used ornament. Near the end of the nineteenth century, American architect Henry Hobson Richardson modified the Romanesque form by using rough stones rather than smooth stones. This "rusticated" Romanesque architecture, called Richardsonian Romanesque, has a heavy authoritative look.

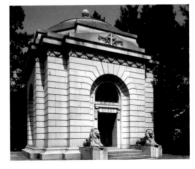

Romanesque, Ehret Mausoleum, Woodlawn Cemetery, Bronx

GOTHIC

Perhaps no style of architecture is so closely associated with cemeteries as Gothic. Its towers, spires, and buttresses are the stuff of ghost stories, dark and stormy nights, and evil sorcerers. Because Gothic architecture did not borrow heavily from any of the pagan Classical styles, it is most closely associated with Christianity.

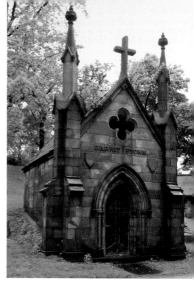

Gothic, Storm Mausoleum,
Trinity Cemetery, Manhattan

UNIQUELY FUNERARY HYBRID

Not all architecture fits into the customary architectural styles. Architects often blended totally unrelated styles and sometimes created styles of their own. Nowhere is this architectural grab bag more apparent than in the cemetery. Indeed, many mausoleums and funerary structures are a triumph of form over function. The closest type of architecture that these whimsical structures can be compared to is the "follies" of Victorian architecture.

Uniquely Funerary, Geraghty Mausoleum,
Calvary Cemetery, Woodside, Queens

MODERN CLASSICISM

In the early twentieth century, influential architects advocated a return to Classical architecture. Various forms of Classical Revival architecture exist to this day. Some types almost exactly mirror their two-millennium-old cousins, but most are sleeker, more stripped down. In

Modern Classicism, Mausoleums,
Gate of Heaven Cemetery, Hawthorne

the cemetery, look for buildings that appear to be scaled-back versions of Classical architecture. There is an absence of or a spartan use of ornament. Columns are modestly scaled or engaged (attached to the structure).

ART NOUVEAU

Emerging at the end of the nineteenth century was Art Nouveau. The style had a relatively short run on the scale of world architectural history. The best examples of Art Nouveau, which is described as naturalistic and organic, can be found in European cities such as Paris and Prague and in Buenos Aires, Argentina, where it is sometimes known as the Liberty style.

Art Nouveau, Billman Mausoleum, Kensico Cemetery, Valhalla

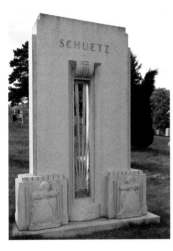

ART DECO

The Exposition Internationale des Arts Décoratifs et Industriels Modernes, held in Paris in 1925 as a showcase for "new inspiration and real originality," introduced a new architectural and decorative style called Art Deco, which would soon permeate designs in fabrics, automobiles, appliances, office buildings, and even mausoleums and monuments.

Art Deco, Schuetz Monument, Green-Wood Cemetery, Brooklyn

MODERN

With the modern age has come a lack of ornament and hard, clean lines. The range of modern architecture extends from tilt-up concrete buildings to massive glass, steel, and stone structures that look like they belong on a *Star Wars* set. In the cemetery, some of these structures are very utilitarian-looking while others seem to be ready to blast off from Earth.

Modern, Giacinto Mausoleum, Gate of Heaven Cemetery, Hawthorne

Monument Styles

COMMUNITY MAUSOLEUMS
Around the beginning of the twentieth century, community mausoleums started springing up in America. Most community mausoleums also have

cremation niches; however, some have stand-alone structures used solely for cremains. These buildings are called columbariums.

Ferncliff Community Mausoleum, Ferncliff Cemetery, Hartsdale

GARDEN CRYPTS
A somewhat more economical alternative to those desiring aboveground burial is a garden crypt, essentially community mausoleums without a roof or any significant architectural features.

Garden Crypts, Woodlawn Cemetery, Bronx

COLUMBARIUMS
Although cremation has been around for eons (ashes to ashes/dust to dust), it's a rather recent phenomenon in America. In the multiethnic New York area, some of the best examples can be seen in cemeteries catering to those whose roots are with Far Eastern cultures and religions. The Vatican lifted the ban on cremation in 1963, and even Catholic cemeteries are building columbariums.

Columbarium, Woodlawn Cemetery, Bronx

SCATTERING AND CREMATION GARDENS
Catering to the truly economical and environmentally conscious, many cemeteries are building landscaped areas that are called scattering gardens, often with a memorial wall inscribed with names. Sometimes the

cremains (cremated remains) are scattered while other times they are placed in small niches.

Cremation Garden, Woodlawn Cemetery, Bronx

EXEDRA

These monuments are usually shaped like a curved or rectangular bench, but there are also many examples where the bench is straight. Often, a statue or architectural feature with the family name is at the center of the exedra.

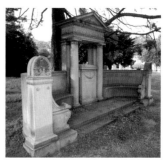

Exedra, Green-Wood Cemetery, Brooklyn

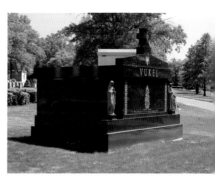

Sarcophagus, Calvary Cemetery, Woodside, Queens

SARCOPHAGUS

Besides mausoleums, the most abundant forms of architecture in the cemetery are the various interpretations of one of the oldest funerary monuments—the sarcophagus. The word "sarcophagus" combines the Greek words *sarco* (flesh) and *phagus* (eater), literally "a flesh eater," since the earliest types of these burial vessels were made out of a type of stone that reduced the body to bone in a matter of weeks. In its simplest and most utilitarian form, the sarcophagus is a container for the body, but unlike a coffin or casket, it is designed to (more or less) last for eternity. It is rare to find a sarcophagus in a cemetery that actually contains a body. Most are purely ornamental.

GARDEN MAUSOLEUM

In the twentieth century, a hybrid tomb developed that was a cross between a sarcophagus and a mausoleum. These garden mausoleums are frequently built for two.

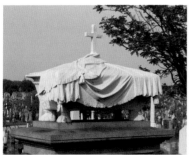

Garden Mausoleum, Gate of Heaven Cemetery, Hawthorne

PEDESTAL TOMB

To give sarcophagus-like tombs a more imposing look, designers place them on pedestals. The pedestal tomb may also sport an array of accessories such as urns, draped urns, crosses, and angels.

Pedestal Tomb, Calvary Cemetery, Woodside

FALSE CRYPT

These tombs are hollow. Removing the top often accesses an underground vault. The sides of the false crypt are thin slabs of stone and frequently become damaged from age, vandals, or storms.

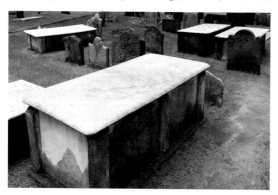

False Crypt, Trinity Churchyard, Manhattan

HIP TOMB

This tomb takes on the form of a miniature low-slung house. At its simplest, a hip tomb is a rectangular box with a two- or four-sided hip roof applied to the top. Crosses are often worked into the design because of the shape of the hip tomb.

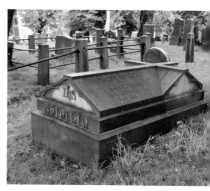

Hip Tomb, Trinity Cemetery, Manhattan

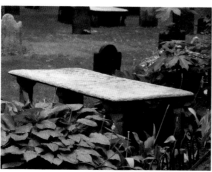

TABLE TOMB

These tombs look like a stone table. Its horizontal design and thin top make it vulnerable to weathering, and the inscription often becomes illegible.

Table Tomb, Trinity Churchyard, Manhattan

DEATH'S HEAD GRAVESTONES

In the churchyards in Manhattan and scattered among some of the other cemeteries are death's heads gravestones. The first death's heads were often skull and crossbones or a skull gnawing a femur. But over time, the skull was gradually transformed to a more cheerful "soul effigy," or skull with wings. The wings suggest the soul might fly to a better place. As time ticked on, the skull turned into a face and, finally, into a chubby cherub.

Death's Head (with skull), Trinity Churchyard, Manhattan

Death's Head (with face), Trinity Churchyard, Manhattan

TABLET

The most common type of traditional grave marker is the tablet. Ask someone to draw a cemetery, and they'll depict a field jam-packed with stone tablets. They come in all shapes and sizes, from a simple stone to elaborately ornamented stele.

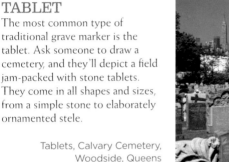

Tablets, Calvary Cemetery, Woodside, Queens

FLAT MARKERS

Flat markers have become the dominant grave marker in today's cemeteries. While most are rather pedestrian, there is still room to make a personal statement. When the flat marker protrudes above the ground, it is called a pillow marker.

Granite flat markers, Gate of Heaven Cemetery, Hawthorne (left)

Bronze flat marker, Ferncliff Cemetery, Hartsdale (below left)

Pillow marker, Moravian Cemetery, Staten Island (below)

ZINC TOMBSTONE

One of the most curious types of grave markers is made of metal. The Monumental Bronze Company of Bridgeport, Connecticut, manufactured zinc tombstones (which they called white bronze) from the late-1870s until the mid-1930s. The light-blue-gray material is very similar to the color of gray granite, but unlike granite, it's almost impervious to aging. The gravestones were available in a variety of designs and had interchangeable panels. They are quite easy to spot because of the clean look of the lettering, and rapping on them will reveal they are hollow. Some models had secret compartments.

Zinc Tombstone, Green-Wood Cemetery, Brooklyn

TREESTONES

Treestones, or tree stumps, are some of the most curious varieties of funerary art. They were derived from the Victorian rusticity movement, the most common example of which is cast-iron lawn furniture that looks like it's made of twigs. Treestones provide a ready canvas for symbols because so much symbolism is closely tied to nature. Treestones are a popular funerary motif for members of the Woodmen of the World (see page 221).

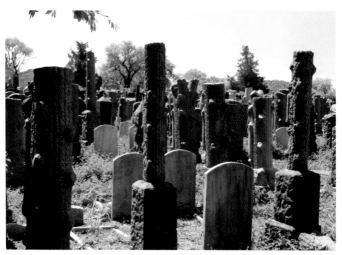

Treestones, Mt. Carmel Cemetery, Glendale, Queens

Tour at Green-Wood Cemetery

THE BIG FOUR

In the nineteenth century, large cemeteries were major tourist and recreation destinations. Until the establishment of public parks such as Central Park in Manhattan in 1848, there was little public open space. This was particularly true in large cities. Soon after Green-Wood Cemetery was established in Brooklyn in 1838, the public flocked there in droves. In fact, the public's appreciation of this green oasis was so great that cries soon went out for the establishment of something similar in Manhattan. Thus the seeds of Central Park were sewn.

Part of the interest in cemeteries can be attributed to Queen Victoria, who went on a veritable mourning rampage following the death of her beloved husband, Prince Albert, in 1861. She built monuments, memorials, and buildings dedicated to Albert, wore nothing but black, and went into permanent mourning for the remaining 40 years of her life. Her influence on societal mores was so great that the era was called the Victorian Era. Simply put, a proper person followed Victoria's lead. Even families of humble means scraped together money to purchase a family plot.

But in the first couple of decades of the twentieth century, major social changes occurred, such as the popularity of the automobile, which led to better mobility, which led to the fragmentation of families. Income tax laws curbed the disposable income of well-to-do families, which led to a slowdown in monument and mausoleum construction. And Queen Victoria's grip on the collective psyche understandably lessened after her death. The care of the dead and the places where they resided became less important. The Great Depression in the 1930s was the death knell for cemeteries as places of recreation. From the 1940s through the end of the twentieth century, most historic cemeteries that were established during the Victorian Era entered a period of decline. Many suffered from financial woes, went into receivership, and were reluctantly taken over by the parks department in their host cities. However, that all began to change incrementally as the twentieth century ticked into the twenty-first. Among the factors were the environmental movement and the concurrent appreciation of open space, patriotism for all things historic fueled by the nation's bicentennial, and a rise in cremation that allowed the cemeteries to create a lot of room for burial in a small space. Slowly, cemeteries became popular destinations for outings once again. Forward-thinking cemetery administrators and concerned community members recognized they had an incredible treasure under their feet.

There are four cemeteries in the greater New York City area that are particularly "tourist friendly." All have free maps, sponsored tours, and friendly staffs. If you journey to one of these cemeteries, please consider making a small donation to one of their "friend's of" organizations. They are preserving our past to better our future.

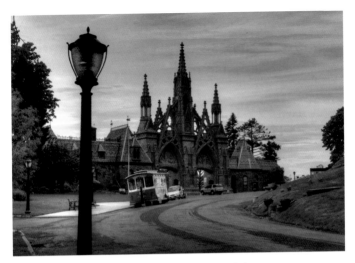

The Green-Wood Cemetery (Gothic entrance gate)

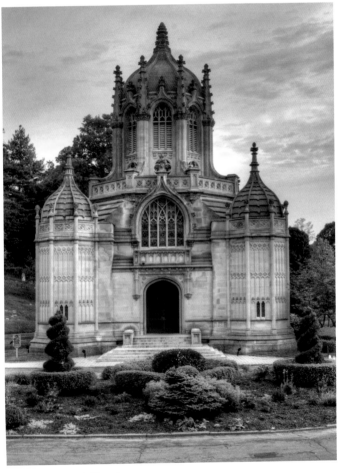

The Green-Wood Chapel

The Green-Wood Cemetery

500 25th Street

Brooklyn, New York 11232

(718) 768-7300

www.green-wood.com

Maps in office

40° 39' 29.23" N 73 59' 40.56" W (entrance gate)

I n the first part of the nineteenth century, New York City was facing a
looming burial crisis. The population was booming, available land was
being gobbled up, and the tiny churchyards that were the traditional
burying grounds for urban dwellers were full to bursting. What to do?
Recognizing the problem, Brooklyn leader Henry Evelyn Pierrepont
turned to another eastern seaboard city with a similar problem. In 1831,
civic leaders in Boston established Mount Auburn Cemetery, America's
first garden cemetery, in the suburb of Cambridge. Green-Wood would
become the second. Mount Auburn's inspiration came from Père
Lachaise Cemetery in Paris. Established in 1804, it was a response to
the overcrowding of the city's burial grounds. Rather than simply create
a larger burial ground, the founders of Père Lachaise wanted to create
a bucolic park-like environment that encouraged people to linger and
enjoy nature.

It didn't take long for Green-Wood Cemetery to become the
premier cemetery in the New York metro area. By 1860, Green-Wood
was attracting over 500,000 visitors a year and soon became America's
second most popular tourist destination (Niagara Falls was number
one). Green-Wood's 478 acres of glacial ponds, spectacular scenery,
and notable residents are an American treasure, so much so that it was
declared a National Historic Landmark in 2006. What the *New York Times*
said in 1866 is still true for many New Yorkers today: "It is the ambition
of the New Yorker to live upon Fifth Avenue, to take his airings in the
[Central] Park, and to sleep with his fathers in Green-Wood."

The Green-Wood Chapel
40° 39' 22.98" N 73° 59' 43.10" W

When Green-Wood was first laid out in the 1830s, a section of land
named Chapel Hill was set aside for the erection of a chapel. But as
the years ticked on, it was determined that a chapel wasn't necessary,
and the Chapel Hill land was divvied up and sold as plots. However, at
the dawn of the twentieth century, the cemetery's Board of Directors
decided that the cemetery needed a proper chapel. Land was
reclaimed from Arbor Water, a pond near the cemetery entrance, and
the cemetery requested plans from some of the leading architectural
firms. The cemetery awarded the construction contract to the firm
of Warren and Wetmore. The firm had previously designed a number
of signature buildings in New York, including the Commodore
Hotel, the Yale Club, and the New York Yacht Club. Warren and

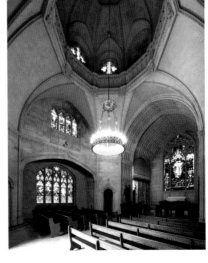

Wetmore's design of the Green-Wood chapel is a smaller scale version of Christopher Wren's Tom Tower at Christ Church, Oxford, England. The Green-Wood chapel never proved wildly popular for funeral services, and it was eventually closed in the 1980s. A major renovation of the structure began in the late 1990s, and it is now open for special events.

Acea Mausoleum

40° 39' 08.46" N 73° 59' 53.80" W

The perfectly petite Acea Mausoleum was constructed by Farrington, Gould & Hoagland, one of New York's most prolific mausoleum builders. Although the firm was based in New York, it always used granite quarried in Barre, Vermont.

Spending eternity inside the mausoleum are Nicolas Acea (October 22, 1828–January 7, 1904), his wife Francisca Toste y Garcia Fallencida Acea (?–May 24, 1912), and their young son Tomas Acea y Terry (August 10, 1867–July 25, 1884). Cuban-born Acea made his fortune growing and refining sugar in Cienfuegos, Cuba, where he and his wife died. An inscription on the pedestal where young Tomas Acea is frozen for eternity reads in part "[he] flew to heaven leaving an eternal emptiness in the hearts of his parents."

Chauncey Mausoleum
40° 39' 12.82" N 73° 59' 23.70" W

Multi-crocketed Gothic spires reach toward the heavens in what appears to be a boarded-up octagonal fairy-tale castle on the eastern flank of Butternut Hill. For reasons that have been obscured by time, some accounts have stated the Chauncey family mausoleum was known as the "Prisoner's Vault" because it was constructed during the Civil War (1861–1865) by Confederate prisoners confined at Sing Sing Penitentiary. In fact, the Chauncey Mausoleum was featured prominently well before the Civil War in an 1847 book, *Green–Wood Illustrated*, profiling the cemetery. By 1847, five of the 36 crypts had already been filled by members of the Chauncey family. A selection of the purple prose that accompanies the illustration in the 1847 tome is worth repeating: "A soft light falls on the tessellated floor from the small rose windows of colored glass, which bear also the armorial escutcheons of the family that is to sleep below them."

Daly Mausoleum
40° 39' 24.36" N 73° 59' 23.59" W

Marcus Daly
December 5, 1843–November 12, 1900

Margaret Price Daly
September 7, 1853–July 14, 1941

Marcus Daly worked for John Mackay (see page 32) in Virginia City, Nevada, then ventured to Butte, Montana, where (with the backing of George Hearst, father of newspaper magnate William Randolph Hearst)

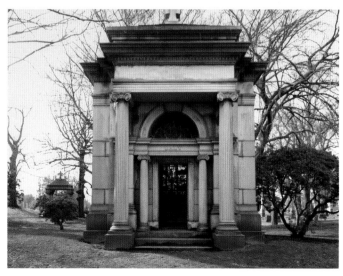

in 1881 he developed what was soon to be discovered to be one of the world's greatest concentrations of copper. Daly purchased the Anaconda Copper Mine from one Michael Hickey, who was said to have named the mine after reading an account by another Green-Wood resident Horace Greeley (see page 43). Greeley had written that at the end of the Civil War, Ulysses S. Grant's forces had surrounded Robert E. Lee's forces, choking them "like an anaconda."

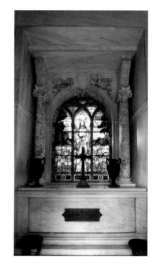

Marcus Daly's life was the personification of the American Dream. He had arrived virtually penniless in a wave of Irish emigration at age 15 and had become a multimillionaire within 20 years, lording over mines, banks, power plants, and vast tracts of timberland. He was also a great lover of thoroughbred racing and often gave his employees days off to watch horseracing at a track near the Anaconda Mine. Many of his employees were Irish. His mines worked 24 hours a day in three shifts, but in a show of respect to the miners and the Irish heritage of many of them, he closed the mines on Miners' Union Day and St. Patrick's Day.

Reposing in the mausoleum are Marcus and Margaret Price Daly. Accounts of the day said that his body was originally going to be sent to Montana for burial, but those plans were obviously changed. Gracing the polished marble interior of the Daly mausoleum is a religious-themed, Tiffany-style, stained glass window crafted in opalescent glass.

Thomas Durant
February 26, 1820–October 5, 1885
40° 39' 25.79" N 73° 59' 2 3.20" W

Thomas Clark Durant's mausoleum is slightly tucked into a hillside. A large granite door tells viewers that there is no need to linger, that there is no need to try to peek inside; the mausoleum's interior is not viewable, not even a peephole view. It is an odd testament to an enthusiastic man who was a master of publicity.

Thomas Durant was born in Lee, Massachusetts. He went to Albany Medical School, obtained a degree, and then served

Photo courtesy of John Thomas Grant.

for a time as a professor of surgery. But he had his sights set on bigger things. After working for his uncle's grain exporting company for a while, he realized that there was a great need for a better transportation system, which led him into the railroad industry. He became embroiled in a lawsuit over the construction of a bridge

and hired a young attorney named Abraham Lincoln to defend him. That association became beneficial when Abraham Lincoln became president a few years later and in 1862 awarded Durant's company, the Union Pacific, a major part of the building of the Transcontinental Railroad. Construction of the railroad was hampered by the Civil War but, never one to miss an opportunity to profit from other's woes, Durant made a financial killing by smuggling in cotton from the Confederate States.

When the railroad construction kicked into high gear after the Civil War, Durant staged a number of publicity events to draw attention to the project and to garner investors. The events ended with Durant wielding the sledgehammer that drove the Golden Spike into its resting place at Promontory Summit, Utah, finishing the Transcontinental Railroad.

The mausoleum was not completed until almost three years after Durant's death, and the interior is rarely seen. Rather than the standard utilitarian stone box with crypts, the mausoleum's interior is an architectural gem. It sports polished granite columns, two rooms, three statues, and a high-relief frieze panel. Art critic Effie Brower, who seemed to have an opinion on most of Green-Wood's monuments, commented in her book *Greenwood Leaves* on one of the statues holding a wine goblet: "What does it mean? . . . Can it be that he who lies beneath was a victim [of drinking] or was he saved by faith from the 'cup.'"

Charles Feltman Mausoleum
November 8, 1841–September 20, 1910
40° 38' 52.64" N 73° 58' 55.66" W

The Archangel Michael, sword at the ready, tops the domed cupola of Charles Feltman's temple mausoleum. With Corinthian columns, cherubs, statuary, urns, and statues of a half-dozen pensive women, the

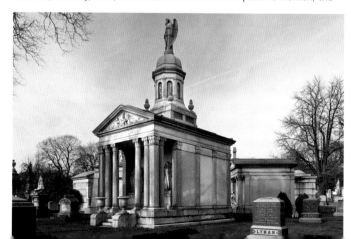

Feltman Mausoleum could easily serve as a primer for any student of evocative classical revival architecture. Most municipalities would be happy in having a building as ornate as this to decorate their town square.

Hopeful Mourners, Feltman Mausoleum

Feltman, a pie maker/baker, had a pushcart on New York's Coney Island. The pies he was selling weren't doing so well, and he just couldn't seem to compete with the inns on Coney Island that were selling hot dishes. Feltman pondered long and hard, and thought back to his youth. He remembered a long, slightly curved sausage, known as a dachshund sausage, that the butcher's guild in Frankfurt, Germany, had popularized. A lightbulb went off in his head; he abandoned the pie business and concentrated on selling frankfurter sandwiches. His cart was quite small, and he only had room for his little frankfurter sandwich and two condiments, mustard and sauerkraut. His simple idea was an instant success, and shortly thereafter, he opened Feltman's German Beer Garden, complete with carousel, where he continued to sell his moneymaking sausages.

Feltman wasn't the only person immortalized in American folklore because of these slender little sausages. In 1913, Feltman hired Nathan Handwerker to help him for the princely sum of $11/week. A few years down the road, two frankfurter aficionados, Jimmy Durante and Eddie Condon, irritated that Feltman had raised his price to 10 cents, convinced Nathan to open his own operation and sell them for 5 cents. Nathan promoted his frankfurters (made according to his wife Ida's recipe) by offering them free to any of the doctors at the nearby Coney Island Hospital on the condition that the docs ate them while standing next to his stand in their hospital whites and wearing their stethoscopes. Another triumph for capitalism and for Nathan, whose frankfurters and other meat products continue to thrive to this day.

Spending eternity with Charles Feltman are other members of his family, including his wife, Joanne Koester Feltman.

Cornelius Kingston Garrison
March 1, 1809–May 1, 1885
40° 38' 55.32" N 73° 59' 30.68" W

This Moorish Revival mausoleum is the final port of call for Commodore Cornelius Kingston Garrison. His tomb was designed by New York architect Griffith Thomas, who also designed a number of buildings in New York City, including the original New York Life Insurance Building (1860). In 1908, The American Institute of Architects called Thomas "the most fashionable architect of his generation." For the Garrison Mausoleum, Thomas worked with Islamic, Byzantine, and Moorish forms, topping his creation with a dome that one can easily imagine was transported straight from St. Basil's Cathedral in Moscow. Of particular interest is the way the polychrome granite treatment is used to bring attention to the different architectural elements. It is one of the most elaborately styled mausoleums in Green-Wood.

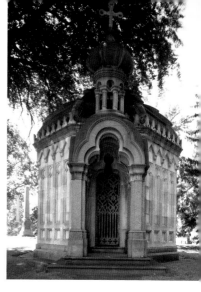

Cornelius Kingston Garrison's title of Commodore was largely honorary: rather than piloting ships, he was in the far more lucrative business of owning them. After moving to St. Louis, Missouri, in 1839, he earned his first fortune building steamboats and operating a steamboat company. At age 40, he made money capitalizing on the 1849 California gold rush, not by mining gold but by establishing a banking house in Panama, which was one of the routes the gold seekers took to get from the East Coast to the California gold fields. Several years later, he took a job as an agent for the Nicaraguan Steamship Company, earning $60,000 a year (about $1.7 million today). By 1853, he was elected mayor of San Francisco. Although he only served as mayor for one year, he instituted a number of social reforms, brought gas lighting to the streets, started a city beautification program, and had new schools built. After his term as mayor ended, he went to New York where he found continued success as a financier, speculator, and operator of steamship lines. It appears that his highly successful steamship lines, which traded goods with Australia and the Orient, may have had a strong influence on the design of his mausoleum.

Unfortunately, Garrison may be best remembered as the recipient of a now famous letter from Cornelius Vanderbilt. Referring to a business Garrison and his partner Charles Morgan had that must have competed with Vanderbilt's business, Vanderbilt wrote: "Gentlemen: You have undertaken to cheat me. I won't sue you, for the law is too slow. I'll ruin you. Yours truly, Cornelius Vanderbilt."

Rinelli/Guarino Mausoleum
40° 38' 46.28" N 73° 59' 29.69" W

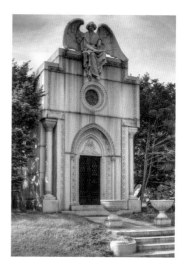

Angels in cemeteries tend to be heroic or mournful or contemplative. This plus-sized statue of the Archangel Michael seems to have fluttered on over to the Rinelli/Guarino Mausoleum and simply alit there, perhaps taking a break before heading to his next destination. Look closely and you'll see that Michael holds his sword in his right hand at rest across his lap, symbolizing that the earthly struggles of the mausoleum's inhabitants have ended. His left hand is also in a relaxed pose. The first permanent occupant of the mausoleum was Pietro Rinelli, who died in 1913.

Harder Mausoleum
40° 39′ 13.21″ N 73° 58′ 59.16″ W

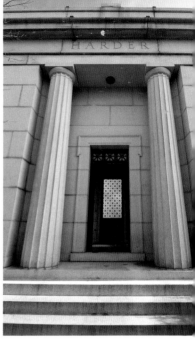

Most mausoleum interiors tend to be rather pedestrian storehouses for the departed. The Harder Mausoleum, which was built by W. W. Leland Studios, might fit that description save for interesting juxtaposition of the crypts. Rather than being flat to the wall, they protrude out at a 45-degree angle. The crosshatched window echoes the angular pattern. The mausoleum's first permanent guest was Victor Achilles Harder (August 15, 1847–August 9, 1914).

Victor Harder was born in Manhattan but lived almost all his life in Brooklyn. While still a youth, he was employed by Mayor, Lane and Company and later bought the company. He seemed to have a talent for buying and developing companies. He was the president of the Powhatan Brass and Iron Works in West Virginia and the Essex Foundry in Newark, and was a director of the Connecticut Tobacco Corporation. He was best known as the founder of the Victor A. Harder Real Estate and Construction Company in Brooklyn. Subsequent generations of Harders continue to use the mausoleum.

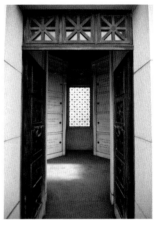

Victor Harder's business ventures received the usual amount of attention in the local papers, but one of his daughter's exploits caused a bit more attention than the wealthy family wanted. On November 10, 1910, the *New York Times* reported that Harder's 17-year-old daughter, Hortense, had been caught smuggling. Smuggling? It seems that young Hortense was returning from her studies in Europe and accidentally forgot to declare that she had seven new designer gowns in her trunks. An innocent-enough mistake, one might suppose, but an inspection of Hortense's handbag revealed labels that had been removed from the dresses, no doubt to elude customs inspectors about the garments' provenance. Not so, claimed Hortense. She said she had removed the labels, not to evade paying customs duties but so her friends couldn't find out where the gowns were made and order the same one. After all, Hortense's coming-out party was being scheduled, and it would be absolutely devastating for another girl to have the same gown. Somehow it was all worked out. An $800 customs fine was paid, and young Hortense didn't wind up with a criminal record. On January 20, 1911, Hortense made her debut in a spectacular Paris gown. Whether the label had been sewn back on is not known.

Kampfe Mausoleum

40° 39' 11.01" N 73° 58' 55.78" W

On June 15, 1880, the Kampfe brothers (Frederick, Richard, and Otto F.) patented the *Star,* the first safety razor manufactured in the United States. Other inventors soon came out with their own safety razors, and from 1880 to 1901, over 80 safety razor patents were issued in the United States. Gillette, which is often mistakenly credited with the invention of the safety razor, didn't acquire a patent until 1904. By 1906, a number of the Kampfe brothers' businesses were consolidated into the American Safety Razor Company. Today, the company (now the Personna

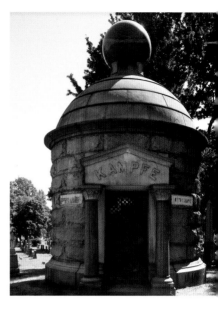

American Safety Razor Company) produces blades for shaving, medical, and industrial uses.

Mausolea are often the result of a bit of playfulness on the part of architects. Although the designer of the Kampfe Mausoleum has been lost to the ages, it appears that he may have used a cookie jar for his inspiration. The bit of color seen through the bronze door is a stained glass window depicting an angel telling Mary that Jesus has risen from the dead. The bronze door depicts a woman with a lamp about to enter the mausoleum. Seven Kampfes are spending eternity in the whimsical mausoleum. The last internment was Maria Kampfe, who died in 1946.

Imre Kiralfy

1845–April 27, 1919
40° 39' 13.64" N 73° 58' 57.81" W

Imre Kiralfy was born in the Austro-Hungarian Empire city of Pest in 1845 (now Budapest, Hungary). He was the oldest of seven children born to Jacob Konigsbaum, a well-to-do clothing manufacturer, and his wife Anna (Rosa) Weisberger. The Jewish family suffered through the 1848 Hungarian Revolution. Young Imre showed a talent for the arts and dancing in particular, making his debut as a Hungarian folk dancer at age 4 and adopting the stage name Kiralfy. Eventually, five of his six siblings joined him on stage.

The family moved to Berlin and then to Paris, while the children performed in theatres in Britain, France, and the Low Countries. In 1872, Imre married Englishwoman Marie Graham (1851–1942) in New York. The couple had nine children, but only six survived into adulthood. The Kiralfy brothers started producing extravagant stage shows with large chorus lines, elaborate costumes, and spectacular special effects, but after a few years, the brothers split because of artistic differences.

Imre struck out on his own, producing shows in England and the

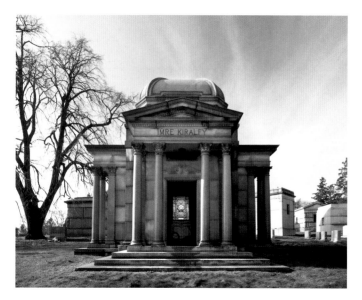

United States. His best-known productions were *The Fall of Babylon*, *Nero*, *Columbus*, and *The Black Crook*.

Assisted by his son Charles, Imre created a lavish spectacle titled *America* in the Auditorium Theatre in Chicago to coincide with the 1893 World's Columbian Exposition there. *America* grossed $900,000 in its seven-month run. Returning to London, Imre rebuilt the Earl's Court exhibition grounds as a small-scale version of Chicago's White City in 1893. Then he began planning Great White City in the Shepherd's Bush section of London in 1905. Built in a palatial oriental style, it opened in 1908 with the Franco-British exhibition and eventually tallied eight million visitors. Imre Kiralfy died in Brighton, England, leaving £136,000 (about 8 million dollars today) in his will.

Imre Kiralfy was originally interred in London's Kensal Green Cemetery. Then in 1921, his wife, Marie, had him cremated. He remained homeless until the Kiralfy Mausoleum was completed in 1924. Marie joined him (she too was cremated after her death in England) in 1942. The pedestal at the center of the mausoleum holds an engraved silver platter.

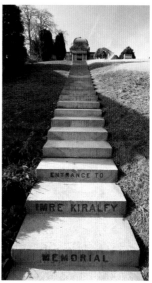

A 29-step granite stairway marches up the hill to the Kiralfy Mausoleum.

Many of the carved decorations and the stained glass windows contain Freemason symbols. In later life, Imre Kiralfy became very involved with the Freemasons and rose to become a 32nd-degree Freemason. The window contains an inscription in Latin, *In Hoc Signo Vinces* ("in this sign conquer"), which is frequently used by the Knights

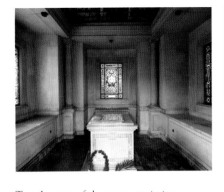

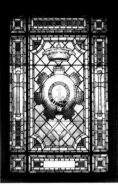

Templar, one of the secret societies associated with the Freemasons. Below the inscription is a compass and square enclosing the letter G (symbolizing God or geometry), the symbol most associated with the Freemasons.

John LaFarge
March 31, 1835–November 14, 1910
40° 39' 6.54" N 73° 59' 8.50" W

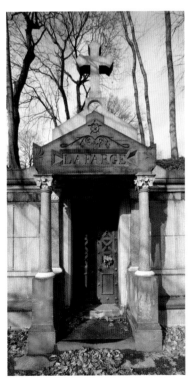

The mausoleum/vault of American artist John LaFarge (or La Farge) is tucked into a hillside just above Atlantic Avenue. LaFarge was born in New York City. He developed an interest in art during his early schooling (he was doing watercolors at age 6) but was steered toward a career in law. That began to change when he visited Paris, where he started associating with people involved in the arts. Upon his return to the United States, he began executing drawings and landscapes that showed a marked gift for combining color values. He started illustrating books and then moved into murals, where he exhibited a vivid sense of composition and color. He was particularly drawn to religious-themed subjects and was commissioned to do murals for churches in Boston and New York.

Some of LaFarge's most well known works were those he executed in stained glass. He is credited with first using opalescent glass in stained glass windows, receiving a patent for his process on February 24, 1880. He ushered in what has become known as the "opalescent era" (1880–1920), where glass was produced in multicolored textured sheets, often with an iridescent sheen. Among his stained glass masterpieces are

windows at the Trinity Church in Boston, St. Paul's Chapel at Colombia University in New York, First Unitarian Church in Philadelphia, Trinity Episcopal Church in Buffalo, and the Biltmore Estate in Asheville, North Carolina. He also designed mausoleum windows, one of which can be seen on page 67.

Mackay Mausoleum
40° 39' 14.81" N 73° 59' 1.32" W

John Mackay
November 28 1831–July 20, 1902

Marie Louise Hungerford Mackay
1843–1913

Clarence Hungerford Mackay
April 17, 1874–November 12, 1938

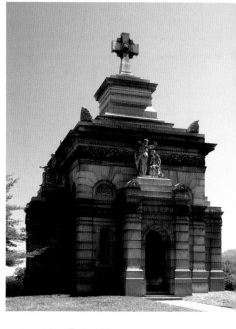

Television viewers of the 1960s and '70s will no doubt remember the popular series *Bonanza* (1959–1973), which was centered on the fictitious Ponderosa near the real-life town of Virginia City, Nevada. The series detailed the adventures of four main characters—Ben Cartwright and his three sons (Adam, Hoss, and Little Joe). Although the Cartwright clan was fictitious, there really was a Bonanza: the Big Bonanza, a vast deposit of silver ore in Virginia City that was developed by four powerful men: James Fair, James Flood, William O'Brien, and John Mackay (who was the most well-liked of the group, thanks in part to his hardscrabble Irish-American upbringing that the working-class miners identified with).

Mackay was born in Dublin, Ireland, and grew up in New York City. As a youth, he worked in a shipyard, but in 1851, he caught the gold-fever bug and journeyed to California, bent on striking it right in the placer mines of the Mother Lode. Mackay made a modest amount of money and then went to Virginia City, Nevada, to dabble in silver mining. After losing nearly all the money he had made in California, he teamed up with Fair, Flood, and O'Brien to speculate on mining stocks and develop silver mines. In 1873, the quartet struck it rich when their firm discovered a vast body of ore, which became known as the Big Bonanza, which yielded over $180 million (over $3.5 billion today).

Eventually Mackay left Virginia City and became involved in other ventures. In 1884, along with James Bennett, he formed the Commercial Cable Company to compete with Jay Gould's Western Union Telegraph

Company. In later life, he traveled extensively, maintaining residences in New York, London, and Paris. However, he never forgot the area that made him rich. He supported a number of charities and endowed an orphan asylum in Virginia City. In 1908, six years after his death, his widow, Marie Louise Hungerford Mackay, gave money to found the Mackay School of Mines at the University of Nevada.

The Mackay Mausoleum is an Italian Renaissance Revival masterpiece. In 1898, it cost $250 thousand to construct (about $5 million today if a company had the skilled artisans to build it). According to an account written at the time, the mausoleum's 26 1/2-square-foot, 14-inch-thick roof-stone was the largest piece of stone ever quarried in the United States. The account further states that the four bronze statues (crafted in Munich, Germany) topping each of the four arms of the mausoleum are allegorical figures representing Sorrow, Faith, Death, and Life. Another unique aspect of the mausoleum was that it was fitted with a heating and electrical system.

Also spending eternity in the Mackay Mausoleum is Mackay's second son, Clarence, who was the father-in-law of composer Irving Berlin.

The interior of the Mackay Mausoleum deviates from the utilitarian designs of many mausoleums. It has an altar

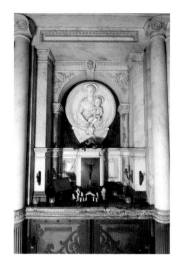

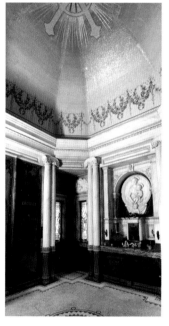

(which at one time held a family bible), a beautiful domed mosaic ceiling, and eight stained glass windows. Since the mausoleum was heated and fitted for electricity, it could serve year-round as a small chapel. The twenty-two crypts are set behind bronze-framed heavy marble panels. The marble used in the interior panels was imported from Italy, France, and Belgium.

The crypts of John and Marie Mackay are located directly beneath the altar. Family members still decorate the mausoleum's altar.

Each of eight stained glass windows, which were crafted in Munich, Germany, depicts a different beatitude. This one reads, "Blessed are those who hunger and thirst."

Originally, 60 lightbulbs were concealed above the cornice to illuminate the mosaic dome. A modified Celtic cross is a nod to John Mackay's Irish ancestry.

Steinway Mausoleum
40° 39' 05.65" N 73° 59' 37.62" W

The largest private mausoleum in Green-Wood holds the earthly remains of dozens of members of the Steinway family, and there's room for dozens more. Heinrich Engelhard Steinweg (1797–1871) arrived in the United States with his family in 1851. He soon anglicized his name to Henry Engelhard Steinway. He was already a successful piano-maker in Germany, and he and his four sons found ready work at piano companies in New York before striking out on their own in 1853 as Steinway and Sons. The company soon became known for quality workmanship and garnered awards at expositions in London and Paris. Steinway's simple principle was to build the best possible piano without regard for price and to strive to always improve the instrument. The company has earned over 120 patents, a greater number than any other piano company.

The Steinway Mausoleum was built shortly after Henry Steinway's death for $80,000 ($1.5 million today). It was designed by John Moffitt and contains over 200 individual crypts. Its hilly perch makes it appear even more massive and imposing. The cemetery frequently opens it to visitors during special events.

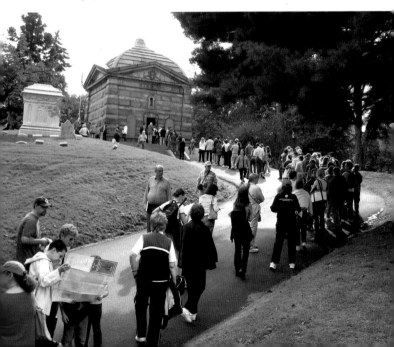

Two walls of crypts line the interior of the mausoleum. Each wall contains 56 crypts. A large granite slab covers an underground vault. Just out of view at the bottom left are the crypts of Henry Steinway and his wife, Julia. The lettering on the marble cover fronting his crypt reads, "E. Henry Steinway, Born February 15th, 1797, at Wolfshagen, Duchy of Brunswick, Germany, arrived in New-York June 29th, 1850. Name lawfully changed from 'Steinweg.' Died February 7th, 1871."

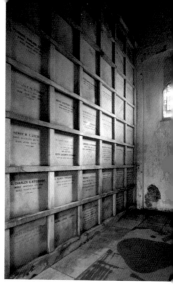

Stewart Mausoleum
40° 39′ 27.46″ N 73° 59′ 39.00″ W

Noted architect Stanford White designed this mausoleum for the Stewart family. Although records do not indicate how many monuments and mausoleums White personally designed, his firm—McKim, Mead & White—designed 40 funerary monuments between 1879 and 1919. Most of the firm's designs are classical in origin, and the firm often collaborated with other designers and sculptors to achieve the final product.

White's rather plain design for the Stewart Mausoleum is enhanced by bronze reliefs sculpted by Augustus Saint-Gaudens in 1883. Saint-Gaudens often collaborated with Stanford White. Saint-Gaudens achieved fame as the designer of the U.S. $20 gold piece, often referred to simply as the "Saint-Gaudens." The bronze panels Saint-Gaudens crafted for the Stewart Mausoleum are very low relief and look as if they have been scratched into the surface. One panel depicts an angel holding a banner or scroll, symbolizing the taking of the inventory of one's life. The other panel presents an angel holding a long horn, symbolizing the Archangel Gabriel, who signals the heavens of the impending arrival

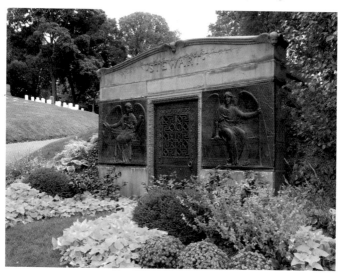

of another soul. The angel is seated on a bench that is inscribed with a biblical verse.

The Stewart family mausoleum contains, among others, David Stewart (1810–1891), who made his fortune in coal and iron mining, and was the owner of the Stewart Iron Works in Uniontown, Pennsylvania. In 1830, he married Adelia Smith. They had four children; the oldest, Isabella, later became famous as "Mrs. Jack" Gardner of Boston, founder of the Gardner Museum. She opened her "house museum" to the public but ruled over it like a mother hen. Even in her later years when she was bedridden, she would call out to imaginary visitors not to touch her treasured works of art.

John "Papa Johnny" Torrio
February 1882–April 16, 1957
40° 39′ 27.01″ N 73° 59′ 12.48″ W

Johnny Torrio had a relatively long life, especially considering his checkered provenance. He was born in the village of Irsina, Italy, and his family immigrated to America when he was two. He grew up in the Lower East Side, becoming involved in the Five Points Gang as a teenager. He quickly developed into a cold, calculating, cunning, and crafty criminal; hence his other Mob nickname "the Fox." By all accounts, Torrio became wildly successful in his less-than-mainstream profession of running various Mob rackets. He moved to Chicago in 1918, taking his understudy Alphonse Capone along with him. Torrio and Capone worked together throughout the 1920s, presiding over the Chicago Outfit. They became multimillionaires, running various operations that included a bootlegging, gambling, and prostitution.

But, as with all businesses, there were conflicts and rivalries with other businessmen. On January 24, 1925, a group of Chicago businessmen known as the North Side Gang attempted to take over Torrio's business by eliminating him. As Torrio was driving home from a shopping trip with his wife, Anna, he was greeted by a hail of gunfire initiated by North Side Gang members Earl "Hymie" Weiss and George "Bugs" Moran. Although Torrio was severely wounded, he managed to survive. Shortly thereafter, Torrio officially retired and moved to Italy. However, Torrio returned to the United States in the 1930s and continued to serve as an elder statesman and advisor to the Mob. He died of a heart attack while sitting in a barber's chair. Wary to the end, he was seated "Chicago style" (facing the door).

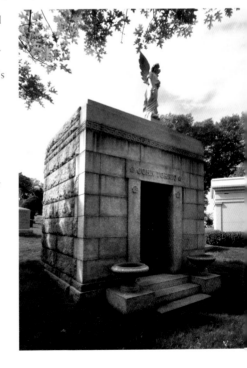

Van Ness Parsons Mausoleum
40° 39' 26.94" N 73° 59' 28.61" W

American cemeteries often have a schizophrenic attitude towards Egyptian architecture. While almost all Egyptian architecture has something to do with death and the afterlife, thus making it a perfect fit for the cemetery, its pagan origin often raises the hackles of the religious community. Memorial designers frequently soften the pagan profile of Egyptian forms by adding Christian figures and symbols.

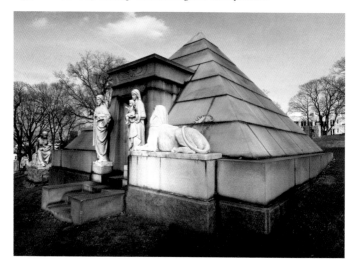

The Van Ness Parsons Mausoleum is a perfect example of this hybridization. Over the entrance to the mausoleum are vulture wings, which is an Egyptian symbol for maternal care, but that is softened by statues of an adoring sphinx gazing upon Jochebed holding her son Moses, while another statue portrays Jesus holding a lamb, symbolizing innocence (Jesus is known as the Lamb of God). In the distance is another maternal figure that may be a representation of Pharaoh's daughter finding Moses in the bulrushes on the Nile in Egypt.

The most noted occupant of the mausoleum is Albert Ross Parsons (1847–1933), a noted pianist and head of the piano department at the Metropolitan Conservatory of Music. More apropos to the mausoleum, Parsons was also an Egyptologist who wrote the book *New Light from the Great Pyramid: An astronomico-geographical system of the ancients recovered etc.*, in 1893. Also sharing space in the pyramid is Parsons' wife, Alice Schuyler Van Ness, who died in 1931.

John Wiarda
March 11, 1860–1909
40° 38' 56.92" N 73° 59' 37.56" W

This substantial domed Classical Revival mausoleum holds the remains of John C. Wiarda. He was educated in Germany and Brooklyn, and then gained employment in the metal industry, rising to president and treasurer of the L. A. Eberhardt Company. Eventually he formed his own firm, J. C. Wiarda & Co. Manufacturing Chemists, in the Greenpoint area of Brooklyn, just a stone's throw from Green-Wood Cemetery. Wiarda was active in a number of organizations. He was a member of the

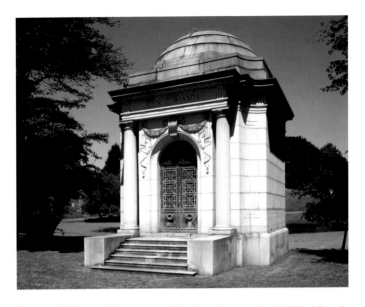

Society of Chemical Industry, the Brooklyn League, the 7th Ward Board of Trade, and the James McLeer Camp of the Sons of Veterans. His true love seemed to be as a yachtsman. He was a commodore of the Jamaica Bay and South Bay Yacht Clubs and owned his own yacht, the *Lonta*.

Minerva and the Altar to Liberty
40° 39' 25.98" N 73° 59' 21.71" W

A statue of Minerva, the Roman goddess of war, wisdom, art, schools, and commerce, stands at the highest point in Green-Wood (indeed, the highest point in Brooklyn). She looks directly at the Statue of Liberty in New York Harbor a few miles distant. Charles Higgins, a manufacturer of

India ink and glue, whose mausoleum is a few paces away, wanted to honor a group of riflemen who were killed in the Battle of Long Island in 1776. He felt that the battle, which has often been called "the first battle of the nation," had long been ignored, so he headed a movement to have a statue of Minerva and an Altar of Liberty erected near the site of the battle (the Battle Hill section of Green-Wood). The statue, which was sculpted by Frederic Wellington Ruckstall, was unveiled on August 27, 1920, the 144th anniversary of the Battle of Long Island.

Henry Bergh
August 29, 1811–March 12, 1888
40° 39' 6.97" N 73° 59' 5.02" W

Henry Bergh was born into a wealthy family. After he graduated from college, he worked in a shipyard owned by his father. His father sold the shipyard a few years later and gave Henry a substantial inheritance, some of which he used to tour Europe with his new bride, Catherine. While in Europe, he observed that animals (work animals, in particular) were often treated better than they were in the United States. Bergh found his calling, and in April 1866, he founded the American Society for the Prevention of Cruelty to Animals (ASPCA). He was instrumental in establishing the New York Society for the Prevention of Cruelty to

Children in 1874 and the Massachusetts Society for the Prevention of Cruelty to Children in 1878.

When Bergh died on March 12, 1888, his body was put in the receiving vault in St. Marks Church in Manhattan until the roads could be cleared of snow. Three days later, the funeral procession (with Mayor Abram Hewitt as a pallbearer and other luminaries including circus entrepreneur P. T. Barnum in attendance) made its way to Green-Wood. In 2006, a large bas-relief was installed at the base of Bergh's pyramidal mausoleum, and for the first time in over 100 years, the public was invited to bring their pets into Green-Wood.

Charlotte Canda
1828–February 3, 1845
40° 39' 19.20" N 73° 59' 30.57" W

If this monument looks like it's not well thought out and a bit unprofessional, it's because its basic form was designed by a teenage girl and not a trained architect or designer. When she was 16 years old, Charlotte Canda, whose French parents ran a finishing school in New York City, sketched a design for a memorial for her deceased aunt. Little did young Charlotte know that she was actually sketching a draft of a monument for herself.

February 3, 1845, was a dark and stormy night, but the weather scarcely put a damper on Charlotte Canda, who was all aglow from her combination 17th birthday and coming-out party. Charlotte and her father, Charles Canda, gave one of her friends a carriage ride to her Waverly Place home in Manhattan, but as Charlotte's father was escorting her friend to the door, the horses, perhaps afraid in the raging storm, bolted and ran. The carriage careened through the streets of Manhattan with Charlotte still inside. Alas, the carriage door had been

left ajar, and a short time later, young Charlotte Canda tumbled out of the carriage and violently hit her head on the curb. Unaware of what had happened, Charles Canda searched for Charlotte then found his way home. Shortly after he arrived home, he and his wife were summoned to the place where Charlotte was ejected from the carriage. Charlotte succumbed in her father's arms soon thereafter.

Charlotte Canda was interred at the Old St. Patrick's Cathedral on Prince and Mott Streets in Manhattan. But soon thereafter, her father took Charlotte's sketch for her aunt's grave, added a few flowery embellishments, and turned it over to sculptor Robert Launitz to finish the design and craft a suitable monument. Most of the monument was executed by Launitz and fellow-sculptor John Franzee. The result of the Canda/Launitz collaboration has the look of a Gothic Revival wedding cake. In the center of the monument and housed in a structure reminiscent of a grotto, Launitz carved a statue of Charlotte in the party dress she wore that fateful night. The Canda Monument is awash with symbolism. There are books (Charlotte was fluent in five languages), musical instruments she played, drawing tools she used for her sketches, down-turned torches signifying a life extinguished, parrots that were her pets, and 17 roses circling her head. Further symbolizing her age are the dimensions of the monument: it is 17 feet high and 17 feet long.

To add a touch of Romeo and Juliet to the Canda saga, her despondent fiancé, French nobleman Charles Albert Jarrett de la Marie (1819–1847), took his own life two years later. Charlotte had been buried on consecrated ground, but because Charles had committed suicide, he could not be buried with his bride-to-be. Charles lies in unconsecrated ground just off to the right under a small upright tombstone with his family's coat of arms.

The entire ensemble cost upwards of $45,000 (over $1 million today). From the time of the monument's erection in 1847 and all the way through the 1850s, it was the most popular monument in Green-Wood (indeed, some accounts say it was the most popular monument in all America).

Cassard Angel

40° 39' 09.18" N 73° 59' 45.61" W

Directly across Oak Avenue from Horace Greeley is the Cassard angel,
which mourns over fallen members of the Cassard family. It's a copy of
the Story angel in the Protestant Cemetery in Rome. The Story angel,
known variously as the Angel of Grief and the Weeping Angel, was
carved by expatriate American sculptor, poet, and art critic William
Wetmore Story as a monument to his wife Emelyn Story, who died
on January 7, 1895. The Story's home in Rome was a gathering place
for American and English artists, musicians, and writers. The Angel of
Grief was Story's final sculpture. He died in October 7, 1895, at age 78.
Various incarnations of the Story angel dot cemeteries worldwide. The
first Cassard to be laid to rest in the Cassard plot at Green-Wood was
Aurelia Cassard, who died in December 1908. Presumably the angel was
placed on the plot around the same time.

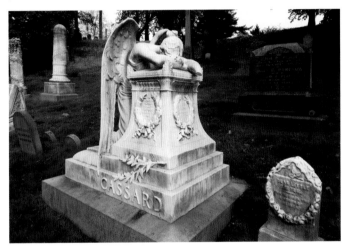

Henry Chadwick

October 5, 1824–April 20, 1908
40° 39' 26.72" N 73° 59' 09.90" W

Even though he never played on an organized team, Henry Chadwick
is known as "The Father of Baseball." He was born in Exeter, England,
to journalist James Chadwick and his wife, Theresa. As a youth, Henry
played cricket and rounders. After the family moved to the United States
in 1837 and settled in Brooklyn, he resumed his childhood activities,
which included playing cricket. He was soon introduced to an American
game that was similar to rounders and cricket; that game became known
as base ball.

In 1844, Chadwick got a job as a reporter for the *Long Island Star*;
thus began a long career in journalism. In the 1850s, he became a sports
reporter for the *New York Times*, often covering cricket matches. At the
time, baseball was in its infancy, but Chadwick was fascinated by it
and began aggressively covering games and promoting baseball as an
American sport. He wrote that as a reporter, he had the power to make
baseball "a powerful lever . . . by which our people could be lifted into
a position of more devotion to physical exercise and healthful out-door
recreation than they had hitherto, as a people, been noted for."

In the years that followed, he wrote baseball manuals, helped codify the rules, was instrumental in organizing teams into leagues, and invented the "box score" system that still exists (with minor variations) today. Chadwick had some well-documented disagreements with Abner Doubleday, who is widely credited with inventing baseball in Cooperstown, New York, as a uniquely American sport (Chadwick traced the origins to rounders and cricket in England). In 1938, Chadwick was elected to the Baseball Hall of Fame. He is the only journalist enshrined in the player's wing of the museum.

His nine-foot monument, which was commissioned by a committee chaired by Charles Ebbets (the home of the Brooklyn Dodgers was Ebbets Field), is one of Green-Wood's most personal. Marking the plot are four granite bases connected by base paths. One side of the monument has a bronze catcher's mask and crossed bats, another side has a glove and crossed bats, and another side has a baseball diamond. The pedestal is topped with a granite sphere complete with debossed baseball seams. There are almost always an assortment of balls, bats, and gloves left by baseball fans as a tribute to Henry Chadwick, the Father of Baseball.

Clarence D. MacKenzie

February 8, 1849–June 11, 1861
40° 39' 16.14" N 73° 59' 18.70" W

Young Clarence MacKenzie was only 12 years old when he marched off to the Civil War as a drummer boy with Brooklyn's Thirteenth Regiment. While at a training camp in Annapolis, Maryland, he was accidentally killed in his tent by a stray bullet fired by men who were drilling close by. Although he was never in a battle, Clarence MacKenzie was Brooklyn's first casualty of the war. His body was brought back to Brooklyn and buried in the Hill of Graves at

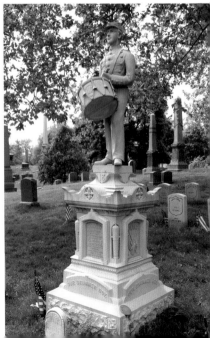

Green-Wood; it was later reburied in the Soldiers' Lot, which Green-Wood donated specifically for Civil War Veterans. To commemorate Brooklyn's first casualty of the Civil War, the grave was marked with a 10-foot-high zinc (white bronze) monument of Clarence, crafted by The Monumental Bronze Co. of Bridgeport, Connecticut. Its head was based on a likeness of young Clarence.

Horace Greeley
February 3, 1811–November 29, 1872
40° 39' 10.02" N 73° 59' 47.30" W

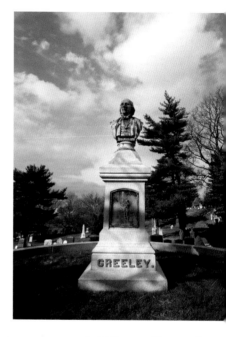

Horace Greeley's bust-topped tomb caps rise on the north side of Oak Avenue. His lofty, panoramic eternal rest seems appropriate. Horace Greeley was born into an agrarian lifestyle in Amherst, New Hampshire. His parents, Zachary and Mary, were poor farmers, and young Horace eschewed their lifestyle, apprenticing as a printer in Poultney, New Hampshire. Apparently the printer's ink got into his blood. He moved to New York at age 20, then three years later he founded a weekly publication titled *New Yorker*. Four years later in 1838, Whig politicians selected him to edit a campaign newspaper titled *Jeffersonian*. He was off and running.

In 1841, he merged two newspapers to form the *New York Tribune*, a newspaper he edited until his death. Never one to conform to the edicts of others, he supported a number of radical causes for the day, including women's rights (but not the right to vote) and the abolishment of slavery. He also dabbled in spiritualism and phrenology (the pseudo-science that states the personality and character can be determined by the shape of and bumps on a person's head). He was particularly fervent about promoting agrarian reforms and the settlement and exploration of the American West. Although there is no firm documentation that he actually originated the phrase "Go west, young man," he certainly popularized it.

Greeley dabbled in politics for much of his life and served as a representative for New York in the U.S. House of Representatives in 1848 and 1849. His political life culminated with a run for the presidency as a candidate for the Liberal Republican Party in 1872. The Republican candidate, Ulysses S Grant, soundly defeated him. Greeley holds the rather dubious distinction of being the only presidential candidate who died before the Electoral College votes were cast.

While Greeley was on his deathbed, Whitelaw Reid, one of his

longtime adversaries (Reid had wrested control of the *Tribune* from Greeley), entered the room. Greeley looked at Reid and reportedly shouted, "You son-of-a-bitch, you stole my newspaper." Greeley expired shortly thereafter.

He wanted a simple funeral, but his daughters arranged an elaborate funeral culminating with his burial at Green-Wood. Alas, his bronze bust faces southeast, not west.

Elias Howe
July 9, 1819–October 3, 1867
40° 39' 22.62" N 73° 59' 21.16" W

Fannie the Dog
?–December 10, 1881

Elias Howe's story will surely bring a smile to any litigator's face. He was born to a poor family in Spencer, Massachusetts. Like many young men of the time in New England, he found a job apprenticing in a textile factory. Then after a series of textile mill closings, he apprenticed as a mechanic, eventually working for a master mechanic in Cambridge, Massachusetts. Young Elias persevered at his job, barely making enough money to support his wife and family. His

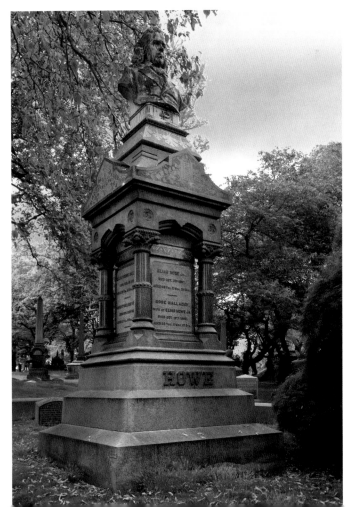

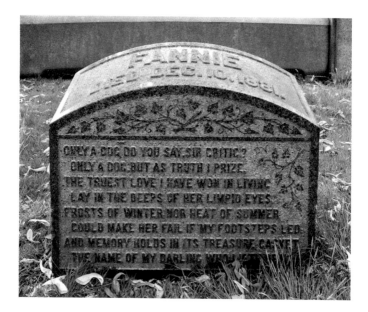

breakthrough came in 1846 when he invented and patented a speedy (for the time) sewing machine using a lockstitch design. Other inventors had conceived and built sewing machines, some as early as 1790, but none had proved very reliable or useful. Elias Howe's sewing machine suffered the same fate. He even went to England to try to garner investors, but his efforts were unsuccessful. He returned to the United States in 1849, virtually penniless. Then, to make things worse, his wife died. As a final insult, two men, Walter Hunt and Isaac Singer, started manufacturing sewing machines that were virtually identical to Howe's and raking in money. Down but not out, Howe hired an attorney and sued for patent infringement. The case took five years to litigate, but justice prevailed and Howe received a settlement and royalty of $5 for every sewing machine the Singer Sewing Machine Company and a handful of smaller companies sold. Exact figures are difficult to calculate, but ultimately the combined settlement and royalties yielded him millions of today's dollars.

And the Howe monument will bring a smile to any dog-lover's face. Most cemeteries strictly forbid the burial of pets. There are some notable exceptions, such as people who are buried with an urn of their favorite pet's ashes or some surreptitious nighttime pick-and-shovel forays by well-meaning pet lovers. It is unclear what transpired at Green-Wood to usurp the regulation, but peek around back of the Howe monument and you'll see a small stone with the name "Fannie" and "died December 10, 1881" on top. Fannie was the family dog. The ivy-topped script carved into the face of the granite stone reads,

> Only a dog, do you say, sir critic?
>> Only a dog, but as truth I prize
> The truest love I have won in living
>> Lay in the deeps of her limpid eyes
> Frosts of winter nor heat of summer
>> Could make her fail if my footsteps led
> And memory holds in its treasure casket
>> The name of my darling who lieth dead

Merello Volta Monument
40° 38' 46.12" N 73° 59' 24.76" W

Mystery continues to
shroud this mournful
monument. At one time,
there were persistent
rumors that the monument
commemorated a bride who
was shot by a Mafia rival,
but it is more likely the
monument is an evocative
testament to another
murder.

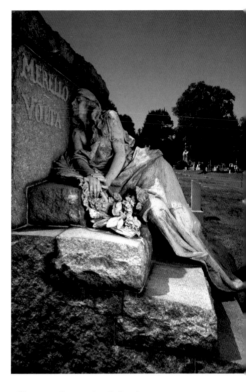

On the morning of
June 26, 1909, Pietro
Silverio and Annie Terello,
who were servants of
wealthy Brooklyn widow
Mrs. Dominica Merello,
had an altercation at Mrs.
Merello's summer home
in Midvale, New Jersey.
Apparently Pietro was
angry about orders given to
him by the servant girl. As
the day progressed, Pietro
grew more and more angry
at Annie, and his temper
flared. By late afternoon, he
had had enough and told
Mrs. Merello he wanted to quit. She gave him a check for the amount
due him, and he retired to his room to gather his belongings.

A short while later, as the Merello home was readied for an
outdoor supper party, loud moans could be heard from Pietro's room.
Rosie Guarino, the 35-year-old daughter of Dominica Merello, went
to check to see what the trouble was but was assured by Pietro that
all was well. Shortly after Rosie returned to the supper party, Pietro
emerged from his room, pistol in hand. He approached Annie Terello,
who was getting water at the well, and fired two shots into her, which
ultimately proved fatal. Pietro rushed back into the house and returned
with a shotgun, apparently intent on delivering a coup de grâce to
the mortally wounded Annie. As he ran with the shotgun, he was
intercepted by Rosie Guarino, who screamed, "Pietro, what are you
doing? What do you mean?"

"I'll shoot you too," yelled Pietro, and as Rosie fled, Pietro
shouldered the shotgun and felled Rosie, blowing a three-inch hole in
her shoulder and penetrating her lungs. The dinner guests (all of whom
were women) scattered, and Pietro fled into the woods. He was caught a
few hours later and transferred to the local jail.

The grounds around the Merello Volta Monument are punctuated
with a number of graves of the Merello, Volta, and Guarino families
(little is known about the Voltas). Many of the graves, including
the grave of Rosie Guarino, have a *burial* date of December 1911,
suggesting that the bodies were transferred to the location after the
monument was erected.

Lola Montez
(Marie Delores Eliza Rosanna Gilbert)
ca. February 17, 1821–January, 17, 1861
40° 38' 53.58" N 73° 59' 36.49" W

There aren't too many of us mortals who wind up getting a phrase attached to our moniker. There's "in like Flynn" (actor Errol Flynn's amorous exploits), The Real McCoy (multiple origin theories, but meaning "the real thing"), and then there is "What Lola wants, Lola gets." Chalk that up to Marie Delores Eliza Rosanna Gilbert, aka Lola Montez.

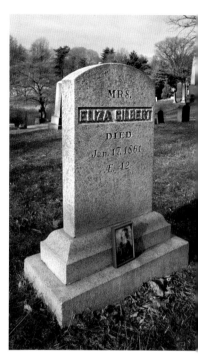

Some of the specific facts pertaining to the woman who became known as Lola Montez, such as her birthplace and date, are a bit hard to pin down, while others are well documented. She was allegedly born in Limerick, Ireland, in 1818 or 1823 to 15-year-old Eliza/Elizabeth Oliver. Eliza's daughter was a precocious child, constantly making mischief. She was described by a teacher as possessing great grace and beauty, which was unfortunately counterbalanced with a violent temper and haughty air. At age 16, to avoid an arranged marriage with a man over 40 years her senior, she eloped with an army officer and went with him to Calcutta, India. Five years later, the couple separated, and she reinvented herself as a dancer with the stage name "Lola Montez, the Spanish Dancer." She rocketed to fame, performing her risqué "spider dance," where she pretended to shake crawling spiders for her petticoats. Her seductive powers were legendary. In the next few years, she reportedly had affairs with King Ludwig I, Franz Liszt, Czar Nicholas I, Honoré de Balzac, and Alexandre Dumas. She performed all over the world, shocking some while pleasing others. It is difficult to track the exact time when the phrase "what Lola wants, Lola gets" actually originated, but what's clear is that it definitely was applied to the proclivities of Lola Montez.

After her dancing career ended, she spent the remainder of her life tending to downtrodden women. She died virtually penniless. Her friends scraped together enough money to purchase a small granite marker with an abbreviated version of her baptismal name, Eliza Gilbert. Her obituary in the *New York Times* read, in part, "There are few leaders of the newspaper literature of the day who are not familiar with the name of that eccentric, brilliant, impulsive woman, known as LOLA MONTEZ. As a danseuse, an actress, a politician, a courtesan, a lecturer, a devotee, she has occupied a large space of the public attention for many years, both in this country and in Europe. Her career, so strangely erratic, so wonderfully checquered, came to its end on Thursday last."

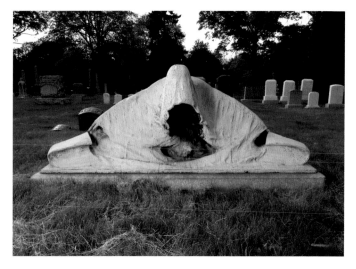

Charles Adolph Schieren
February 28, 1842–March 10, 1915
40° 38' 45.59" N 73° 59' 17.09" W

Marie Louise Schieren
August 5, 1840–March 11, 1915

One of the most mournful monuments at Green-Wood marks the graves of Charles and Marie Schieren. He was born in Dusseldorf, Rhenish Prussia, then in 1856 immigrated to the United States with his parents. He trained as a cigar maker before getting into leather making and specializing in leather belting. By the mid-1890s, he had established manufacturing plants in New York, Chicago, Boston, and Philadelphia, and tanneries in Pennsylvania, Tennessee, and Maryland. Turning his eye to political office, he served as mayor of Brooklyn in 1894 and 1895. Both he and his wife,

Marie, contracted pneumonia in the winter of 1915 and died within hours of each other. The epitaph on their grave reads, "In their lives they were lovely and in their death they were not divided."

The evocative bronze statue hovering over their graves was crafted by Solon Borglum, the brother of Gutzon Borglum, who carved the statues of four presidents at Mount Rushmore, South Dakota. Solon Borglum, who was a close friend of the Schierens, titled his work *Azreal, the Spirit of Death*, which is no doubt his artistic interpretation of "Azreal, The ANGEL of Death," a winged (rather than cloaked) representation of the angel that separates the soul from the body in Hebrew and

Muslim cultures. The female figure's face can only be seen from ground level. The tips of her fingers on each of her outstretched arms touch an oversized closed book symbolizing a full and rich life completed. The sculpture was cast by the Gorham Co. Founders, New York.

Louis Comfort Tiffany
February 18, 1848–January 17, 1933
40° 39' 18.76" N 73° 59' 44.99" W

Artist and designer Louis Comfort Tiffany is best known for his signature Tiffany lamps and stained glass windows. In fact, his lamps are so distinctive that the name "Tiffany lamp" has become generic for any stained glass lamp, just as Scotch tape, Kleenex, and Rollerblades have become synonymous with a particular product. Tiffany had a privileged childhood, attended military academies, then trained as a painter in New York and Paris. By 1879, with the help of his father and other business associates, he formed Louis Comfort Tiffany and Associated American Artists. The business thrived, but he wanted to concentrate on glass; in 1885, he formed the Tiffany Glass Company, which later became Tiffany Studios.

Tiffany used opalescent glass to create colors and textures, and used as little of the traditional painting on glass as possible. Although he is best known for his lamps and windows, he also produced a broad range of interior decorative items. At its peak, his factory employed more than 300 artisans. The well-to-do commissioned his firm to craft windows for their homes, businesses, and mausoleums. Some of the windows in mausoleums have been valued at upwards of $1 million (see Tomb Raider, page 239). The highest value of any Tiffany window is the 12-foot-tall *The Face of Princess Minnehaha, standing in front of Minneapolis' Minnehaha Falls*, which has been appraised at over $3 million. Examples of his mausoleum windows can be seen on pages 62, 64, and 73.

The area around Louis Comfort Tiffany's humble gravestone erupts with the markers of a number of members of the Tiffany family, including his father, Charles Lewis Tiffany (February 15, 1812–February 18, 1902), who founded the original Tiffany and Company in 1837.

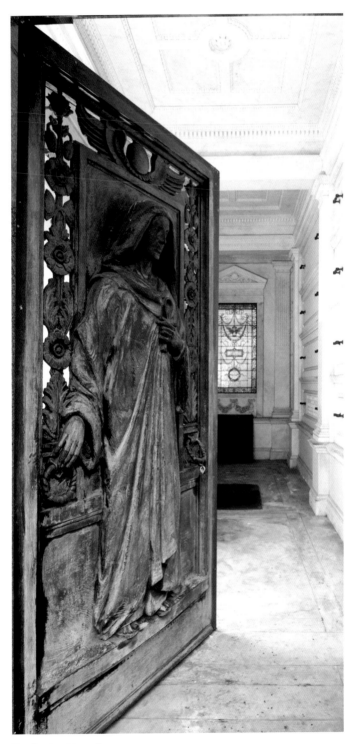

Huntington Mausoleum

The Woodlawn Cemetery

Webster Avenue & East 233rd Street

Bronx, New York 10470

(718) 920-0500

www.thewoodlawncemetery.org

40° 53' 43.18" N 73° 51' 50.01" W (main entrance)

40° 53' 15.71" N 73° 52' 40.11" W (Jerome Avenue gate)

I f you want to study New York City's architecture, forget about craning your neck or dodging taxicabs. Just hop on the Number 4 subway north towards the Bronx and sit down and relax. The last station is poetically positioned at the Jerome Avenue entrance to Woodlawn Cemetery—it's the end of the line. Woodlawn's 1,300-plus mausoleums are a study in almost every architectural style ever since there was architecture. Indeed, there is no better collection and condensation of architectural styles anywhere in the United States, and maybe the entire planet.

Woodlawn Cemetery was founded in 1863. At the time, the land was part of Westchester County; then in 1874, New York City gobbled up the land, and Woodlawn became part of the Bronx. Woodlawn was originally laid out using the rural cemetery ethos that was popular at the time. The design was altered a few years after the cemetery opened to conform to a more open landscaping theme, called the landscape-lawn plan, which meant eliminating fences and encouraging plot owners to have centerpiece monuments surrounded by smaller gravestones. The vast lawns became the perfect canvas for the glorious mausoleums that punctuate the immaculate grounds. By the end of the nineteenth century, Woodlawn had eclipsed Green-Wood in Brooklyn as the place for New York's movers and shakers to construct their eternal home. The 400-acre cemetery has over 300,000 burials. The addition of a large community mausoleum, a fair amount of undeveloped land, the rise in cremation (which requires less space), and a well-managed endowment fund assures that Woodlawn will continue to be an active cemetery for years to come.

Armour Mausoleum
1837–September 8, 1901
40° 53' 22.28" N 73° 52' 34.83" W

This fleshy-colored mausoleum is the final resting place of meatpacker Herman O. Armour, head of the commission house H. O. Armour and Company, which merged with his brother's Armour & Company, meat packers, in 1875.

The Armour Mausoleum, designed by Renwick, Owen & Aspinwall in 1901 and fabricated by Norcross Brothers, is designed in an exuberant rendition of the Classical Revival style. It is crafted in Stony Creek and Quincy granite, and features a copper dome roof with tiles in a

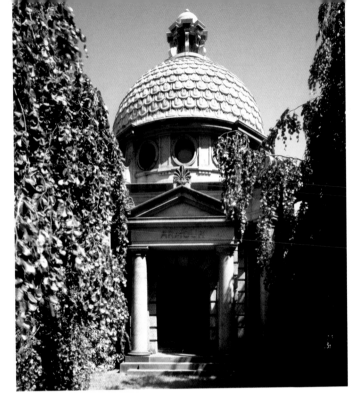

decorative scale pattern and an ornate bronze cupola. The octagonal mausoleum is supported by four pairs of Doric columns. The rusticated arched entrance is flanked by two Doric columns, which support a simple architrave that bears the family name. The pedimented gable above the door features decorative acroteria at the peak and at the corners.

Jules Bache
November 9, 1861–March 24, 1944
40° 53' 12.37" N 73° 52' 33.97" W

German-born Jules Semon Bache rests among the many robber barons, financiers, and millionaires he lived with. Bache made his living as a banker and stockbroker. In 1886, he became a minority partner in the stockbrokerage firm of Leopold Cahn & Co., then when he took over full control of the company in 1892, he renamed it J. S. Bache & Co. Through crafty investing and financial acumen, he became enormously wealthy. And, to his credit, he gave away much of his fortune to support the arts and charitable causes. He was a longtime collector and patron of the arts, and donated a number of Raphaels, Rembrandts, Titians, and others to the Detroit Institute of the Arts and the Metropolitan Museum of Art. In 1981, Bache & Co. was acquired by Prudential Financial, Inc., for $385 million and is now known as Prudential Bache.

His tomb reflects his interest in the arts. For his mausoleum, he chose a replica of the elegant Kiosk of Trajan, or "pharaoh's bed," at the temple of Isis on the island of Philae on the Nile River. Bache's Kiosk of Trajan was designed by Davis, McGrath & Kiessling in 1916 and fabricated of Barre granite by Farrington, Gould & Hoagland. The hallmarks of the Bache Mausoleum are the 14 massive columns, which are capped with abstractions of lotus blossoms (signifying the unfolding

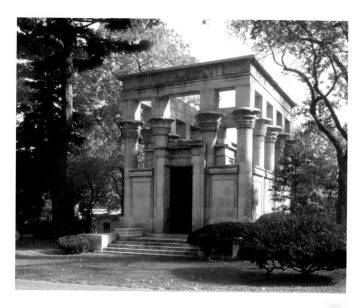

creative universe), and the open roof design. A winged solar disk, which is associated with divinity and royalty, is carved above the lintel. The winged sun is also symbolic of the soul. When placed above doors, it served as a reminder to visitors of the eternal nature of their soul. The landscaped lot was designed by Charles Wellford Leavitt in 1918. His original design was quite spartan and meant to reflect the aridity of the Egyptian climate. The Bache Mausoleum and its grounds were featured in a 1917 article in *Architectural Review* magazine on mausoleum architecture and in a 1921 article titled "Planting the Mausoleum Plot" in *Park and Cemetery* magazine. It also appeared in the "Portfolio of Current Architecture" in the May 1920 issue of *Architectural Record*, and on covers of *Park and Cemetery* magazine in April, May, June, and July 1932.

Kiosk of Trajan
Island of Agilika, Philae, Egypt
24° 1' 30.29" N 32° 53' 4.48" E

Jules Bache visited Egypt and was inspired by the Kiosk of Trajan (aka Trajan's Kiosk). The Kiosk of Trajan was built around AD 100 on Philae Island on the Nile near Aswan. When the Aswan High Dam was constructed, the rising waters of the Nile began to cover the island. UNESCO stepped in and, in a monumental undertaking, moved the buildings on the island to the nearby (and higher) island of Agilika. The

Kiosk of Trajan was thought to house the bark (boat) of the goddess Isis, who was one of humankind's most worshipped goddesses. The ancient scholar Apuleius gave her a voice in *The Golden Ass*: "At my will the planets of the sky, the wholesome winds of the sea, and the lamentable silences of Hell are disposed; my name, my divinity is adored throughout the world."

Belmont Mausoleum
40° 53' 12.75" N 73° 52' 36.34" W

Oliver Belmont
November 12, 1858–June 10, 1908

Alva Vanderbilt Belmont
January 17, 1853–January 26, 1933

While the Bache Mausoleum is a scaled-down copy of a famous building, the Belmont Mausoleum is an almost exact full-scale replica of a famous building, the Chapel of Saint-Hubert in the Queens section of Chateau Amboise in France's famed Loire Valley. The Chapel was designed by Leonardo DaVinci in the Gothic Flamboyant style in the early 1500s. DaVinci spent the last three years of his life in the village of Amboise as a guest of Francois I. Upon his death in 1519, DaVinci's remains were supposedly placed in a sarcophagus in the chapel he designed. The Belmont version was designed by the architecture firm of Hunt & Hunt (1908) and fabricated in limestone by Barr, Thaw & Frazer.

Oliver Hazard Perry Belmont, who rests beneath the protruding

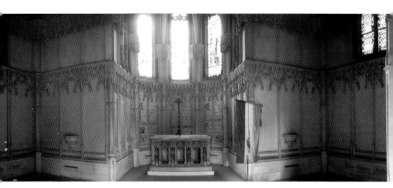

gargoyles of his mausoleum, was hardly a religious man. His great love was horses. The oldest race in the Triple Crown, the Belmont Stakes, is named for his father, August Belmont Sr. Oliver was also a financier and a U.S. representative in congress from New York. After he died, following an attack of appendicitis, his wife Alva Vanderbilt Belmont (she was previously married to William Vanderbilt) used large sums of her fortune to support the growing suffragette movement. Alva lived a long life, and after her death in Paris in 1933, her remains were placed in the Belmont Mausoleum. Interred along with Alva is the suffragette banner she carried, inscribed with the words, "failure is impossible." The banner hangs inside the mausoleum. As early as 1917, Alva Belmont opened the mausoleum to the public, and it is frequently opened today for tours given by the Friends of Woodlawn Cemetery.

The interior of the mausoleum is also a duplicate of DaVinci's tomb, complete with apse, altar, transept, nave, and vaulting with carved arches. It was crafted by the Guastavino Company in 1910. Inside the ornate mausoleum, five stained glass windows by Maitland Armstrong (1910) adorn the nave. A bas-relief sculpture in limestone (carved on-site) by Francois Michel Louis Tonetti (1910) and an oil and gilt mural by William Mackay (1910) also decorate the interior of the mausoleum.

Above the doors, an elaborate frieze carved in high relief depicts Hubert's vision of Christ in the antlers of a stag. Above that, a triptych depicts two figures (left and right) kneeling before the mother Mary holding the Christ child (center).

The tympanum above the entrance (below) on the Belmont Mausoleum and the Chapel of Saint-Hubert are virtually identical.

Belmont Mausoleum

Chapel of Saint-Hubert

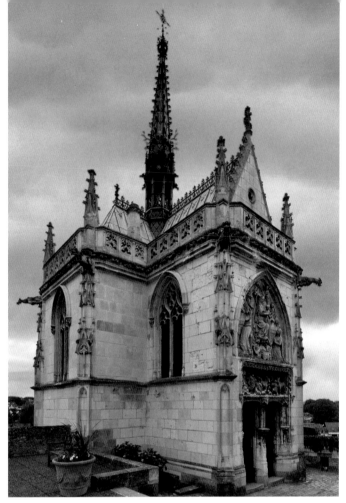

Chapel of Saint-Hubert

Amboise, France
47° 24' 46.75" N 0° 59' 8.53" E

The Chapel of Saint-Hubert is part of the Château Amboise, which is perched on a strategic high promontory overlooking the Loire River. The château had its beginnings in the eleventh century and was extensively remodeled in the Gothic Flamboyant style starting in 1492. The Chapel of Saint-Hubert was built between 1491 and 1496.

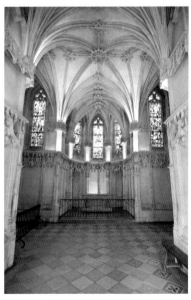

George Ehret
April 6, 1835–January 1927
40° 53' 19.04" N 73° 52' 35.49" W

This big-shouldered Romanesque Revival mausoleum is the eternal home of a big-shouldered man. George Ehret was born in the city of Hofweier in the Grand Duchy of Baden, Germany. His father, who was a prosperous brewer in Germany, came to the United States in 1852. Young George followed in 1856. He went to work for Anton Hupfel in Manhattan and in six years became Hupfel's master brewer. Then Hupfel lent him enough money, combined with what he had saved, to start a brewery of his own. Ehret christened it the Hell Gate Brewery. To get pure water, he drilled an artesian well through 700 feet of rock, saying he would not defile good hops with city water. In 1871, he produced 33,512 barrels of beer; by 1874, production topped 100,000 barrels; by 1900, the Hell Gate Brewery's production soared to over 600,000 barrels. Barrel-chested George Ehret became one of the richest men in New York. When he died in 1927, his obituary stated that "George Ehret had kindly little eyes and a wedge-shaped bald head, spreading out at the neck. His stiff collars, always too big for him, were immense, low and broad; he tucked the ends of his black bow tie up under the flaps of his collar. His figure was square, his legs a little bowed." His estate was valued at $40,000,000.

His massive 56-crypt mausoleum was designed by Schikel & Ditmars in 1900 and fabricated by Robert Caterson. The mausoleum features an arched entrance with windows filling the rise of the arch. Two bronze doors are guarded by granite lions sculpted by J. Massey Rhind. The cornice is decorated with a continuous heavily relieved festoon just below the complex roofline. The tiered domed stone roof is topped by a round finial. Inside, opposite the entrance, a Tiffany stained glass window depicting an angel holding a scroll is set above a bas-relief marble cross, which is surrounded by a laurel wreath and bronze ivy edge.

The June 1907 issue of The *American Architect and Building News* includes a photo of the Ehret Mausoleum. The landscape at the mausoleum was designed by Woodlawn Cemetery in 1910.

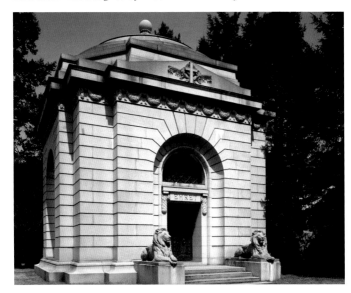

William F. Foster

1841–1895

40° 53′ 23.21″ N 73° 52′ 17.20″ W

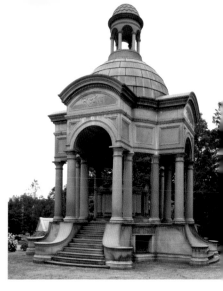

William F. Foster made his rather large fortune by manufacturing a rather small product: fasteners. He also made kid gloves. His final resting place was the subject of a lot of media attention when it was constructed in 1895. The canopied granite structure, which has a cruciform footprint, was designed by architect John Wooley, who had offices at 111 Fifth Avenue. Wooley's design broke the mausoleum mold since it did not have walls and a door. Despite using massive blocks of granite, the tomb has a much lighter feel, thanks to its open-air construction. The base of the tomb is a single 42 x 24-foot 40-ton slab of granite, which was one of the largest ever quarried in Westerly, Rhode Island, an early center for granite quarrying in the United States. Under the slab are catacombs, which have space for eight permanent residents. Centermost on the massive slab is a double sarcophagus containing the mortal remains of William F. Foster. Sixteen Tuscan columns frame the stone ensemble. In all, over 1,100 tons of granite were used in the construction of the 52-foot-high tomb.

The structure takes the form of a canopy tomb rather than a mausoleum, although its sheer size puts it in a classification usually reserved for mausoleums. In the simplest sense, canopy tombs are tent-like structures that shelter a sarcophagus. These structures, usually composed of columns or pillars supporting a dome, are open-air affairs, and unlike mausoleums, they have no doors restricting entry. Canopies may be seen in a variety of ancient architecture. They didn't become part of the European and American architectural repertory until the eighteenth century, when architects began using them for garden pavilions. The decorative potential of these canopied pavilions and kiosks were soon exploited by designers of funerary monuments. They are often seen hovering over a grave or small monument, or sheltering a sarcophagus. The Foster Tomb is among the largest canopy tombs in the world.

Francis Patrick Garvan

June 13, 1875–November 7, 1937

40° 53′ 18.93″ N 73° 52′ 20.74″ W

Francis Patrick Garvan was appointed to the office of "Alien Property Custodian" by President Woodrow Wilson during World War I. As part of his job, Garvan took it upon himself to confiscate a number of German patents. He believed doing so fit within his job description. Then, he sold those patents to the Chemical Foundation Inc., a company where he just happened to be president. Things looked a little fishy, so in 1922, when Wilson's successor, Warren G. Harding, took office, a full inquiry was instituted. This was followed by a well-publicized

months-long trial. Amazingly, Garvan was cleared of any wrongdoing, and the foundation, which had already made a considerable amount of money by licensing the use of the patents to American companies, was now in the position to subsidize the American Chemical Society, the National Research Council, chemical laboratories at leading universities, and the publication of the bulletin *Chemical Abstracts*. In the course of his lifetime, Garvan received honorary degrees from Fordham, Notre Dame, and Yale Universities as well as Trinity College. Also reposing in the mausoleum is his wife, Mabel Brady Garvan, who collected art and donated much of her collection to Yale University.

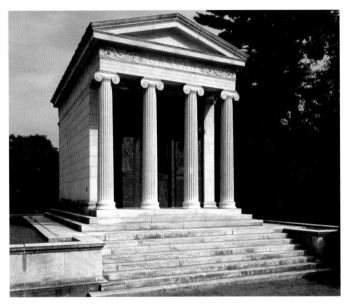

John Russell Pope designed Garvan's Ionic Temple mausoleum in 1927. The Garvan Mausoleum is rescued from being a fairly run-of-the-mill temple mausoleum by the two frieze panels that flank the double doors. The panels depict six women bearing symbols of death, including an urn, palm frond, eternal flame, and scroll, The frieze panels were created by Edward Sanford Jr., who also sculpted most of the decorative sculpture in California's State Capitol in Sacramento. The mausoleum's interior features a simple altar and is finished with marble that has a distinctive vein-like pattern. The landscape surrounding the mausoleum was designed by the Olmsted Brothers.

John W. Gates
May 18, 1855–August 9, 1911
40° 53' 17.60" N 73° 52' 35.25" W

John Warne Gates was a financier and owner of the American Wire Company, which was an early manufacturer of barbed wire. He made millions when he sold the company to J. P. Morgan's U.S. Steel Corporation. Gates was also the founder of the Texas Company, which became the Texaco Oil Company. Gates was known for a fondness of gambling. In 1900, he bet $70,000 on a horse race in England and reaped a $600,000 return. Rumors escalated his winnings to a million dollars and he acquired the nickname "Bet-a-Million" Gates.

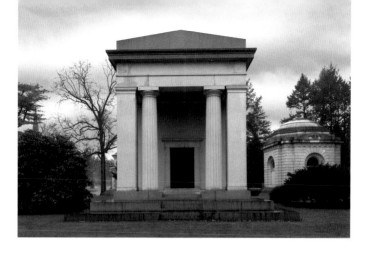

The massive Gates Mausoleum is executed in a Classical Revival style with two fluted Ionic columns on the front and sides that have a plain entablature and slightly gabled pediment. The mausoleum features a door crafted by Robert Aitken in 1914, depicting a mourning woman draped in cloth.

Inside, the mausoleum features two male portrait busts in marble, a combination altar and sarcophagus, a stone table, and two stone chairs. The mausoleum's interior is crafted largely in pink granite. Centermost

is a dark-hued stained glass window. In a 1932 article in *American Landscape Architect*, the mausoleum is illustrated as the "most impressive in Woodlawn."

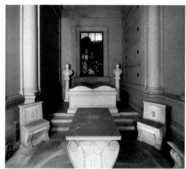

Jay Gould

May 27, 1836–December 2, 1892
40° 53' 27.58" N 73° 52' 15.23" W

Architect H. Q. French of New York designed this Ionic peripteral temple mausoleum, reminiscent of the Parthenon, for Jason "Jay" Gould, the man who defined the term, "Robber Baron." French was the designer of a number of elegant tombs, most of them in the Classical Revival style. Unfortunately, little is known about French's life, but he has left behind a legacy of beautiful architecture. To add to the beauty of the Gould Mausoleum is a huge weeping birch tree, which was designated one of the "113 Great Trees in New York City" in 1985.

A number of members of the Gould family are entombed in the mausoleum, including Gould's wife, Helen, who died in 1889,

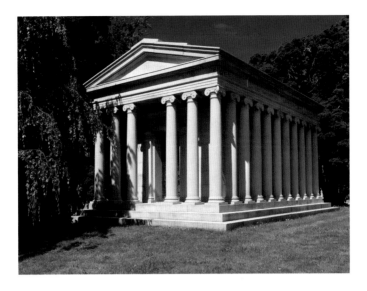

and several of their children. All of the caskets are in wall crypts. Interestingly, Jay Gould's crypt is soldered closed. Apparently the Gould family didn't want a repeat of an incident that occurred in 1876, where the body of another millionaire, A.J. Stewart, was stolen from St. Mark's Cemetery in Manhattan and his remains were held for ransom. An undisclosed amount of money was paid by Mrs. Stewart for the return of what was presumed to be her husband (embalming wasn't an exact science in the 1870s).

Accounts of the day suggest that some of Gould's enemies on Wall Street had the casket sealed so there was no way he could ever show up to wreak havoc again. The *London Times* obit summed up Gould's life best when it declared, "All honor to the greatest money maker of any age or clime. He was less a man than a machine for churning wealth. Napoleon's combinations were never vaster. . . . It will be impossible to explain one phase of civilization without a frequent mention of his name."

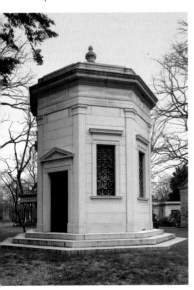

Robert Graves
1866–November 27, 1931
40° 53' 24.82" N 73° 52' 40.47" W

Robert Graves came from a prominent New York family. He inherited a large fortune from his father's wallpaper business and lived an affluent lifestyle. However, he led a troubled life and was married three times. His second wife, Margaret J. Loughman Plant, was formerly the wife of Henry B. Plant, president of the H. B. Plant Company, which had a number of railroad holdings. Graves inherited her fortune when she died. In 1931, his mounting financial problems (perhaps as a result of the general financial collapse of the stock market in 1929) stunned him into

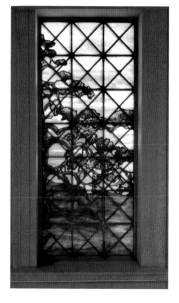

despondency. On November 28, 1931, he was found slumped in his chair after apparently firing two bullets into his head. However, he must not have died completely in financial ruin: his will left $50,000 to a charitable fund called the "Hundred Neediest Cases Fund," administered by the *New York Times* in the name of his wife's charity, the "Margaret Plant-Graves Fund."

His octagonal mausoleum is set on a three-tiered podium, It features fluted pilasters marking each of the corners and an antefix at the peak of the stepped stone roof.

Inside the mausoleum are seven nature-themed stained glass windows crafted by Tiffany Studios in 1909.

Harbeck Mausoleum
40° 53' 24.17" N 73° 52' 38.22" W

John H. Harbeck
ca. 1840–November 8, 1910

Kate Alice Harbeck
1859–December 31, 1930

43° 46' 22.85" N 11° 15' 18.24" E
(Baptistery in Florence, Italy, north doors)

John H. Harbeck certainly had an interesting life as well as a contentious life *and* afterlife. His father, William H. Harbeck, was a founding partner of a substantial warehousing empire on Furman Street in Brooklyn, known as the Harbeck Stores. John Harbeck reaped the rewards of that business, made investments of his own, including ones in Colorado and railroad stocks, and led a rather opulent life, thanks to his comfortable financial situation. In 1870, he met one Caroline Montgomery, who claimed she was about to be divorced from her scallywag of a husband, Andrew Montgomery. John's and Caroline's hearts soon "beat as one," and by 1871, John installed her as his wife at his upscale home on West 55th Street. Caroline was his "wife," thanks to a far-from-binding oral agreement. All was reasonably rosy for the usual seven years until Harbeck became enamored of Kate Hammel, a young and pretty, unemployed telegraph operator. Harbeck and Hammel embarked on a clandestine affair and eventually married in early 1880. Caroline didn't respond favorably to the news and sued Harbeck for divorce. Divorce? Divorce from what? The testy divorce proceedings were covered by the *New York Times* in multiple floridly detailed stories in the spring of 1882. There was tearful testimony, hysterical screaming, and lots and lots of "he said, she said" accusations. There were suits and countersuits. The case finally wound up in the Supreme Court, Special Term, before Justice Larremore. Nowadays, the high-society divorce would have been

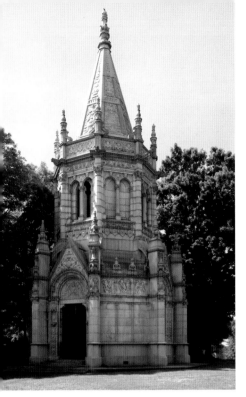

great fodder for tabloid journalists. Alas, after all the finger-pointing and weepy wailing, Caroline lost the case and soon disappeared from the scene.

Homewrecker Kate Hammel and John H. Harbeck apparently lived a happy life, spending much of their time traveling and maintaining a second home in Boulder, Colorado. Harbeck died at the Plaza Hotel in New York while en route to Paris to purchase a home and establish residency there. After Harbeck's death, Kate paid inheritance taxes in New York, since that's where the bulk of their financial holdings were. The State of Colorado claimed otherwise, and a lengthy court battle ensued, with Kate Harbeck claiming the couple's primary residence was New York. The State of Colorado eventually won the case, and New York lost the $100,000 it had collected.

Colorado may have been Harbeck's last legal residence, but his real last residence is in New York, although it took almost a decade for him to move in. John H. Harbeck lived in style and went out in style. His elaborate Renaissance Revival mausoleum was designed in 1918 by Theodore Blake, a primary architect with the firm of Carrere and Hastings. It's set in a prominent oval lot that forms an island on Parkview Avenue and is the most magnificent mausoleum in Woodlawn. The octagonal structure has richly decorative detailing on a vertical mass constructed in three sections. The broad lower section features double bronze doors that are replicas of the north doors of the Baptistery in Florence, Italy, which were crafted by Lorenzo Ghiberti in the early fifteenth century. The center section has arched windows. It connects the base with a steeply sloped broached tower. Two levels of pinnacles with crockets punctuate each

Baptistery in Florence, Italy (north doors)

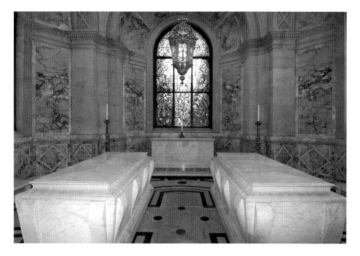

Harbeck Mausoleum (interior)

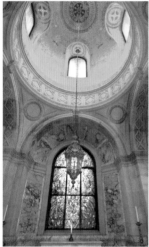

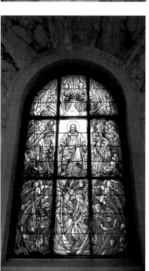

of the vertices of the octagon at the base and center sections. Elaborate allegorical and floral carving is found in the arch of the door and pediment and along horizontal bands that form friezes at the three sections of the structure. Carved buttresses connect the lower pinnacles to the center section of the mausoleum.

The interior is similarly ornate with carved vaulting and an inlaid marble floor. It was designed and fabricated by Guastavino Company. Two flanking stained glass windows in a regular geometric pattern were executed by Tiffany Studios in 1917. They are set into the arches in the center section of the mausoleum, which has a domed mosaic ceiling that reflects light from the windows into the base. The Harbeck Mausoleum is the only private mausoleum in Woodlawn that was wired for electricity (the electrical service was never connected). The original gold-plated chandeliers and candelabras were made by the Caldwell Company in 1918.

A large Christian-themed center window, also crafted by Tiffany Studios in 1917, is located opposite the door above a marble altar in the center rear of the main level.

Collis Potter Huntington

October 22, 1821–August 13, 1900
40° 53' 37.91" N 73° 51' 53.76" W

Collis Potter Huntington was one of four individuals known as the Big Four (along with Leland Stanford, Mark Hopkins, and Charles Crocker), who were responsible for developing the transcontinental railroad system in the United States. Huntington was involved with the Central Pacific, Southern Pacific, Chesapeake and Ohio Railways. Following his death, his substantial art collection became a major part of the Metropolitan Museum of Art in New York. After Collis's death in 1900, his nephew Henry E. Huntington assumed leadership of many of the Huntington endeavors. Over the years, other family members also continued and expanded many of his cultural and philanthropic projects. Sculptor Anna Hyatt Huntington (1876–1973), nationally recognized for her heroic equestrian statues (*Jose Marti* in Central Park, New York City; *El Cid Campeador* in Seville, Spain; *Joan of Arc* in New York City) as well as other animal sculptures, is also entombed in the mausoleum.

The massive Classical Revival (Tuscan) mausoleum was designed by Robert Caterson in 1891. It features a pair of Tuscan columns framing the entrance, which is detailed with a massive door depicting a standing woman draped in a heavy robe, sculpted by Herbert Adams in 1932 and cast by Gorham Bronze. The symmetrical mausoleum has six Tuscan columns along each side with square columns that form exaggerated pilasters at each corner. The pediment is unadorned. The mausoleum is situated on the top of a slope overlooking the narrow valley of the Bronx River; massive stairs modeled after the original Penn Station extend from the entrance down the east slope to Chapel Hill Avenue.

Elsewhere on the plot is a separate cenotaph honoring Arabella Huntington, by Anna Hyatt Huntington in 1951, that depicts a standing figure with scarf and robes draped over two seated figures; the inscription reads, "Alas we know your deeds, your words make warm the memory of our loss so, in the night we dreaming find the dark in starlight's spell and know that from your eyes that starlight fell."

Along with the crypts of fallen members of the Huntington family, the interior has a stained glass window with an hourglass and wings, signifying the transitory nature of life, and a bas-relief panel of Collis Huntington crafted by sculptor Bella Lyon Pratt in 1911.

John Stewart Kennedy

January 4, 1830–October 30, 1909
40° 53' 29.27" N 73° 52' 11.41" W

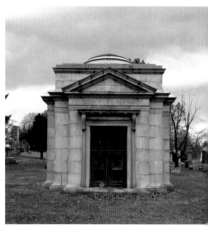

John Stewart Kennedy was born in Glasgow, Scotland. Although he received little formal education, he educated himself and got a job as a clerk. At age 20, he was sent to the United States to represent an iron firm he was working for. Shortly after his arrival, he went into business with banker Morris K. Jessup. Kennedy became an adept negotiator and was a skilled reorganizer. He used those skills when he became one of the receivers of the Central Railroad of New Jersey in 1888. In later life, he became involved in a number of philanthropic causes, and his will stipulated over $30 million in bequests. John Stewart Kennedy has been called one of America's "little-known rich men." His drab-colored garden-variety Classical Revival mausoleum belies a spectacular interior ceiling.

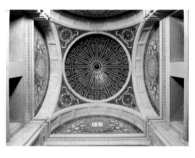

The interior of John Stewart Kennedy's mausoleum sports an intricate mosaic on the underside of the dome. Its rich hues of blue, red, gold, and green brighten the white marble interior. Even though the mausoleum is over a century old, there are still a number of empty crypts.

Colonel Daniel S. Lamont

February 9, 1851–July 23, 1905
40° 53' 17.44" N 73° 52' 25.51" W

Colonel Daniel S. Lamont was Secretary of War under President Grover Cleveland, vice president of the Northern Pacific Railway, and president of the Northern Pacific Express Company. He was also a director of a

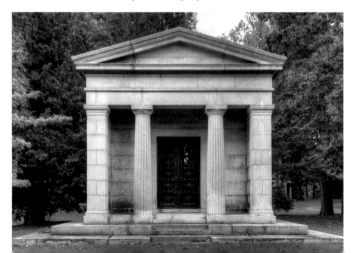

variety of banks and corporations. His rather plain Classical Revival mausoleum was designed by architects Little & O'Connor in 1903. But peek inside and you'll see a spectacular window by John LaFarge (see page 32) that was installed in 1904. The window features a standing angel, clothed in hues of green, purple, and yellow, set in a deep blue background. The angel is depicted dropping flowers from both hands. The colors in the window change in hue, vividness, and depth depending on the intensity and blending of outside and inside light.

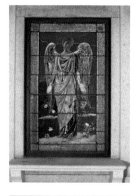

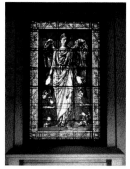

Julius Manger
1868–March 28th 1937
40° 53' 20.26" N 73° 52' 37.73" W

Julius Manger was born in Boonville, Missouri. He and his brother William became involved with building construction in Galveston, Texas, and later located the hub of their activities in New York City. Their entry into the New York real estate market was the construction of more than 500 homes in the Bay Ridge section of Brooklyn. Expanding their business to larger-scale buildings, they erected the Builders Exchange Building on West 33rd Street in Manhattan. In 1907, the Mangers traded the Builders Exchange for the Plaza Hotel in Chicago, which was the beginning of their extremely successful chain of hotels. When William died in 1928, the Manger hotel properties were valued at $22,000,000, a tidy sum for the time.

Julius Manger continued buying hotels, and at the time of his death, the list included the Plaza in Chicago; the Manger Hotel in Boston; the Endicott, Martha Washington, Grand, Windsor, and Imperial Hotels in New York City; and the Annapolis Hotel, Hamilton Hotel, and Hay-Adams House in Washington, D.C.

Architect/designer Franklin Naylor built the mausoleum in 1927 for Dominico Dumbra, but it was purchased by Julius Manger in 1935. The Manger Mausoleum was one of the last hurrahs of the Golden Age of the Mausoleum, which ran from around the end of the Civil War to the Great Depression. Fittingly, it is one of the most elegantly crafted mausoleums in the United States.

Naylor was so proud of his creation that he published a pamphlet detailing its construction. The Manger Mausoleum was Naylor's largest and most complex design in his 35 years as a memorial architect, and

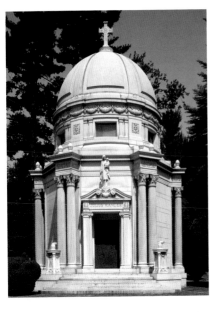

he called the finished mausoleum "one of the largest private mausoleums in the world and the largest in America." His design goes under the broad heading of Beaux-Arts architecture with a nod to Renaissance Revival forms.

The design of the base of the mausoleum is a double equilateral triangle, the intersection of the two triangles forming a hexagon. These two triangles form the Star of David, also known as the Seal of Solomon, and contained within its boundaries are representations of the four elements: fire, air, water, and earth. The hexagonal base is ringed with six sets of paired Corinthian columns.

Thomas F. Mason
1815–1899
40° 53' 16.73" N 73° 52' 33.43" W

Thomas F. Mason's tidy little Classical Revival mausoleum is a showcase for bas-relief panels. There is a cartouche in the gable above the door. Smooth masonry on the front of the mausoleum is contrasted by rusticated masonry on the sides. Two bas-relief bronze panels, sculpted by Oscar Lenz in 1899, flank the entrance. The panels are surrounded by egg-and-dart molding. The double doors are embellished with Victorian-era geometric floral designs. The panel on the left shows an angel taking the inventory of Thomas Mason's life (which appears to have been in the insurance business) and is inscribed with the Latin words *Ab Initio, Ad Finem* ("from beginning to end"). The panel on the right depicts an angel with a horn, presumably Gabriel, awaiting the results of the inventory. The panel is inscribed with the Latin phrase *Sic Transit Gloria Mundi* ("thus passes away the glory of the world").

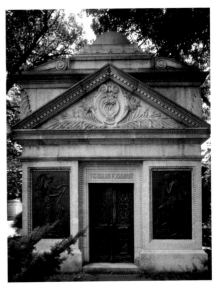

The phrase is from the "Service of the Pope's Enthronement." At the moment it is uttered, a handful of flax is burned to indicate the transient nature of earthly grandeur. A similar rite is said to have been used in the triumphal processions of the Roman Republic. In other words, "you can't take it with you."

William H. Porter

January 8, 1861–November 30, 1926
40° 53' 18.11" N 73° 52' 22.16" W

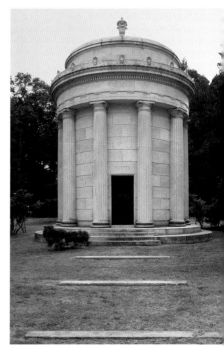

William Henry Porter's life seems like a classic Horatio Alger story. He was born in Middlebury, Vermont, to parents who were struggling farmers. In 1876, when he was 15, the family faced financial ruin and was forced to sell their bucolic farm in Middlebury. The family then moved to Saratoga Springs, New York, where William attended high school. Unfortunately, his parents' financial woes meant that he would need to drop out of high school and find a job. He found work at a local inn. Then, while waiting tables in 1878, a wealthy banker who was staying there noticed his work ethic and admired his intelligence. The banker offered him a job at his bank in New York City.

Young William Henry Porter quickly rose through the ranks and proved to be a banking "systematizing genius." In 1903, he became the president of the Chemical National Bank and, in the same year, became one of the founders and directors of the Bankers Trust Company of New York. In 1911, he became a partner of J. P. Morgan and Company. William H. Porter used part of his fortune to found the Porter Medical Center in Middlebury, Vermont.

The Porter Mausoleum is sited on a circular lot. It was designed in 1927 by architects Trowbridge & Livingston and was fabricated of white Vermont marble in the same year by Marc Edlitz & Son. The circular mausoleum features a series of engaged fluted Tuscan columns that ring the perimeter. The columns support an entablature with toothsome dentil molding and an elaborate cornice. The cornice includes a series of acroterium connected with intricately carved, fence-like, arabesque-patterned marble panels. The stepped stone roof features an urn-like finial. The Porter Mausoleum was featured in an August 1928 advertisement for the Vermont Marble Company in *Park and Cemetery* magazine. Also reposing inside the mausoleum is William H. Porter 's wife, Esther J. Porter.

Henry A. C. Taylor
1840/1841–May 20, 1921
40° 53' 16.36" N 73° 52' 25.95" W

Henry A. C. Taylor was a financier and corporate director who served as director of National City Bank, a trustee of New York Life Insurance Co., director of the Metropolitan Opera and the Real Estate Company. He came from an old New York family and, after graduating from Columbia University, quickly rose through the ranks of his father's firm, Moses Taylor & Co.

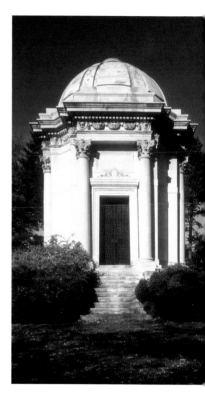

The mausoleum was designed in the Classical Revival style by architects McKim Mead & White in 1900. It was fabricated by R. C. Fischer & Co. in Vermont marble. The mausoleum's façade features two heavily relieved Corinthian columns that frame a set of two immense bronze doors with intricate grille work. Dentil molding and a coronet inscribed with the letter T (for Taylor) embellish the lintel above the door. Festoons, putti, and dentil molding decorate a frieze that circles the perimeter of the mausoleum. The mausoleum is topped with a dome that rises above a complex projecting cornice. The base of the structure is unusually high, which hints at the additional interment vaults that are accessed by a removable floor slab.

The white marble interior of the mausoleum is vaulted with an arch at the nave. It contains twin sarcophagi housing the earthly remains of A. C. Taylor and his wife of 53 years, Josephine W. Johnson Taylor. The sarcophagi, which are each emblazoned with two putti in relief holding a cartouche, are separated by a raised altar.

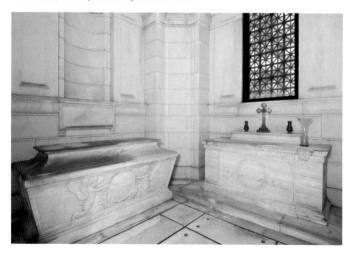

Dr. Lucien C. Warner
1841–1925
40° 53' 32.24" N 73° 52' 13.50" W

It's unclear how much actual doctoring Dr. Lucien C. Warner engaged in. What is clear is that along with his brother, I. DeVer Warner, he bolstered the lot of women at the turn of the century. Well, sort of. During Victorian times, fashionable women were literally tied into restrictive corsets. Besides the bodily harm that resulted from these unnatural strictures, the corsets were said to make women excited in socially unacceptable ways. Enter the Warner brothers. In the late nineteenth century, the brothers introduced Dr. Warner's Sanitary Corset (later changed to Dr. Warner's Health Corset). They opened up a small shop in New Haven, Connecticut, and employed women to hawk their product door-to-door (Lucien Warner had already used the door-to-door method to sell medical books). The brothers soon found that the way to make significant money was to sell their corsets to retailers in bulk. Sales soared. What helped sell the brothers' corsets was that they replaced the rigid materials such as whalebone used in other company's corsets with more flexible and even elastic fibers. Women were overjoyed. The company continued to prosper and still exists today. In addition to the Warner's brand, the company, now known as Warnco, also owns the brands Calvin Klein, Speedo, Chaps, and Olga. Lucien Warner also owned the Warner Chemical Co. Reposing in the mausoleum alongside Lucien Warner is his wife, Keren Osborne Warner, who died in 1933.

The Warner Mausoleum was designed by architect R. H. Robertson in 1888, with additional work done by William Angus, Inc., in 1915. This substantial circular mausoleum is ringed with engaged repeating Corinthian columns. Multiple decorative acroterium circle the top at the termination of its sloped roofline, and a prominent pinecone finial tops the elegant ensemble. The bronze entry door, fabricated by Gorham Bronze in 1915, was designed by architect Cass Gilbert. The mausoleum originally contained a mosaic designed by Tiffany Studios, but it was removed in 1915. The Warner Mausoleum was featured in an 1899 issue of *The Inland Architect and News Record*.

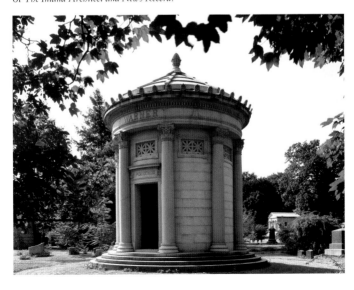

William Webb

June 19, 1816–October 30, 1899
40° 53′ 24.76″ N 73° 52′ 15.74″ W

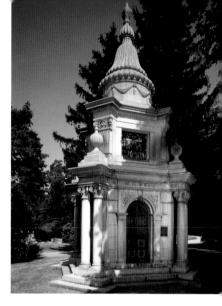

William Henry Webb was a master shipbuilder whose clipper ships set speed records that still stand. He inherited his father's shipbuilding business in 1840 and proceeded to turn the renamed William H. Webb Company into America's most prolific shipyard, churning out 133 vessels from 1849 to 1865. So swift were his ships that one advertisement proclaimed, "Flying Craft for San Francisco, Now Up" In 1853, he launched his last clipper ship, *Young America*, his personal favorite, saying to the mate, "Take good care of her, mister, because after she's gone, there will be no more like her." She later set a Liverpool–San Francisco speed record for sailing. Fittingly, she did not end her life as a broken-down vessel sold for scrap; rather, *Young America* was lost at sea in 1886. Webb was realistic and saw steam and steel replacing sail and wood. To that end, he also built a number of steamboats and steamships. He liquidated his company after the close of the Civil War and busied himself with a number of philanthropic works. He used a considerable amount of his fortune to endow the Institute of Naval Architecture.

The Webb Mausoleum is one of those structures that defy coherent explanation. Viewing the bottom half of the structure, one could make a good case for Classical Revival. Its doubled Corinthian columns, the carvings above the door, and the door itself could have come straight from a Roman temple. But from the column capitals on up, the mausoleum begins to look quite different, like some sort of exotic confection rather than architecture.

The odd-looking dome, which seems to be melting and dripping

over the edges, can be found on a number of other fanciful mausoleums throughout the country. It's not hard to imagine this mausoleum appearing in the pages of *Alice in Wonderland*. All it needs is the White Rabbit with a watch and the Cheshire Cat with a smile.

The interior includes two delicately carved marble bas-relief sculptures, one depicting a ship in full sail and the other depicting busts of Webb and his wife encircled by a garland, half of oak leaves and half of lilies. The mausoleum also has three windows designed by Tiffany Studios in 1892.

Henry H. Westinghouse
1853–1933
40° 53' 13.01" N 73° 52' 32.48" W

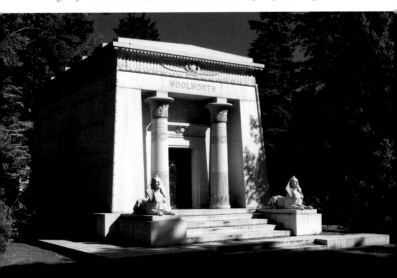

Nowadays, people tend to associate the Westinghouse name with household appliances, but the high-dollar items manufactured by the company include massive power transformers, motors, generators, and turbines. The company's genesis can be attributed to George Westinghouse, who invented the air brake, which was the first practical brake used for railcars. Henry H. Westinghouse, who resides with his wife, Clara, in this petite Classical Revival mausoleum, was the chairman of the board of the Westinghouse Air Brake Company and the last surviving brother of George Westinghouse.

The inside of the Westinghouse Mausoleum is graced with a delicately beautiful stained glass window that has been attributed to Tiffany Studios. The window, which was crafted in 1910, depicts a field of white lilies set against an orange and purple sky.

F. W. Woolworth
April 13, 1852–April 8, 1919
40° 53' 18.71" N 73° 52' 33.78" W

Franklin Winfield Woolworth developed a sales formula based on attractive displays and reasonable fixed prices. He cunningly realized that pricing articles for sale in increments of 5 cents and 10 cents, which were the most commonly used coins at the time, encouraged sales. Woolworth found that these business practices encouraged impulse buying and generated increased sales and revenues. By the time of his death, there were over 1,000 of his "five and dime stores." F. W. took his own frugality a little too far, however; he died of septic poisoning because he

didn't want to pay to see a dentist. Also entombed in the mausoleum is the much-married and terribly unhappy Barbara Hutton (1912–1979), known as the "Poor Little Rich Girl," who was the granddaughter of F. W. Woolworth and heir to his multimillion-dollar estate.

The Barre granite mausoleum was designed by John Russell Pope and built by Farrington, Gould & Hoagland in 1921. It's constructed in the Egyptian Revival style with two Greek sphinxes (Egyptian sphinxes are male) flanking the entrance steps. Two columns with horizontal banding and palm capitals frame the recessed entrance. The exterior walls are slanted in at about 70 degrees since Egyptian architecture relies on massive stone and angles rather than arches to create strength. Both the entablature and the lintel above the entrance feature relief carvings of a winged solar disc, an icon that Egyptians believe offered protection to the dead. The mausoleum has a cavetto cornice (curved with arch) and roll molding at its corners and where the façade meets the entablature.

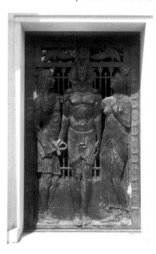

The bronze door was designed by sculptor Julius C. Loester and cast by the Roman Bronze Company. The interior was renovated by the family in 1941 with Italian marble and large double marble sarcophagus by Evans of Boston. The landscape design by Brinley and Holbrook, who executed plans for the New York Botanic Garden in 1920, "employed a formal scheme to accentuate the solidity and scale of the building, while successfully screening a vista spotted with many imposing mausoleums."

Anna B. Bliss
1851–1935
40° 53' 16.65" N 73° 52' 21.91" W

Anna B. Bliss (1851–1935) was a philanthropist who contributed to the League of Political Education, which erected Town Hall in New York. She also made significant donations to the Metropolitan Museum of Art.

The Bliss Monument was designed by William Welles Bosworth in 1913 and fabricated by George Brown & Co. It features a curved exedra bench inscribed with "Our souls have sight of that immortal

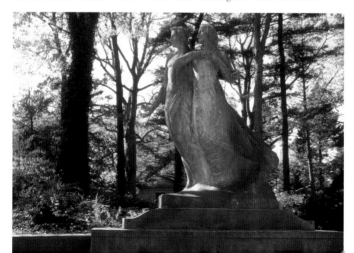

sea which brought us hither." The sculpture pictured was designed by Robert Aitken in 1917 and fabricated by Piccirilli Studios. It depicts a man and woman looking forward, draped in cloth, representing "the onward progress of two souls." This monument hints at the Art Deco style, which attained widespread popularity in the 1920s and '30s. It was featured in several publications, including *Monumental News*, which declared it "monument of the year" in 1917. According to a May 1919 article in *Architectural Review*, the memorial is a "significant contribution to the art of funeral commemorative monumental design" and "this design gives evidence of thought and of serious purpose and it establishes new precedents in this field of design." The Bliss Monument was also featured in a 1929 article in *Park, Cemetery and Landscape Gardening*. The exedra contains niches for cremated remains and provides a location to view the sculpture from many vantage points. The landscaped lot was designed by Armand Tibbets in 1921.

Nellie Bly

May 5, 1864–January 27, 1922
40° 53' 4.32" N 73° 52' 37.38" W

Nellie Bly, born Elizabeth Jane Cochran (changed to Cochrane because of the elegance of the trailing "e"), was one of the first notable female journalists. She spent her early years in a fairly well-to-do family, but when her father died when she was six, the family's fortunes took a downward turn. Things only got worse when her mother remarried a man who turned out to be a violent alcoholic. In 1880, young Elizabeth wrote a letter to a Pittsburgh newspaper, rebutting an editor's story that Elizabeth deemed sexist. The editor was so impressed with Elizabeth's earnestness that he offered to hire her. At the time, female journalists were usually assigned to the "women's pages," and after the editor changed her name to Nellie Bly (female journalists usually used a pseudonym), that's where Elizabeth wound up. However, she soon broke out of the mold and began a series on the plight of female factory workers. After the story, she went back to reporting for the women's pages but successfully lobbied the newspaper to send her to Mexico as a foreign correspondent. At age 21, she was off to Mexico. While in Mexico, she reported on the people and customs, but more importantly, she investigated the corrupt government and was nearly arrested before she was able to escape the county.

When she returned to Pittsburgh she was assigned once again to the women's pages and theater-and-arts reporting. Unhappy with the situation, she quit her job and journeyed to New York. Penniless after four months of searching, she convinced Joseph Pulitzer's newspaper, *New York World*, to hire her to do an investigative report on the Women's Lunatic Asylum. Bly went undercover, posing as an insane woman, and spent 10 days at the asylum. Her report of the abuses and conditions at the asylum was a sensation for Pulitzer's newspaper. Her book, *Ten Days in a Mad-House*, which was a compilation of her stories, brought about

major reform. Next up for the adventurous Nellie Bly was a trip around the world that was meant to replicate Jules Verne's novel *Around the World in 80 Days*. Nellie Bly made the trip in the world record-setting time of 72 days, 6 hours, 11 minutes, and 14 seconds. Her dispatches were widely read and brought her lasting fame.

Nellie Bly essentially retired from journalism at age 31 after she married Robert Seamen, who was 42 years her senior. When Seaman died in 1904, she took over leadership of his company, the Iron Clad Manufacturing Co., which made a variety of steel containers. While there, Bly invented a 55-gallon steel drum that is still in use today. Unfortunately, the company went bankrupt after embezzlement by employees, and Nellie Bly went back to reporting, covering women's suffrage stories as well as reporting from the Eastern Front in WWI. Elizabeth Jane Cochrane Seaman (Nellie Bly) died of bronchopneumonia in St. Mark's Hospital in New York City in 1922 at age 57. Her simple tombstone was replaced with a larger one by the New York Press Club in 1978.

Admiral David Farragut

July 5, 1801–August 14, 1870
40° 53′ 31.82″ N 73° 51′ 57.15″ W

The monument to Admiral David Glasgow Farragut is in the form of a draped broken mast, symbolizing the end of a seafaring life. Farragut was born in Kentucky into a family with a strong military background. Young David was commissioned as a midshipman at age 9 and quickly rose through the ranks. At age 21, he was promoted to lieutenant; at age 43, he rose to commander; and he became a captain at age 54. While serving as commander, he was instrumental at establishing Mare Island in San Francisco Bay as the major West Coast port for ship repair. Although he had a strong familial allegiance to the South, when the Civil War broke out he made it clear that his sympathies were with the North. He distinguished himself by winning a decisive victory at the Battle of New Orleans on April 29, 1862, and shortly thereafter, Congress bestowed on him the rank of rear admiral and then admiral, the first time those ranks were used. Farragut may be best remembered for an action he took during the Battle of Mobile Bay on August 5, 1864. Mobile Bay was heavily peppered with tethered mines known as torpedoes. When a couple of his ships started turning back after running into the torpedoes, he gave an order to Captain Percival Drayton, the commander of the *Hartford*, and to Rear Admiral James Edward Jouett, the commander of the *Metacomet*. Farragut said, "Damn the torpedoes! Four bells! Captain Drayton, go ahead! Jouett, full speed!" The short version is "Damn the torpedoes! Full speed ahead!"

Matthew Henson

August 8, 1866–March 9, 1955
40° 53' 4.32" N 73° 52' 37.38" W

This simple gravestone is actually a cenotaph of a man who accomplished much. Matthew Alexander Henson was born in rural Maryland. At the age of 12, he signed on as a cabin boy on a merchant ship and, for the next several years, sailed the seas and became a skilled navigator. In 1887, Henson met Commander Robert E. Peary and joined him on an expedition to Nicaragua. Peary was impressed with Henson's navigational skills and seamanship. In the next few years, Henson and Peary made a number of trips together. During their Arctic excursions, Henson traded with the Inuit people and learned their language. In 1909, Commander Peary prepared to make his eighth attempt to reach the North Pole and selected Henson to be one of the six people to make the final push to the Pole. As the team approached its destination, Peary was no longer able to walk and was placed on a dog sled. Henson was sent ahead to scout the route and actually overshot the Pole by a couple of miles. When the team got back together to make the run as a team, they found that Henson's footprints had already crossed the Pole. Matthew Alexander Henson planted the American flag and became the first African American— indeed, the first man—to reach the Geographic North Pole.

In 1912, Henson wrote a book, *A Negro Explorer at the North Pole*. Although Peary received the glory, in 1944, Congress awarded Henson a duplicate of the silver medal received by Peary, and he was also honored by Presidents Truman and Eisenhower. In 1988, Henson was reinterred in Arlington National Cemetery in Arlington, Virginia, near Washington, D.C., not far from Admiral Robert E. Peary. The ceremony was attended by a number of members of Henson's family, including his Inuit grandchildren (both Peary and Henson fathered children with Inuit women). On November 28, 2000, Henson was posthumously awarded the Hubbard Medal, the National Geographic Society's highest honor.

Richard Hudnut

1855–1928
40° 53' 27.48" N 73° 52' 40.08" W

Richard Alexander Hudnut was one of America's first cosmetics giants. Hudnut's father owned a family drugstore at Broadway and Ann Street. After graduating from Princeton, Richard Hudnut toured France, where he got the idea of producing French-style perfumes and cosmetics for American women. Upon his return from France, he worked in his father's store and then began introducing his French-style cosmetics. Hudnut–brand fragrances included Violet Sec

(1896), Aimee (1902), Vanity (1910), and Three Flowers (1915). His products were so well received that eventually he closed the retail store and focused on selling wholesale. By 1916, he had made his fortune and moved to France. In 1923, Richard Hudnut's stepdaughter Natasha Rambova married Rudolph Valentino. The Hudnut company was acquired by Warner-Lambert Pharmaceuticals in 1955, which became Parke-Davis in 1970 and then Pfizer in 2000.

The delicate-looking monument contains a narrow pavilion supported by three columns sheltering a standing weeping child, sculpted by Alexander Zeitlin in 1928 and fabricated by Presbrey-Coykendall Company.

Kinsley Monument
40° 53' 23.96" N 73° 52' 18.58" W

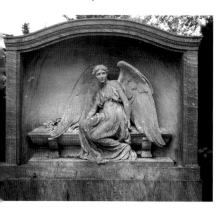

The Angie M. Kinsley Monument, crafted by Daniel Chester French in 1911, is a sculpture of an angel seated on a coffin. It was fabricated of pink Tennessee marble by Piccirilli Studios. Portions of the seated angel are in high relief while other portions for the composition are in bas-relief. Among those peppering the Kinsley family lot are H. M. Kinsley (1831–1894), manager of the Holland Hotel, and his son-in-law and business partner, Gustav Baumann (1855–1914), who managed the Biltmore Hotel.

Fiorello La Guardia
December 11, 1882–September 20, 1947
40° 53' 7.71" N 73° 52' 23.34" W

Fiorello Enrico La Guardia has often been described as one of the most well known American mayors in history. He served three terms from 1934 to 1945. His first name, Fiorello, which means "little flower" in Italian, seemed to presage his diminutive 5-foot-tall (some accounts say 5-foot 2-inch) stature. Embracing the Napoleon complex of vertically challenged males, he was described as irascible, energetic, and charismatic. Although he was elected as a Republican, he was known as a nominal or liberal Republican because of his ability to cross party lines (he supported Franklin D. Roosevelt, a Democrat, for president) for the common good. During the 1930s, he was able to reform politics by subduing the powerful Tammany Hall political machine. He instituted a number of popular public projects by building playgrounds, parks, and

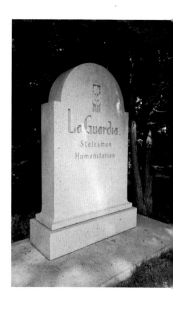

public housing, as well as unifying the transit system and constructing airports. La Guardia Airport in Queens is named after him. Although his popularity waned in the 1940s, and he was often criticized for his authoritarian style, he is still fondly remembered by most as New York City's greatest mayor.

Herman Melville
August 1, 1819–September 28, 1891
40° 53' 33.19" N 73° 52' 2.92" W

Despite its modest size and secluded location, Herman Melville's grave is often visited by fans of the author. Pebbles and stones rest atop his gravestone, signifying that someone has visited.

Herman Melville was born Herman Melvill (his mother added an "e" after her husband Allan Melvill died) in New York City. Allan Melvill's death left the family virtually penniless, but thanks to some generous relatives, young Herman received an education at the Albany Academy where he took a liking to classic literature. He taught briefly at the academy then got a job on a ship and sailed the seas for a few years. Upon returning, he married and settled on a farm in Massachusetts. While managing the farm, he wrote stories and novels, and lectured on his seafaring adventures. In 1851, his most celebrated work, *Moby-Dick*, also known as *The Whale*, was published. Melville based *Moby-Dick* on the events described in an 1821 book titled *Narrative of the Most Extraordinary and Distressing Shipwreck of the Whale-Ship Essex*, a true story of a sperm whale attacking the ship *Essex*. Melville was never able to duplicate the success of *Moby-Dick* and died in relative obscurity. He was rediscovered when his novella *Billy Budd* was posthumously published in 1924. *Moby-Dick* has often been cited as one of the greatest American novels.

To the right of Herman Melville's grave is a cross marking the grave of his wife of 44 years, Elizabeth Shaw Melville.

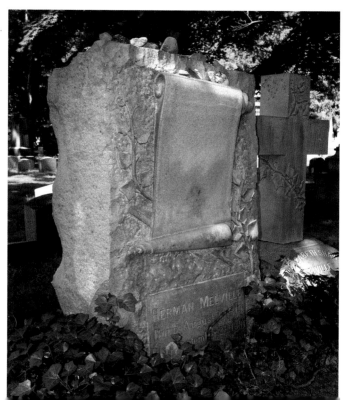

Barbara Piccirilli Monument

40° 53' 41.38" N 73° 52' 28.29" W

The Barbara Piccirilli monument was sculpted and cast in bronze by Attilio Piccirilli in 1926. Set on a polished granite base, a female figure kneeling to console a standing child is depicted.

In 1887, sculptor and stone-carver Giuseppe Piccirilli moved from his home in Tuscany, Italy, to New York City. He brought his wife, daughter, and six sons with him. He and his sons (Attilio, Furio, Ferrucio, Getulio, Masaniello, and Orazio), who were all trained in sculpting and stone carving, continued the business they had started in Italy. Among their most noted works are the New York Public Library Lions, the Maine Memorial, and the Washington Square Arch in New York City, and the Lincoln Memorial in Washington, D.C. The Piccirillis worked for the most famous sculptors of the time. The sculptors brought their clay models to Piccirilli Studios, where the Piccirillis turned them into bronze and stone sculptures. The studio, which was closed in 1946, was in the Mott Haven neighborhood in the Bronx. A number of their projects dot Woodlawn's grounds.

Joseph Pulitzer

April 10, 1847–October 29, 1911
40° 53' 31.03" N 73° 52' 8.63" W

Joseph Pulitzer was a Hungarian-American publisher who built a newspaper empire and contributed substantially to establish the Columbia University School of Journalism. The school annually awards the Pulitzer Prize for excellence in journalism

The exedra-style monument was designed by architect Duncan Candler in 1913 and crafted with Barre granite benches flanking the sides and a simple granite wall forming the back. The center of the monument has a bronze sculpture by William Ordway Partridge (also crafted in 1913) of a seated male figure with draped clothing, contemplating an urn he holds in his hand.

John Goffe Rand
1801–1873
40° 53' 38.10" N 73° 52' 1.79" W

Oh, where would we be without John Goffe Rand? Scraping toothpaste from a jar or scooping artist's oil paint out of a bucket with our fingers, no doubt. Rand was an American portrait painter of some renown and a protégé of Samuel Morse, the inventor of the telegraph. Like Morse, Rand also had an inventive mind. It's all on his gravestone.

Before John Goffe Rand came on the scene, when an artist wanted to paint with oils, he had to grind the pigments and mix them with oil. If there was extra paint, it was put into a "skin," an animal bladder that had been punctured with a bone "spike" that also served as a stopper. Rand had a better idea. Why not replace the animal bladder with a thin tin tube and seal both ends. When paint was needed, simply puncture the thin tube and squeeze out the contents. He patented his invention in 1841, first in England and then six months later in the United States. John Goffe Rand continued to refine his tubes and received additional patents in 1842 and 1844. Rand's invention and others like it were quickly embraced by paint manufacturers in Europe and the United States.

The first widespread use of collapsible metal tubes came in 1892 when a dentist in New London, Connecticut, began packaging

toothpaste in tubes (previously toothpaste was packaged in jars). Dr. Sheffield's Creme Dentifrice was an immediate success. Toothpaste in tubes really took off when Gilbert Colgate started packaging his toothpaste in tubes in 1896.

John Goffe Rand's weathered gravestone is in a secluded location, but it is worth seeking out. The wording is barely legible. Around the palette with a tube at the center, the inscription reads, "Inventor of the artist's color tube." His epitaph reads "John Goffe Rand, 1801–1873, An Able Artist, A Skillful Inventor, A profound thinker, A devout Christian" and "Emma Brainerd Rand, His wife 1791–1879."

All That Jazz

Up until the Reformation in the sixteenth century, there were few formal cemeteries. Most people were buried in small family plots or were unceremoniously disposed of. However, the elect and the well-to-do were often buried inside churches. Travelers to Europe often remark about visiting cathedrals and seeing flat grave markers on the floors, crypts in the walls, and tombs and sarcophagi ringing the interior of the cathedral. And just like real estate, the placement of earthly remains was all about location, location, location. The closer to the altar, the better chance of being inched towards the heavens by the parishioners' prayers. The intersection of the Fir, Wild Rose, Alpine, and Hillcrest Plots at Woodlawn has become a sort of outdoor cathedral for fallen jazz greats. And if there is an altar, it has to be Miles Davis's black granite tombstone.

Miles Davis
May 26, 1926–September 28, 1991
40° 53' 5.93" N 73° 52' 18.83" W

Miles Dewey Davis III was born into a relatively affluent family in Alton, Illinois (across the river from St. Louis). His father, Dr. Miles Henry Davis, was a dentist, and his mother, Cleota, was a jazz pianist, although she didn't tell that to young Miles. She encouraged him to take piano lessons, but he took to the trumpet after his father gave him one when he was 13. By age 16, Miles was earning money by playing the trumpet, and after graduating from high school, he enrolled at the Juilliard School of Music in New York. Although he dropped out of Juilliard, he met a number of musicians in New York who would influence his life and music, and soon joined Charlie Parker's quintet.

Miles Davis became known as an innovative jazz trumpeter and composer, and for four decades he explored a variety of musical styles. In the 1950s, he became a leader of the "Cool Jazz" movement and made several celebrated records: *Birth of the Cool*, *Porgy and Bess*, and *Sketches of Spain*. His 1959 album *Kind of Blue* is the best-selling jazz recording of all time. In the 1960s, he experimented with fusion, merging jazz with rock and roll. The music inscribed on his memorial is from Davis's original composition, *Solar*, recorded in 1954.

Duke Ellington

April 29, 1899–May 24, 1974

40° 53' 5.53" N 73° 52' 18.27" W

Edward Kennedy "Duke" Ellington was born in Washington D.C. Both of his parents were pianists although neither made their living by performing. Young Edward began taking piano lessons at age 7. His mother Daisy taught her young son good manners and how to dress in a dignified way. His dapper ways soon earned him the nickname of Duke. Like most boys, he loved sports and baseball in particular, but he stuck to his piano lessons.

While still a teenager, he became a sign painter in the daytime and played piano at night. In 1917, he formed his first group, The Duke's Serenaders. Although he thrived in the Washington, D.C., area, he decided to move to Harlem and soon became one of the leading figures in what became known as the Harlem Renaissance. Ellington made four records in 1924, and his band soon became the house band at the Cotton Club. That gig lasted from 1932 until 1942.

His music falls under the broad umbrella of "orchestral jazz, swing and big band." He was an active performer for over 60 years, which included leading his band for 51 years. During that time, he made dozens of records and earned 13 Grammy Awards. He received the Presidential Medal of Freedom from President Richard Nixon in 1969 and a posthumous Pulitzer Prize in 1999.

Lionel Hampton

April 20, 1908–August 31, 2002

40° 53' 5.60" N 73° 52' 17.00" W

Lionel Hampton was born in Louisville, Kentucky. He spent the first few years of his life moving with his family before settling in Chicago in 1916. In his teens, Hampton took up the xylophone and drums while attending the Holy Rosary Academy near Chicago. He moved to California in the late 1920s, played drums with the Les Hite Band, and then began practicing on the vibraphone. He took to it like a duck to water, and it became his instrument. In late 1936, Benny Goodman heard Hampton playing on the vibes and asked him to play in what would become the Benny Goodman Quartet. The group became one of the first racially integrated small bands to play before mainstream audiences.

A few years later, Hampton formed his own band, the Lionel Hampton Orchestra. One of the orchestra's first hits was its version of the song *Flying Home*, which became the epitaph that graces Hampton's gravestone.

Throughout his long life, Lionel Hampton received a number of honors and awards. Among them are 10 honorary doctorates, a Papal Medal from Pope Paul VI in 1968, a star on the Hollywood Walk of Fame in 1982, and a National Medal of Arts presented by President Bill Clinton in 1996.

Joyce Wein

October 21, 1928–August 15, 2005
40° 53' 5.32" N 73° 52' 21.22" W

Starting during the middle of the twentieth century, the trend in funerary monuments became more and more pedestrian. The humble flat memorial marker has now become the gravestone of choice.

But in the late twentieth century, there began a resurgence in unique memorials. Individuals have been waking up to the fact that they only have one chance to make a last impression. Joyce Alexander Wein has certainly made hers.

Wein was the wife and business partner of jazz impresario George Wein. Along with her husband, she was responsible for the long-term cultural impact of the Newport Jazz Festival in Newport, Rhode

Island, the New Orleans Jazz and Heritage Festival, and the promotion of jazz throughout the world. Joyce Wein was an avid collector of African American Art and a generous contributor and supporter of the Studio Museum of Harlem and the Harlem Children's Zone. She was also a founder of the New York Coalition of 100 Black Women, the forerunner of similar organizations throughout the United States. Her gravestone reflects her passions in life: jazz, the arts, good wine, reading, and tennis. Wein's monument was sculpted by master stonecarver Simon Verity. From 1988 until 1997, Verity and his assistants worked on the carving of the West Portal (Portal of Paradise) of the Cathedral Church of Saint John the Divine, located at 1047 Amsterdam Avenue in Manhattan.

Max Roach

January 10, 1924–August 16, 2007
40° 53′ 5.32″ N 73° 52′ 21.22″ W

Directly next to Joyce Wein's monument is the black granite tablet marking the final gig of Maxwell Lemuel Roach, one of the pioneers of bebop music. He was a noted percussionist and is considered one of the most important and accomplished drummers in history. He played with many of the most famous jazz musicians, including Dizzy Gillespie, Charlie Parker, Charles Mingus, Duke Ellington, and Miles Davis. Indeed, Ellington and Davis are both buried within a few steps of each

other. Over the years, Roach cut dozens of singles and albums and also composed music for plays. He was particularly happy performing at concerts all over the world. In the 1960s and '70s, he became involved in the Civil Rights Movement and composed a number of songs reflecting his passion. Of particular note is *We Insist! Max Roach's Freedom Now Suite*, a jazz album recorded in 1960 containing a suite that Roach and lyricist Oscar Brown developed in anticipation of the centennial of the Emancipation Proclamation in 1963. In 1988, Max Roach was given a MacArthur Foundation "genius" grant. In 1989, Roach was cited as a Commander of the Order of Arts and Letters in France.

Kensico Tower Entrance

Kensico
Cemetery

273 Lakeview Avenue

Valhalla, New York 10595

(888) 536-7426

www.kensico.org

Maps in office

41° 4′ 59.26″ N 73° 47′ 5.45″ W (administration building)

Kensico might rightly be called the jewel in the crown of the Westchester County cemetery complex. There are five cemeteries neatly bisected by the Taconic State Parkway in the side-by-side communities of Valhalla and Hawthorne, including Kensico, Gate of Heaven, Mount Eden, Mount Pleasant, and Sharon Gardens. Kensico has the largest number of notable residents and an eclectic array of architecture.

Kensico Cemetery was organized in 1889 by a group of seven White Plains citizens. The name Kensico is an anglicization of Siwanoy Indian chief Co-ken-se-co, one of the signatories of the deed for the city of White Plains. The objective of the organizers of the cemetery was to establish a vast cemetery complex that would serve the death-care needs of New Yorkers for generations to come. The original cemetery was platted at 250 acres. It is now 461 acres. By 1890, a private railroad station to accommodate special funeral cars and an office was built, and in 1891, the cemetery saw its first burial. In 1894, Kensico's first community mausoleum was built, followed by a larger Gothic Revival community mausoleum in 1925. Kensico's meticulously manicured grounds contain a mix of magnificent mausoleums, celebrity grave sites, and a number of specialized plots dedicated to organizations such as the Freemasons, Friars Club, Actors Fund, among others. Maps indicating burial locations of notable residents and a brochure detailing the history of the cemetery are available at the administration building. Kensico Cemetery also contains Sharon Gardens, a Jewish burial area that is directly across from the main part of Kensico.

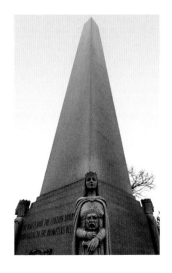

Actors Fund
41° 04′ 43.56″ N 73° 47′ 27.90″ W

Most large cemeteries have special areas reserved for members of clubs, organizations, and secret societies such as the Freemasons, Elks, and Odd Fellows. Just around the bend from Sergei Rachmaninoff's grave is the New York–centric Actors Fund plot. Centermost in the plot

is a soaring obelisk that was erected in 1941. Carved into the marker are the words, "The play is done the curtain drops slow falling to the prompter's bell." The obverse of the obelisk lists the presidents of the Actors Fund starting with Lester Wallack, who served from 1882 to 1884. Individual graves are marked with flat granite stones. There is also an Actors Fund plot in Green-Wood Cemetery in Brooklyn. The Actors Funds has approximately 11,000 performing arts and entertainment professionals across the country and has offices in New York, Los Angeles, and Chicago.

Anne Bancroft
September 17, 1931–June 6, 2005
41° 4' 37.02" N 73° 47' 32.34" W

Anne Bancroft was born Anna Maria Louisa Italiano in the Bronx. After attending public schools there, she attended a series of acting schools in New York before moving to Los Angeles, where she worked in the studio system. She appeared in a number of live television dramas under the name Anne Marno, and then, when she won her movie debut in 1952 in *Don't Bother to Knock*, she changed her name to Anne Bancroft. Finding the Hollywood studio system unsatisfactory, she returned to New York, where she won acclaim in a number of Broadway plays. Bancroft returned to Hollywood in the 1960s and found ready work in significant roles. In 1962, she won the Academy Award for her portrayal of Annie Sullivan in *The Miracle Worker*. She is probably best remembered for her role as Mrs. Robinson in the 1966 blockbuster hit *The Graduate*. Bancroft continued acting and receiving critical acclaim throughout the 1970s, '80s, '90s, and into the twenty-first century. Her last role was in a 2004 episode of the television program *Curb Your Enthusiasm*, where she played herself. Anne Bancroft was married twice, first to Martin May from 1953 to 1957, and then to Mel Brooks from 1964 until her death in 2005.

Henri Bendel
January 22, 1868–March 22, 1936
41° 04' 41.79" N 73° 47' 20.80" W

Henri Bendel was born in Vermillionville, Louisiana. His father died when he was only six, but his mother was a competent businesswoman, and the family did well in a number of different businesses; Henri gravitated toward the millinery business. After marrying Blanche Lehman, who was a member of the prosperous Lehman family, the

couple moved to New York, where Henri set up shop as the proprietor of an upscale millinery shop. The French-speaking Bendel prospered by catering to the wealthy and importing fashions from Paris. He also designed fashions and became one of the premier fashion designers in the United States. Over the years, he opened a number of stores in the United States. The flagship store still operates on Fifth Avenue in New York. His grave is marked by a large bronze statue of a woman with a bouquet of roses. Roses are often used on women's graves, and in this instance they may represent the life of Blanche Lehman, since Blanche died shortly after the couple moved to New York. Henri never remarried.

Paul Bonwit

September 29, 1862–December 11, 1939
41° 4' 36.92" N 73° 47' 0.61" W

This simple gray granite mausoleum holds the remains of department store titan Paul Bonwit, who was born in Hanover, Germany. He moved to Paris at age 16 and then immigrated to the United States in 1883 at age 21. He briefly worked in a department store in Lincoln, Nebraska, then moved to New York City to accept a position with Rothschild and Company, eventually becoming a partner. In 1895, he opened his own store; two years later, he teamed up with Edmund Teller to open a store called Bonwit Teller, which specialized in high-end women's apparel, and prospered throughout much of the twentieth century. Paul Bonwit controlled the company until 1934, when he sold the store and brand to the Atlas Corporation. In 1980, Donald Trump bought the flagship Fifth Avenue store and subsequently tore it down to make way for the Trump Tower.

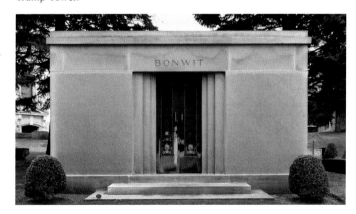

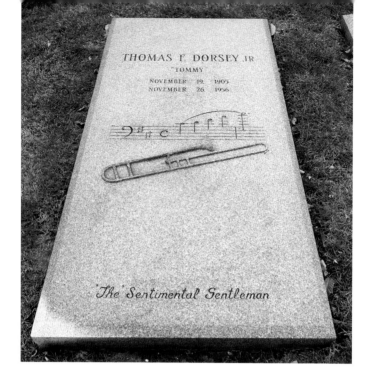

Tommy Dorsey

November 19, 1905–November 26, 1956
41° 04' 36.49" N 73° 47' 5.22" W

Thomas Francis Dorsey Jr. was born in Shenandoah, Pennsylvania, to Theresa Dorsey and Thomas Francis Dorsey Sr. By age 15, he was an accomplished trombonist, playing with his brother Jimmy in a band. In 1928, the Dorsey Brothers had their first hit, "Coquette." The Dorseys continued performing together and eventually formed the Dorsey Brothers Orchestra. In the mid-1930s, Tommy Dorsey broke away from the orchestra and formed his own band. It struggled for a couple of years and then changed its style to have a jazzier feeling. In 1940, Dorsey hired a young singer named Frank Sinatra, who recorded 80 songs with the Dorsey band between 1940 and 1942.

Throughout the 1940s, Dorsey used a wide array of popular artists in his band, including Buddy Rich, Doc Severinsen, and Gene Krupa. In the 1950s, he turned to the new medium of television and, after reuniting with his brother Jimmy, appeared on *The Jackie Gleason Show*. The brothers also had their own production, *Stage Show*, which ran for varying lengths of time from 1954 to 1956. On January 28, 1956, a young performer made his first television appearance on *Stage Show* and sang "Shake, Rattle and Roll." His name was Elvis Presley, and he appeared on the program five more times early that year. Presley didn't appear on *The Ed Sullivan Show* until October 1956.

In his career, Dorsey accumulated 286 Billboard chart hits, 17 number one hits with his band, three wives, and four children. He died in his sleep from choking, perhaps because he had taken too many sleeping pills. Spending eternity beside him is his third wife, Jane New Dorsey (October 20, 1923–August 24, 2003). Her gravestone reads, "Tommy called her his E Flat." (Compositions in E Flat Major are bold and heroic. Compositions in E Flat Minor are often dark and mysterious.)

J. Gordon Edwards

June 24, 1867–December 31, 1925

41° 4' 19.65" N 73° 47' 20.18" W

This one-of-a-kind mausoleum is the resting place of prolific silent film director J. Gordon Edwards. Canadian-born Edwards was one of the most prominent movie directors in the silent film era. He began his career as a stage actor and director and then in 1914, he made his film debut as director of *St. Elmo*. Not long after his debut, he became a director at Fox Film Corporation (Fox merged with Twentieth Century Pictures in 1935 to become Twentieth Century Fox). From *St. Elmo* in 1914 until his last film, *It Is the Law*, in 1924, Edwards directed over 50 films. He is best know for directing the original *Cleopatra* in 1917; *The Queen of Sheba* in 1921, which contained an enormous chariot race; and for all of Theda Bara's films from 1916 to 1919 (including her most noted role in *Cleopatra*). Theda Bara said that Edwards was the kindest director she had ever worked with.

Edward's wife, Angela, commissioned the mausoleum some years after Edwards' death, and it is an homage to the exotic high-production period films Edwards directed. The twin minarets were originally wired for electricity. Inside the mausoleum are a number of movie props, including chairs and a tiger-skin rug. Often Angela would visit the mausoleum and read while seated in one of the chairs. When she died in 1965, she directed that she be cremated and her ashes be mingled with her husband's. Their ashes are sealed in one of the crypts, which is inscribed with the last line (Canto XXXIII, line 145) of *The Divine Comedy Part III Paradiso* by Dante Alighieri: *"L'amor che move il sole e l'altre stele"* ("The Love which moves the sun and the other stars"). J. Gordon Edwards is the grandfather of director Blake Edwards (July 26, 1922–December 15, 2010).

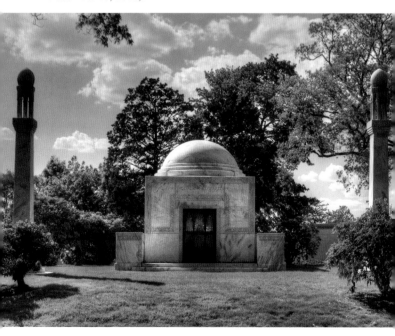

Friars Club
41° 04' 47.65" N 73° 47' 1.42" W

The Friars Club also has a large plot at Kensico. The emblem of the club is a friar surrounded by the words *Prea Omnia Fraternitas* ("Before all things, Brotherhood or Brotherhood Forever"). The club, which is well known for its celebrity roasts, was founded in 1904 as the Press Agents Association. While most of the A-list members of the Friars Club are buried in individual plots, there are a few well-known celebrities here. One notable resident is New York radio announcer William B. Williams.

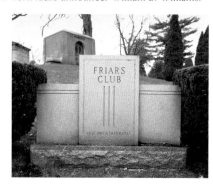

Frank Sinatra credited Williams for having resuscitated his career. Williams nicknamed Sinatra "chairman of the board." One of the most recent arrivals at the Friars Club plot was pie-throwing comedian and television personality Soupy Sales, born Milton Supman (January 8, 1926–October 22, 2009).

Lou Gehrig
June 19, 1903–June 2, 1941
41° 4' 25.67" N 73° 47' 0.99" W

Lou Gehrig was born to Heinrich and Christina Gehrig in Manhattan. Young Lou was a natural at playing baseball. In high school, he hit a grand slam home run out of Wrigley Field in Chicago. After graduating, he attended Columbia University from 1921 to 1923. In the spring of 1923, he was spotted by a scout for the New York Yankees, and two months later he was playing for the team. Gehrig had limited playing time for the first couple of years, then he had a breakout season in 1926 when he batted .313—he never looked back. Despite being overshadowed by superstar Babe Ruth for two-thirds of his career, Gehrig continued to break records, astounding his fans and the media. In

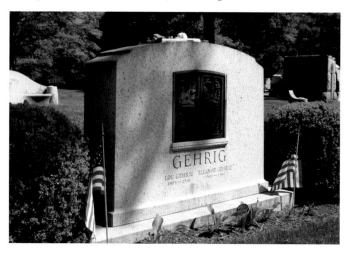

1936, *Time* magazine proclaimed him "the game's number one batsman." His most astounding record was playing in 2,130 consecutive games starting on June 1,1923, and ending on April 30, 1939. The games that he played even though he was injured earned him the nickname "The Iron Horse." That record stood until September 6, 1995, when Baltimore Orioles shortstop Cal Ripken bested it.

Lou Gehrig didn't play his 2,131st game because he was suffering from a disease that he had had for sometime. Gehrig's performance had dropped off significantly around the middle of the 1938 season. He just couldn't perform like he used to. On June 13, 1939, he went to the Mayo Clinic in Rochester, Minnesota. After six days of testing, he was diagnosed with a progressive, incurable neurological disorder called amyotrophic lateral sclerosis (ALS), which soon became known as Lou Gehrig's Disease. A week later, the New York Yankees announced Gehrig's retirement and then proclaimed July 4, 1939, as Lou Gehrig Appreciation Day. The Yankees then retired Gehrig's uniform number "4," making him the first player in Major League Baseball history to be honored that way.

Lou Gehrig's grave is almost always piled with bats, balls, gloves, and other memorabilia. It is a testament to a dying man who had this to say on Lou Gehrig Appreciation Day,

> *Fans, for the past two weeks you have been reading about the bad break I got. Yet today I consider myself the luckiest man on the face of the earth. I have been in ballparks for seventeen years and have never received anything but kindness and encouragement from you fans.*

Danny Kaye
January 18, 1913–March 3, 1987
41° 4' 43.66" N 73° 47' 4.61" W

David Daniel Kaminsky was born to Ukrainian Jewish parents in Brooklyn. He attended public school in New York but never graduated. He gravitated to the performing arts and learned to be a tumbler when he was a teenager. Those performances sent him to the Catskills and the Borscht Belt. He made his film debut in the 1935 short *Moon Over Manhattan* and soon found ready work as a comic in low-budget shorts. Kaye enhanced his comic persona by dyeing his hair red, singing tongue-twisting songs, and assuming a manic manner. By the late 1940s, he was

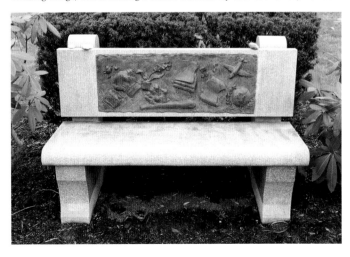

starring and co-starring in movies, most notably *The Secret Life of Walter Mitty* (1947), *White Christmas* (1954), and *The Court Jester* (1956). He had his own television program on CBS, *The Danny Kaye Show*, that ran from 1963 to 1967.

In later life, Kaye slowed down his work in the entertainment business and became the first owner of the Seattle Mariners baseball team, an avid pilot, an ambassador for UNICEF, and a big supporter of musicians' pension funds.

The bronze plaque on the memorial bench that marks his grave details the loves of his life: music (a piano, radio, sheet music, and notes), piloting airplanes (an airplane), cooking (a chef's hat, teapot, and cups), gardening (a flowerpot), UNICEF (a globe with olive branches), and baseball (a bat, ball, and glove).

William Lawrence
1842–1927
41° 04' 40.37" N 73°47' 4.67" W

William Van Duzer Lawrence was born on a farm outside Elmira, New York. His parents, Robert D. Lawrence and Catherine Van Duzer Lawrence, both came from prominent Dutch-American families. At age 19, William went to work in the family's pharmaceutical business and quickly rose through the ranks. He amassed a considerable fortune in both the pharmaceutical and real estate business. At the turn of the nineteenth century, he built a suburban housing development called Lawrence Park in Bronxville, New York. The development catered to the upper middle class, and because of its semirural setting, it was attractive to established painters, sculptors, and literary types. The artistic aura of the place must have rubbed off on Lawrence. In later life, he started making contributions to a variety of institutions. His most well known outpouring of wealth was in 1926 when he founded Sarah Lawrence College after the death of his wife, Sarah Lawrence (1846–1925). The centerpiece of his large plot at Kensico is a semicircular low neo-Gothic wall with a throne-like arch. The plot is peppered with the graves of members of the extended Lawrence family.

Tommy Manville
April 9, 1894–October 9, 1967
41° 04' 42.83" N 73° 47' 22.09" W

Tommy Manville (Thomas Franklyn Manville Jr.) was the Paris Hilton of the mid-twentieth century: he was famous for being famous. Like Hilton, he inherited a lot of money. In his case, he was an heir to the Johns-Manville asbestos fortune. Unlike Hilton, he had a predilection to marriage. From his first marriage to chorus girl Florence Huber in 1911, to his last to 20-year-old Christina Erdlen in 1960, he was married a total of 13 times to 11 different women. Marriage became a sort of a sport to him, and he won whatever he was trying to win by securing a spot in the *Guinness Book of Records,* now called the *Guinness World Records.* By all accounts, the playboy reveled in his ability to lure young blond women into his lair, marry them, and then rapidly divorce them. He married Macie Marie Ainsworth in August 1943. They were together for 8 hours of connubial bliss before separating. They got a divorce two months later in October 1943.

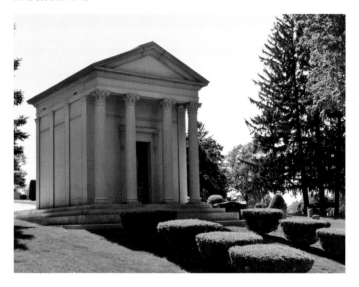

Manville's fortune was not guaranteed from birth. In fact his early marriage antics caused his father to cut him off, and Tommy had to take a job at the Pittsburgh facility for $15 a week. But his father relented, and when the elder Manville died, he left Tommy approximately $10 million (about $125 million today), certainly enough for him to maintain an extravagant lifestyle. Too bad reality TV hadn't been invented yet; Tommy Manville would certainly have been a star.

Louis Mayer
(?–October 19, 1909)
41° 4' 25.32" N 73° 47' 25.77" W

One of the most interesting tombs at Kensico (indeed, it is one of the most unique tombs in the United States) is the Mayer Mausoleum. It was featured in an iconic tomb tome *Memorial Art: Ancient and Modern* authored by Harry A. Bliss in 1914. The Mayer Mausoleum is in the form of a tumulus, one of the oldest formal burial monuments. Examples of

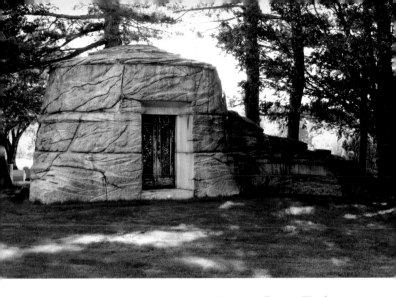

tumuli can be seen dotting many countryside areas in Europe. The form of the tomb can also be likened to the cave where Jesus was buried. Little is known about Louis Mayer or the seven occupants of the Mayer tumulus-style mausoleum.

Harriet Quimby
May 1, 1875–July 1, 1912
41° 04' 34.07" N 73° 47' 19.71" W

A gray granite marker with a bronze relief plaque depicting an airplane marks the down-to-earth home of Harriet Quimby. She was born in Arcadia, Michigan, then moved with her family to San Francisco when she was about 25, where she found work as a journalist. She moved to New York in 1903 and took her journalist credentials with her. She was hired as a theater critic for *Leslie's Illustrated Weekly*. In the next nine years, over 250 of her articles were published. Her writing

took a Hollywood turn in 1911 when she authored five screenplays and even landed a small role in one movie.

In 1910, she became interested in flying, and on August 11, 1911, she took the pilot's test and became the first woman in the United States to earn a pilot's certificate. On April 16, 1912, she became the first woman to fly over the English Channel. Her flying career came to an abrupt end on July 1, 1912, at the Third Annual Boston Aviation Meet in Squantum, Massachusetts. She was

piloting a brand-new two-seat Bleriot monoplane with William Willard, one of the organizers of the event aboard. Something went awry and both Quimby and Willard were ejected from the plane, tumbling to their deaths in Dorchester Bay. A 1991 airmail postage stamp featured Harriet Quimby. The bronze plaque on her grave reads, "The first woman in America to receive a pilot's license to fly, the first woman to fly a monoplane alone across the English Channel April 16, 1912. The life of this heroic girl went out when she fell with her passenger aeroplane at Boston July 1st, 1912. She was dramatic editor of *Leslie's Weekly*. Rest gentle spirit."

Sergei Rachmaninoff
April 2, 1873–March 28, 1943
41° 04' 43.83" N 73° 47' 25.72" W

Sergei Vasilievich Rachmaninoff was born in Semyonovo in northwestern Russia into a noble family, and at an early age, he began taking piano lessons. Although he didn't take a great interest in playing the piano, he displayed a talent for composing. He won a gold medal for his composition of a one-act opera, *Aleko*, when he was 19 years old. As with almost all composers and musicians, he became annoyed in later years when his audiences requested to hear his earlier works rather than his newer compositions. While still a teenager, he met Pyotr Ilyich Tchaikovsky in Moscow, who became a profound influence in his life. Scholars say that Rachmaninoff is the only true heir to Tchaikovsky's romanticism. He was also regarded as one of the finest pianists of the time.

Rachmaninoff moved to New York during the turbulence that followed the Russian Revolution. Despite losing essentially everything when he left Russia, it didn't take him long to get reestablished. He stayed in Europe briefly and then went to New York in late 1919. He was enthusiastically welcomed and soon established a Russian-style home complete with Russian servants. He died on March 28, 1943, less than two months after he and his wife, Natalie, became American citizens. His grave is marked with an Eastern Orthodox cross. Also buried in the plot are his wife, Natalie, and their daughter, Princess Irina Wolkonsky.

Ayn Rand (Alisa Zinov'yevna Rosenbaum)

February 2, 1905–March 6, 1982
41° 04′ 36.70″ N 73° 47′ 6.09″ W

Russian-born writer Ayn Rand is most famous for her two novels *The Fountainhead* and *Atlas Shrugged,* where she extolled her views on a modified view of Capitalism, which she called Objectivism. She was educated at Petrograd State University and studied history and philosophy. In 1925, she received a visa to visit relatives in Chicago and never returned to Russia. She adopted the last name Rand either from an anglicized spelling of her Russian name or some say from a Remington Rand typewriter, but that claim has never been verified. Ayn may have come from the Hebrew word *ayin* for "eye."

Ayn Rand journeyed to Hollywood in the late 1920s, sold a couple of stories as potential screenplays, and worked as a junior scriptwriter. While working in Hollywood, she met aspiring actor Frank O'Connor, and the couple were married in 1929. She made enough money writing short stories and novels to go from one book to the next. She finally struck literary gold with *The Fountainhead* in 1943. The book actually took about seven years to write. She continued working on screenplays and became intensely anti-Communist. Her magnum opus was *Atlas Shrugged,* which was published in 1957. Rand was a heavy smoker and eventually succumbed to lung cancer. Next to her casket at her funeral was a six-foot-high flower arrangement shaped like a dollar sign.

David Sarnoff

February 27, 1891–December 12, 1971
41° 04′ 36.77″ N 73° 46′ 59.39″ W

This bunker-like mausoleum is the final resting place for communications mogul David Sarnoff. He was born near Minsk, Russia, into a poor Jewish family. His father immigrated to the United States, and when he amassed enough money, he sent for his family. Nine-year-old David arrived in the United States in 1900. He began actively working in 1906 after his father became incapacitated with tuberculosis. In the fall of 1906, he got a job with the Marconi Wireless Telegraph Company of America and thus began a 60-year career in communications.

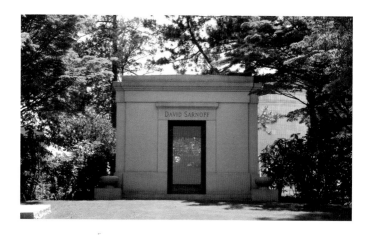

Sarnoff's first major achievement was popularizing radio broadcasting. Until the early 1920s, radio broadcasting was seen as a point-to-point technology, not a point-to-mass-audience medium. Sarnoff's coup was to broadcast a boxing match for his new employer RCA (Radio Corporation of America). Over 300,000 people listened, and sales of radios soared afterwards. He founded NBC (National Broadcasting Company) in 1926 and was also instrumental in the development of television. Spending eternity in the Sarnoff plot as well

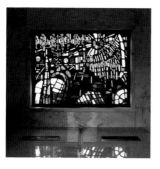

is RCA executive Robert Sarnoff (died 1997) and his wife, opera singer Anna Moffo (June 27, 1932–March 9, 2009).

The interior of the mausoleum sports a multicolored stained glass window done in a jazzy style that was popular from the mid-twentieth century through the 1970s. David Sarnoff and his wife of 54 years, Lizette Hermant (ca. 1900–1974), lie side-by-side in twin crypts.

M. Moran Weston
September 10, 1910–
May 18, 2002
41° 4′ 31.42″ N 73° 46′ 55.95″ W

One of the most interesting personal monuments at Kensico marks the grave of The Rev. Dr. M. Moran Weston II, who was an Episcopal priest and a civil-rights activist. Weston was leader of one of Harlem's most prominent churches and was a founder of Harlem's renowned Carver Federal Savings Bank in 1948. Weston chose the trylon and perisphere, which became the symbol of the 1939 New York World's Fair, to mark his burial

plot. Why he chose this very unique monument is not known. Perhaps he was inspired by the fair's motto, "Building the world of tomorrow," when he was a young man.

Florenz Ziegfeld
March 21, 1867–July 22, 1932
41° 4' 31.42" N 73° 46' 55.95" W

Billie Burke
August 7, 1884–May 14, 1970

Florenz "Flo" Ziegfeld Jr. was born in Chicago to German emigrants. His father, Florenz Ziegfeld Sr., was the head of the Chicago Musical College. At an early age, Florenz Ziegfeld Jr. saw that the best way to make money in the entertainment business was to produce shows rather than to perform in them. He also saw that the best medium to work in was so-called "low culture," a conclusion he came to after seeing Buffalo Bill's Wild West Show in 1883. Ziegfeld produced elaborate shows, combining beautiful chorus girls and variety-style musical numbers. He produced the Follies of 1907, based on a style of performing he had seen in Paris. In 1911, he renamed his venture the Ziegfeld Follies. One of the regular performers in the Follies was one Anna Held, who he may or may not have been married to (certainly he was in a common-law marriage to her from 1897 to 1913). Ziegfeld catapulted her to fame with a series of publicity stunts, including press releases about her milk baths. Then he met Billie Burke.

Mary William Ethelbert Appleton "Billie" Burke came from a performing family. Her father, Billy Burke, was a singing clown with a circus. Billie Burke began acting in 1903, and in a few short years, she was playing leads on Broadway. It was there that she met Florenz Ziegfeld, and the couple married in 1914. Burke was courted by Hollywood studios but preferred stage acting since Hollywood films were still silent. However, by the early 1930s, when sound films finally

took hold, Burke immersed herself in roles. Her stunning beauty allowed her to have an extremely long run in Hollywood. In 1938 at age 53, she played the Good Witch of the North in *The Wizard of Oz.*

The statue of a woman in back of Florenz Ziegfeld's and Billie Burke's simple gravestones is a memorial to Billie's mother, Blanche Beatty Burke.

Paddy Chayefsky
January 29, 1923–August 1, 1981
Sharon Gardens (Jewish section)
41° 5' 1.20" N 73° 47' 16.80" W

Sidney Aaron "Paddy" Chayefsky was born in the Bronx to Ukrainian Jewish parents. He got a degree in accounting from Fordham University and then joined the Army during World War II. He acquired the name Paddy when he asked to be excused to go to Mass, and an officer said he thought he was Jewish; Chayefsky replied that his mother was Irish and the officer responded, "Okay, Paddy;" the name stuck. After being wounded, "Paddy" Chayefsky wrote a book and lyrics to a musical comedy while recovering in the hospital. The book *No T. O. for Love* was made into a play and toured European Army bases.

After he returned from the war, he got a job working at his uncle's print shop and continued to write. In the late 1940s, he continually churned out short stories and radio scripts, and he was also a gag writer. His big break came when he was asked to adapt the story *It Happened on the Brooklyn Subway* for *The Philco Television Playhouse.* In 1953, he wrote a play titled *Marty,* about ordinary working-class people who fall in love, for the *The Philco Television Playhouse. Marty* became a hit movie in 1955.

Paddy Chayefsky's writings are best described as from the "slice of life" or "kitchen sink realism" school, which portrays the real humanity of people rather than glorifying or denigrating them. His most memorable achievements were the screenplays he wrote for *Marty* in 1955, *The Hospital* in 1971, and *Network* in 1976. After writing *Network,* he spent two years writing his novel *Altered States* and the subsequent screenplay, which explored a man's search for his core being through psychotropic drugs and an isolation tank. Reportedly, the stress from writing the novel was so great that he had a heart attack. Not long after *Altered States* premiered, Paddy Chayefsky succumbed to cancer at age 58. Photo courtesy of Jim Logan.

Ichabod Crane

Sleepy Hollow Cemetery

540 North Broadway

Sleepy Hollow, New York 10591

(914) 631-0081

www.sleepyhollowcemetery.org

Maps in office

41° 5' 48.91" N 3° 51' 41.66" W

Ask the proverbial man-on-the-street to conjure up an image of a cemetery and it's likely he'll envision something akin to Sleepy Hollow Cemetery, which has it all: spooky lilting eighteenth-century death's-head tombstones, twisting narrow roads, majestic mausoleums, and magnificent statuary, all perfectly placed onto a hilly woodland canvas. And then there's that abbreviated equestrian on his mighty steed, The Headless Horseman.

What most people think of as Sleepy Hollow Cemetery is actually two cemeteries: the three-acre Old Dutch Burying Ground (one of the settings for Washington Irving's classic story, *The Legend of Sleepy Hollow*), which was established in 1685, and the 95-acre Sleepy Hollow Cemetery, which was established in 1849 as Tarrytown Cemetery. Banking on the marketability of the Sleepy Hollow name, cemetery officials formally changed the name to Sleepy Hollow Cemetery in the mid-1860s. The village of Sleepy Hollow was a little slow to capitalize on their proximity to Sleepy Hollow Cemetery. It was unremarkably named North Tarrytown until 1996, when the name was changed to The Village of Sleepy Hollow. The cemetery continues to be active, thanks to a recent acquisition of land from the adjacent Rockefeller estate and the addition of a green burial area for environmentally friendly in-ground burial as well as burial of cremated remains. Sleepy Hollow Cemetery has a very active Friends of Sleepy Hollow organization that conducts tours, workshops, and special events.

Old Dutch Church
www.odcfriends.org

Although most people see Sleepy Hollow and the Old Dutch Burying Ground as one cemetery, they are actually quite different in texture. Most of the gravestones in the Old Dutch Burying Ground are variations of death's heads, which have a skull or a face with wings sprouting from the sides. Sleepy Hollow Cemetery's tombs largely reflect the symbolism and sensitivies of the Victorian Age.

The Old Dutch Church was constructed around 1685 on a 52,000-acre manor owned by Frederick Philipse. Although the church does not offer regular services, it does host special tributes on Easter, Christmas Eve, and other events. *The Legend of Sleepy Hollow* is a fictitious story, but Washington Irving's description of the church's location still fits the Old Dutch Church two centuries later:

The sequestered situation of this church seems always to have made it
a favorite haunt of troubled spirits. It stands on a knoll, surrounded by
locust-trees and lofty elms, from among which its decent, whitewashed walls
shine modestly forth, like Christian purity beaming through the shades of
retirement. A gentle slope descends from it to a silver sheet of water, bordered
by high trees, between which, peeps may be caught at the blue hills of the
Hudson. To look upon its grass-grown yard, where the sunbeams seem to
sleep so quietly, one would think that there at least the dead might rest in
peace. On one side of the church extends a wide woody dell, along which
raves a large brook among broken rocks and trunks of fallen trees. Over a
deep black part of the stream, not far from the church, was formerly thrown
a wooden bridge; the road that led to it, and the bridge itself, were thickly
shaded by overhanging trees, which cast a gloom about it, even in the
daytime; but occasioned a fearful darkness at night. Such was one of the
favorite haunts of the Headless Horseman, and the place where he was most
frequently encountered.

The interior of the church has changed little since the church was constructed in the late 1600s. Even at the dawn of the twenty-first century, the church is still not fitted with electrical power.

A window in the Old Dutch Church looks out into the burying ground. Many of the inscriptions on the gravestones are in Dutch, reflecting the strong Dutch heritage of the Sleepy Hollow area. And as legend has it, the burying ground contains the grave of the Headless Horseman.

Catriena Ecker van Tessel

November 10, 1736–January 10, 1793
41° 05′ 26.10″ N 73° 51′ 42.49″ W

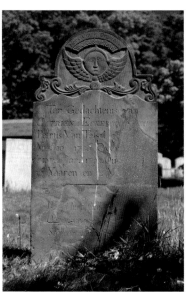

The face of the red sandstone grave marker may be slowly flaking away, but the memory of Catriena Ecker van Tessel will live forever. In Washington Irving's short story *The Legend of Sleepy Hollow*, hapless schoolmaster Ichabod Crane is smitten by comely 17-year-old Katrina Van Tassel, but he must compete with town thug Abraham "Brom Bones" Van Brunt. Folklorists say that the character Katrina Van Tassel is based on Eleanor van Tassel Brush, although the character's name is based on Eleanor's aunt Catriena Ecker van Tessel. Her grave is without a doubt the most visited grave in the Old Dutch Burying Ground. The area around Catriena Ecker van Tessel's grave is peppered with other members of the van Tassel family. The Latin inscription, *Mors Vincit Omnia*, topping her gravestone translates to "Death Conquers All."

John Dustin Archbold

July 26, 1848–December 5, 1916
41° 05′ 52.98″ N 73° 51′ 34.26″ W

John Dustin Archbold was one of the titans of the Gilded Age. He was born in Ohio, the son of Rev. Israel Archbold and his wife, Frances. Israel Archbold died in 1859, and young John became the man of the family. The family moved to Salem, Pennsylvania, which was not far from the

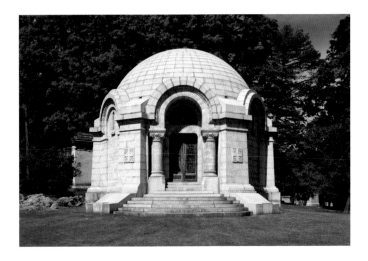

soon-to-be-developed oil fields. He saved his money, and then in 1864, he moved to Titusville, Pennsylvania, in the heart of the oilfields. By age 19, his small investments were paying off, so much so that he was able to buy a home for his mother and send his sister to college. He worked at and invested in oil fields for the next 11 years. During that time, John D. Rockefeller's company, Standard Oil, was hungrily gobbling up smaller companies and was setting its sites on Archbold's company, Acme Oil Company of Titusville. The two men engaged in a spirited and very public battle, but peace was made and Archbold was offered a position at Standard Oil. Over the years, he held positions of vice president and president, and served on the board of directors. In later life, Archbold devoted himself to educational and philanthropic works.

The Archbold Mausoleum had one very interesting temporary guest. When John D. Rockefeller's wife Laura died, the newspapers reported that he asked his old friend John Dustin Archbold if he would house Laura's remains for a while before transferring her to the John D. Rockefeller plot in Cleveland's Lake View Cemetery. "I want to keep her with me as long as I can." Alas, Rockefeller's sentiments just may ring a bit hollow since something else was preventing him from going to Lake View Cemetery: as soon as he crossed the state line into Ohio, he would have been served a summons for a court case he had been avoiding. Laura remained in the Archbold Mausoleum for four and a half months while Rockefeller's lawyers worked things out with tax officials in Ohio.

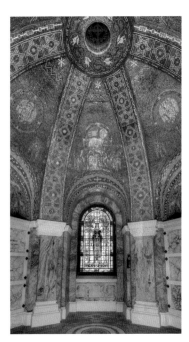

Archbold's one-of-a-kind

mausoleum was fabricated of green granite by Troy Granite in Worcester, Massachusetts. It measures 36 by 36 feet and is 32 feet tall. It contains 12 crypts. The contractor/builder was the Norcross Brothers, which charged $31,308 for the building. The mausoleum and bronze doors were designed by the New York firm of Morris, Butler and Rodman Architects.

The glass mosaic ceiling was crafted by Otto Heinigke (1850–1915). It contains a number of iconic Christian symbols, including winged depictions of the four evangelists, the Agnes Dei, doves, angels, and crosses.

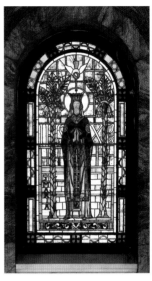

The Tiffany-style stained glass window is fabricated with opalescent glass, using the variegated pattern of the glass rather than staining/painting the glass to bring out the design details. The window depicts a dive-bombing dove, symbolizing the Holy Ghost; an IHS monogram (the first three letters of Jesus' name in Greek); an XP monogram, representing a Chi Rho cross (the earliest Christian symbol); and the Virgin Mary, depicted as Mary Queen of Heaven.

Elizabeth Arden
December 31, 1878–October 18, 1966
41° 06' 01.29" N 73° 51' 28.46" W

This small gravestone marks the final residence of a giant in the cosmetics industry. Elizabeth Arden was born Florence Nightingale Graham in Ontario, Canada, the fifth of five children of a Scottish grocer. She went to nursing school but dropped out, and then went to New York, where she worked for a pharmaceutical company and learned about skincare. In 1909, she formed a company and adopted the name Elizabeth Arden. She traveled to France in 1912 to learn more about beauty, makeup, and facial massage techniques. She returned to the United States and started applying the principles she learned and, rather than marketing her products to the entertainment industry, she introduced them to the average American woman, who

was beginning to enter the workforce. Her idea worked, and by the 1930s, the Elizabeth Arden brand became the most well known cosmetics brand in the world. The company and brand was sold to Eli Lilly and Company for $78 million in 1971. Eli Lilly sold Elizabeth Arden to Fabergé for $657 million in 1987.

Leo Hendrik Baekeland

November 14, 1863–February 23, 1944

41° 05′ 46.76″ N 73° 51′ 32.44″ W

Belgium-born inventor Leo Hendrik Baekeland was the son of a cobbler and a maid. He seemed to have a natural talent for chemical invention. He married after college, and while honeymooning in New York, he met a man who offered him a job in New York as a chemist. A couple of years later, he started his own firm and invented a new type of photographic paper. That paper was purchased by George Eastman, the founder of Eastman Kodak, for $1 million. Baekeland then turned his eyes to resins and invented a moldable product he called Bakelite, which is considered the material that ushered in the age of plastics.

Baekeland sold his company to Union Carbide in 1939. In his later life, he became more and more eccentric and reclusive, getting into frequent fights with his son and insisting on eating all his meals from cans. His monument at Sleepy Hollow is a simple granite bench, a good place to sit and ponder what life would be like without plastics.

Andrew Carnegie

November 25, 1835–August 11, 1919

41° 05′ 47.28″ N 73° 51′ 36.08″ W

Andrew Carnegie is widely regarded as the second wealthiest American industrialist of all time. At the height of his career, his fortune was estimated at $75 to $300 billion modern dollars (John D. Rockefeller's fortune was estimated at between $392 and $663 billion).

Andrew Carnegie's life is a true rags-to-riches story with a happy ending. He was born in Dunfermline, Scotland, to a poor family of weavers. The family moved to the United States in 1848 with young Andrew in tow. Thirteen-year-old Andrew got a job in a cotton mill changing bobbins for $1.20 a week. He progressed rapidly through a series of jobs while educating himself by reading books. He became particularly adept at being able to decipher telegraph messages by simply listening to the clicks of the telegraph. By age 30, he began investing in railroad-related companies.

Andrew Carnie had a knack for investing. Through careful analysis and hard work, he figured out which companies were going

to prosper. During the Civil War, he became involved in transportation of troops and munitions. In 1864, he invested in oil in Pennsylvania, turning a million-dollar profit in one year. After the Civil War, he turned his interest to iron and steel. Carnegie made his largest fortune in steel after launching the Carnegie Steel Company in 1892, which merged with other companies to become U.S. Steel in 1901.

In later life, Carnegie turned his efforts to philanthropy, providing funds and endowments to help foster education. There are a number of Carnegie-endowed institutions in America, Europe, and Scotland in particular. The most well known use of his funds was the establishment of Carnegie libraries all over the world. Between 1883 and 1929, over 2,500 libraries were built, 1,689 of them in the United States. Carnegie's grave marker at Sleepy Hollow is relatively simple considering his great wealth. The Celtic cross is an homage to his Scottish roots. The granite for the stone was quarried at his estate in Sutherland, Highland, Scotland.

Walter Percy Chrysler
April 2, 1875–August 18, 1940
41° 06′ 2.73″ N 73° 51′ 33.86″ W

Members of the Walter Chrysler family repose in this garden-variety Classical Revival mausoleum. One would expect something a bit jauntier.

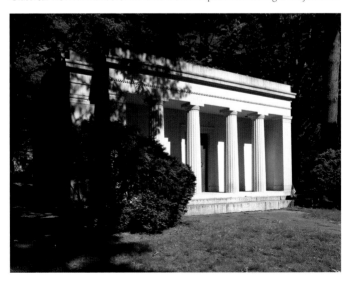

Why? Well, for one thing, one of the most recognizable buildings on the planet bears his name—the Chrysler Building, an Art Deco masterpiece.

Walter Chrysler grew up in Ellis, Kansas. At an early age, he displayed a talent for mechanical things, and he took a number of jobs as a mechanic for railway companies. He advanced through the ranks as a foreman, superintendent, and master mechanic, eventually becoming the works manager at the American Locomotive Company in Pittsburgh. A short time after assuming the position, a director at the company asked him if he might be interested in automobile manufacturing. In short order, Chrysler became the production manager for Buick in Flint, Michigan. Just as he had done in railroading, he rose rapidly, and in 1925, he formed his own company, the Chrysler Corporation. Then came the crowning event of his career: he financed the construction of the Chrysler Building. Before being surpassed by the Empire State Building, the Chrysler Building was the tallest building in the world. It still remains the tallest steel-supported brick building in the world. The Chrysler Building and the accumulation of other successes in his life led to being *Time* magazine's Man of the Year in 1929.

Samuel Gompers
January 27, 1850–December 13, 1924
41° 05′ 47.61″ N 73° 51′ 38.12″ W

Just a few steps away from Andrew Carnegie is another influential leader of America's great industrial age, but one that was on the other side of the fence. Samuel Gompers was one of the labor movement's most influential leaders in the late nineteenth century. He was born into a poor Jewish family in London; then, seeking a better life, he moved with his family to New York in 1863. In New York he apprenticed as a cigar maker and soon joined the cigar makers union. The nature of the cigar-making process meant that Gompers was free to talk to other

workers while he crafted cigars. These conversations were frequently about the working environment and labor unions. His interest in labor unions grew, and in 1875 at age 25, he was elected president of the Cigar Makers' International Union Local 144.

Gompers realized that a larger organization could better serve the needs of labor by uniting many unions under one umbrella. In 1881, he helped organize the Federation of Organized Trades and Labor Unions, which became the American Federation of Labor (AFL) in 1886. With the exception of the year 1895, Gompers served as president of the AFL until his death in 1924. Although some of his ideas and actions might draw criticism in today's world (he supported the Chinese

Exclusion Act of 1882), he was always a strong advocate for the rights of the American worker and equal wages for equal work. He said, "What does labor want? We want more schoolhouses and less jails. More books and less guns. More learning and less vice. More leisure and less greed. More justice and less revenge. We want more . . . opportunities to cultivate our better natures."

Gurnee Mausoleum

March 9, 1813–April 18, 1903
41° 05' 35.93" N 73° 51' 39.65" W

This marble mausoleum is the permanent home of a number of members of the Gurnee family. The most noted resident is Walter S. Gurnee, who was born in Haverstraw, New York, and then moved with his family to Detroit. In 1835, he started a business in Detroit and then moved to the booming city of Chicago, where he got into the leather business, becoming one of the first tanners in Chicago. In 1843, he founded and installed himself as president of the Chicago Hide and Leather Company and later as a partner of Gurnee and Matteson (a saddlery and leather firm), where he amassed his fortune. He became active in a number of trade organizations and soon thereafter became president of the Chicago and Milwaukee Railroad. Gurnee served as mayor of Chicago from 1851 to 1853.

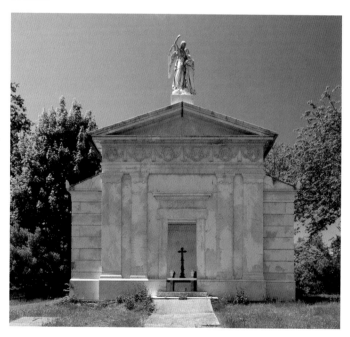

He moved to New York in 1863 and soon became one of the city's movers and shakers in the banking and business world. When he died at age 91, he was serving as the treasurer and a director of the Shelby Iron Company, and served as well on the board of directors of the American Smelting and Refining Company, American Surety Company, Carbon Steel Company, Chrysolite Silver Mining Company, Clifton Iron Company, Pittsburg, Lisbon and Western Railroad, and the Tennessee Coal, Iron, and Railroad Company. He was also a member of a number

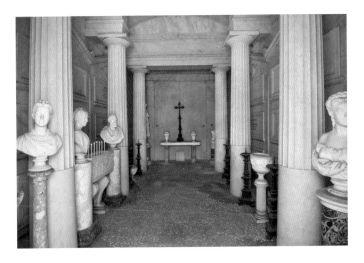

of community organizations, including the American Museum of Natural History and the Metropolitan Museum of Art.

The Gurnee's home on Fifth Avenue in Manhattan was a site of frequent entertainments and gala events. It's only fitting that the family mausoleum is full of activity and life. There are allegorical statues as well as statues of Mr. and Mrs. Gurnee and their daughters. The statues and the mausoleum's interior are all crafted of marble.

Marble busts of Mary Matilda Coe Gurnee (1820–1893) and Walter S. Gurnee (1813–1903) flank a planter.

An exquisite marble bust of Walter and Mary Gurnee's daughter Grace looks into the light.

John Hudson Hall
October 15, 1828–March 3, 1891
41° 05' 39.22" N 73°51' 37.04" W

John Hudson Hall was born in the United States. His ancestry was Dutch, Scottish, and English. Hall began his business life in 1842 as a clerk and worked for a couple of firms before settling in with paper goods manufacturer Elliott, Burimp and Babcock. Through a series of transfers, consolidations, and partnership changes, Hall partnered with

John Campbell to form the paper products firm of Campbell, Hall & Co. When Campbell retired, Hall took over the operations of the company until he retired in 1881. While he was running the paper company, he also dabbled in railroad enterprises and eventually became one of the developers of New York's elevated railroad system. Hall was also a patron of the arts and had a large personal collection. As testament to his love of the arts, his monument is fronted by a statue of an angel crafted by famous American sculptor Augustus Saint-Gaudens.

Helmsley Mausoleum
41° 05' 56.06" N 73° 51' 28.65" W

Leona Mindy Roberts Helmsley
July 4, 1920–August 20, 2007

Harry Brakmann Helmsley
March 4, 1909–January 4, 1997

Once they are buried, most people stay put. Such was not the case for Harry Helmsley, who was born in Bronx, New York. His formal schooling ended in high school, but he got into the real estate business at age 16 and eventually became a broker. With shrewd investing, he built a real estate empire that included lofts, large residential developments, offices, and hotels. When he died, his empire, including interests in the Empire State Building, One Penn Plaza, and numerous hotels; he was worth approximately $1.7 billion. In 1938, he married Eve Ella Sherpick Green but divorced her in 1971. In 1972, he married Leona Mindy Roberts.

Leona Helmsley was born Lena Mindy Rosenthal in Marbletown, New York, to Polish-Jewish emigrants. She attended high school in Manhattan but dropped out to seek her fortune in real estate. She married Leo Panzirer in 1938, divorcing him in 1952. She then married Joseph Lubin, divorced him, married him again, and divorced him again. Her real estate career kicked into high gear in 1964 when she started selling condominiums and co-ops. She met Harry Helmsley in 1968 and joined one of Harry's firms in 1970. After they were married, she devoted most of her time to managing the hotels. She was known as a demanding boss, which earned her the notorious title of the "Queen of

Mean." She was famously quoted as saying "We don't pay taxes. Only the little people pay taxes." Her tax-evading ways caught up with her; she was convicted of federal income tax evasion in 1989 and served 19 months of a 16-year sentence.

When Harry died in 1997, his body was placed in the Helmsley Mausoleum in Woodlawn Cemetery in the Bronx. Harry reposed quietly for a few years, but Woodlawn began building a community mausoleum just across the way from the Helmsley Mausoleum. The community mausoleum was designed to give the not-so-well-to-do the opportunity to opt for aboveground burial. In 2004, Leona Helmsley sued the cemetery for $150 million, claiming that the community mausoleum spoiled the "open view, serenity and tranquility" that she had previously enjoyed. After some legal machinations, all was forgiven and Leona actually gave money to the cemetery's preservation fund.

She soon found a large plot at Sleepy Hollow high on a hill overlooking the Pocantico River and the Rockefeller estate. That suited her just fine. The 3/4-acre plot assured that nothing could be built nearby. She spent $1.4 million dollars to build a 1,300-square-foot Greek Revival–style mausoleum, and she set aside $3 million for perpetual care and maintenance. Helmsley's will specified that $12 million be set aside for the care of her dog, a puffy Maltese named Trouble, and that Trouble, who died in December 2010, be buried beside her in the mausoleum when she dies. Her request may encounter a small hiccup: New York State law prohibits the burial of pets in human cemeteries. But there are always the iconoclasts who see laws not as edicts carved in stone, but as mere suggestions. There are such things as precedents (see page 122, Darling Leo). And the executors of the estate do have a key to the mausoleum . . .

The interior of the Helmsley Mausoleum contains three stained glass windows depicting the New York skyline. Harry's sarcophagus is inscribed, "I wait for the time we can soar together again." Leona's is inscribed "I never knew a day I did not love you."

Washington Irving
April 3, 1783–November 28, 1859
41° 05′ 30.22″ N 73° 51′4 1.71″ W

The person most associated with Sleepy Hollow Cemetery is Washington Irving, who wrote the classic American tale, *The Legend of Sleepy Hollow*. Irving was one of eleven children of Scottish-American immigrants William and Sarah Irving. The family settled in Manhattan. Young Washington Irving didn't develop much affinity for school, but he was attracted to drama and adventure stories. During an outbreak of yellow fever in Manhattan when he was 15, his family sent him up-river to the Tarrytown area. It was there that he became

familiar with a little valley named Sleepy Hollow near the village of Beekmantown. And more importantly, he became entranced with the ghost stories the Dutch-American people told.

Irving started writing at age 19, and then with the help of his brothers, he toured Europe, where his interest in art and the literary world was cemented. Returning to New York in 1806, he studied law but barely passed the bar exam. Writing was his real passion, and he wrote a number of satires using a variety of pseudonyms. Then he hit literary gold in 1809 with his satire *A History of New-York from the Beginning of the World to the End of the Dutch Dynasty*, using the pseudonym Diedrich Knickerbocker. He used part of the proceeds from the book to try to bail out his family after they had disastrous losses resulting from the War of 1812. Alas, he eventually had to declare bankruptcy; but he kept writing, and a serialized collection of his essays titled *The Sketchbook of Geoffrey Crayon, Gent* began to be published starting in 1819. The first installment, which contained the short story *Rip Van Winkle*, was an enormous success as was the sixth installment, which contained *The Legend of Sleepy Hollow*.

Irving continued to write throughout his long life. Many of his writings were penned during lengthy stays in Europe (he served as Minister to Spain from 1842 to 1846), but his last, a five-volume masterwork titled *The Life of George Washington* was written at his home, which he called Sunnyside, in Tarrytown. Washington Irving died of a heart attack at Sunnyside. His last words were reportedly, "Well, I must arrange my pillows for another night. When will this end?" His simple headstone is just outside the boundary of the Old Dutch churchyard, one of the locations mentioned in *The Legend of Sleepy Hollow*.

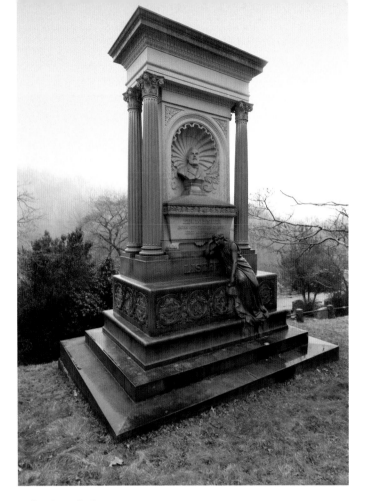

Edwin Lister
September 10, 1829–May 18, 1898
41° 05' 37.01" N 73° 51' 36.86" W

Edwin Lister was one of nine children born to Joseph Lister and his wife in Sunderland, England. The family immigrated to the United States in 1842, where Joseph Lister became involved in the fertilizer business and emerged as one of the pioneers in the field. Edwin and his brother Alfred, went into the family business, eventually forming the Lister Bros. Company, which later became the Lister Agricultural Chemical Company. The company prospered and set up a factory on the Passaic River in Newark, New Jersey, where they manufactured fertilizers, soaps, other animal derivatives, and sulfuric acid. Edwin Lister was also involved in local politics and served as alderman from the tenth ward from 1872 to 1876, and from the fourth ward from 1882 to 1884. He was also a member of the legislature of New Jersey in 1886. Interestingly, the Listers also operated a bone-button and fertilizer factory on what is today part of Sleepy Hollow Cemetery. When he died in 1898, he left a sizable estate worth about $1.5 million (about $35 million today). The Lister heirs engaged in a court battle over Lister's estate and in particular the valuation of his shares of the company. His monument contains a bust of him and a contemplative female figure.

Joshua D. Miner
(1824–1826)
41° 05' 35.52" N 73°51' 42.31" W

Joshua D. Miner was a scoundrel. According to his obituary in the *New York Times* on March 13, 1886, "he came from a family of crooks and in his childhood he was taught how to get money without earning it." The *Times* said that he arrived in New York with a "comfortable fortune" that he had obtained by "close attention to his allied professions of horse thief, counterfeiter and confidence man."

Joshua D. Miner was a handsome, confident, shrewd man who had the ability to charm people and, more importantly, the ability to find and organize like-minded criminals. His formal counterfeiting career started in Ohio, where after an unsuccessful transaction he was sent to prison for passing counterfeit money. Upon his release from prison, he somehow was able to muster up the funds to operate a farm and sawmill in Steuben County, New York. His expenses were low since he paid his employees in counterfeit money. When he was caught trying to pass a bogus $5 dollar bill in nearby Seneca Lake, New York, he asked to look at the felonious item and promptly swallowed it. Sensing that neither Seneca Lake nor Steuben County nor New York was going to be a good place for him to continue his career, he made it back to Ohio, where he continued to pass around counterfeit money. This resulted in another tour in the penitentiary, but somehow he managed to escape. Joshua D. Miner was a persistent man; rather than change his criminal ways, he simply vowed to become better at them. After all, the counterfeiting business was what he knew best.

Like all successful businessmen, he cut off his associations with small-time operators and assembled an experienced and enthusiastic team. This squad consisted of a dozen of the most competent counterfeiters in the business. He set up multiple manufacturing

plants, which helped to avoid printing slowdowns should pesky Secret Service agents raid one of the facilities. One of the most productive production lines was located at 49th Street and 6th Avenue in Manhattan, just steps away from present-day Radio City Music Hall. With Miner at the helm, the team produced hundreds of thousands of dollars in bank notes, which they distributed throughout the United States. Eventually, the whole business unraveled, and in October 1871, Miner and his team were arrested and charged with a variety of offences. Some of the counterfeiters turned state's evidence in exchange for plea bargains. But Joshua D. Miner was a clever man. He hired an ex-judge as his attorney; then at the beginning of the trial, one of the chief counterfeiters, Tom Ballard, who was scheduled to testify against Miner, somehow escaped from jail and was thus unable to testify. The trial, which latest throughout the winter of 1871–72 cost Miner about $40,000, but the jury just couldn't agree on his guilt and he was set free. After he was freed, Miner embarked on what appears to have been a legitimate occupation as a contractor and even invented and patented a rock drill. His wife, Sarah L. Elliott (1833–1871), died shortly after his trial and shares space with him in the plot.

Receiving Tomb
41° 05' 31.07" N 73° 51' 41.19" W

Most nineteenth-century cemeteries had a receiving tomb (also called a receiving vault). These structures served as temporary homes for the deceased while their tombs and mausoleums were being built. In frigid northern climes, the receiving tombs were also used when the ground was too frozen to dig a grave. Most have been boarded up or used as storage sheds. The 42-crypt receiving tomb at Sleepy Hollow has been restored and is one of the star attractions on its tours. The receiving tomb's star billing has gone beyond the cemetery and onto the Silver Screen. It was featured as one of the haunts of the vampire Barnabas Collins in the 1970 MGM film *House of Dark Shadows*.

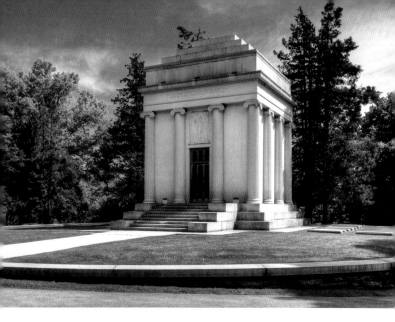

William Rockefeller
May 31, 1841–June 24, 1922
41° 05′ 51.36″ N 73° 51′ 34.98″ W

The largest mausoleum in Sleepy Hollow was built in 1920. It houses
the remains of members of the William Rockefeller family. He was born
in Richford, New York, and then moved with his family to Strongsville,
Ohio, in 1853. He started a refinery in 1865, which was acquired by his
brother John D. Rockefeller in 1867. That company became Standard Oil.
William Rockefeller then became interested in the copper business, and
along with his business partners, he tried to control the copper industry.
The business machinations proved successful, and the Anaconda Copper
Company went on to become the fourth largest company in the world.
William Rockefeller kept a much lower public profile than his brother
John D. Rockefeller and was considered to be much more friendly and
personable than John D. When William died, the gross value of his estate
was estimated at $102 million. He had requested a simple funeral, but
nevertheless, the service received attention in the papers. Of special
note was the number of servants who were allowed to attend the funeral,
including a bootblack who had served him for 40 years.

His impetus for building the mausoleum was to provide a dignified
final residence for his wife of 56 years, Almira Geraldine Goodsell
Rockefeller (1845–1920). Rockefeller hired Welles Bosworth (1868–
1966), an architect trained at the École de Beaux-Arts. At the time,
Bosworth was most noted as being the lead architect for the Pan-
American Exposition held in Buffalo in 1901. John D. Rockefeller later
hired Bosworth to oversee a number of Rockefeller's projects in France,
including the restoration of the Palace of Versailles. Bosworth's design
for the William Rockefeller Mausoleum called for a Classical Revival–
style tomb with engaged Ionic columns and a stepped pyramid–style
roof. The mausoleum is 35 feet 6 inches across the front, 43 feet 8 inches
deep, and 38 feet 5 inches high. The walls are 16 inches thick.

The Presbrey-Leland Company, one of the premier monument
builders of the time, executed the actual construction of the mausoleum.
The firm still operates today. Overseeing the project was monument

builder William Crawford. He chose Barre, Vermont, granite for all the structural elements. Of special note is the 10-foot-wide, 30-foot-long, 14-inch-thick granite walkway that was carved from a single slab of granite. Inside the mausoleum there are 20 wall crypts. The cella (interior space of the mausoleum) is 12 feet by 18 feet 2 inches. In the cella are two marble sarcophagi for William and Almira Rockefeller. Other architectural details include a bronze door and other bronze details fashioned by the William H. Jackson Company of New York and slate crafted by the Structural Slate Company of Pen Argyl (*argyl* is Greek for "slate rock"), Pennsylvania. The bas-relief above the entry has been attributed to French-born sculptor Gaston Lachaise. A number of granite-covered graves of other members of the extended Rockefeller family pepper the lawn area outside the mausoleum. Despite the mausoleum's grand scale and prominent siting, William Rockefeller kept his name low key. Rather than have his name in bold letters in the frieze area over the entry, he chose to modestly place it on the lower step of the stylobate (out of view on the far left; it echoes the "anno domini 1920" on the lower step of the stylobate on the far right).

Headless Horseman Bridge
41° 05' 46.18" N 73° 51' 31.63" W

In *The Legend of Sleepy Hollow*, hapless Ichabod Crane loses his race with the Headless Horseman on a bridge. Although inspiration for the bridge in the story was one originally located in Tarrytown, this rustic bridge was built

to be sympathetic to the style of the one in the story. The bridge connects the original Sleepy Hollow Cemetery with a newer section that was added around 1890. The bed of the bridge was purposely crafted from rough-hewn boards. Whether by accident or design, automobile tires that bounce along the boards mimic the sound of thundering hooves.

Henry Villard
April 10, 1835–November 12, 1900
41° 05′ 54.10″ N 73° 51′ 32.13″ W

Henry Villard (born Ferdinand Heinrich Gustav Hilgard) grew up in a well-to-do family in Bavaria. He was a rebellious child, which his father tried to curb by sending him to military school. Then in 1853 and without his parents' knowledge, he immigrated to the United States. To conceal his identity, he changed his name to Villard. In the next few years, he took a series of jobs at newspapers as he slowly made his way west. He got as far as Colorado and then took a job with a couple of New York papers following Abraham Lincoln's campaign and eventual election. After the Civil War, he took a series of correspondent jobs in Europe. Because he was fluent in German and English, he was hired as a negotiator of German interests in American railroad securities.

He acquired some German clients and traveled back to the United States. He went to Portland, Oregon, in 1874 and, impressed with the natural wealth and transportation opportunities, he convinced his clients to invest in building a railroad. That railroad (with Henry Villard as president) eventually became the Northern Pacific Railway. Like many financiers, his interests changed and varied. He acquired the *New York Evening Post* and *The Nation* newspapers in 1881. He helped inventor Thomas Edison merge his companies into the Edison General Electric Company, which became General Electric.

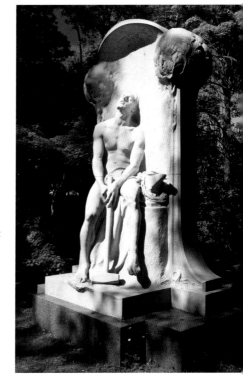

In later life, Villard became involved in philanthropic interests, giving large amounts of money to the University of Oregon, Harvard, Columbia, the Metropolitan Museum of Art, and the American Museum of Natural History.

Villard's monument was executed by Vienna-born sculptor Karl Bittner in 1904. Although trained in classical styles, Bittner began to drift toward more modern angular forms. The Villard monument was sculpted in 1904, and

it exhibits the beginnings of forms that, decades later, would evolve into Art Deco and Moderne. The monument depicts a man with a sledgehammer (perhaps a reference to Villard's position as president of the Northern Pacific Railway), looking toward the stars.

Darling Leo
Died August, 1892
41° 05′ 50.78″ N 73° 51′ 28.74″ W

Sleepy Hollow is a human cemetery. Despite the fact that every year dozens of animals die of natural causes, are eaten by others, or are pancaked on the roadways, the intentional burial of a family pet within the grounds is strictly forbidden. It's the law. But it wasn't always the law. Or, well, maybe the law wasn't rigorously enforced.

In August 1892, Leo, a cocker spaniel owned by one Jessie Gillender, expired. Jessie was the daughter of wealthy tobacco merchant Arthur Gillender, who apparently gave her enough disposable income to provide a dignified burial for Leo. After Leo's demise, Jessie journeyed to a number of undertakers to purchase a suitable coffin for a cocker spaniel. It took a bit of sleuthing, but she was finally able to get coffin-maker

Thomas Kane to construct a spaniel-sized one for $30, complete with a silver plate on top that bore the words "Our Darling Leo." Next, she purchased a plot for $37 on the banks of the Pocantico River at Sleepy Hollow, and Leo was duly buried. Rest in peace by the rolling Pocantico, darling Leo. Well . . . not right away.

Jessie Gillender just didn't want to let go and move on. She visited Leo's grave almost daily, but her tears alone weren't enough to assuage her grief. More tears were needed, so she hired neighborhood kids to mourn with her at Leo's grave, paying them from 50 cents to $1 each, depending on the quality and quantity of the tears shed. Rest in peace, darling Leo, while your mourners rain tears on your grave. Well . . . not just yet.

According to an indictment that was brought before the Grand Jury in White Plains in December 1892, John O'Keefe and John Tracy

(O'Keefe's partner in crime), both of whom resided in Tarrytown, stole into Sleepy Hollow one night that fall and disinterred poor Leo. It seems that O'Keefe, who had his own plot at Sleepy Hollow not far from Leo's, objected to the canine being buried in a cemetery reserved for *Homo sapiens*. After the nefarious pair dug up Leo and attempted to remove him from the cemetery, O'Keefe tripped and fell and broke his leg. Apparently Leo's coffin fell along with O'Keefe, and Leo's eternal home tumbled along the banks of the river. The next day, a much-disturbed Leo, still in his coffin, was found near a bridge. After the coffin was discovered and retrieved, Jessie Gillender repackaged her darling Leo, but this time in a virtually impenetrable masonry vault. Four small granite stones mark his grave by the side of one of Sleepy Hollow's roads. Rest in peace, darling Leo.

Rockefeller Family Cemetery
700 Block of North Broadway
41 6'7.96"N 73 51'38.61"W

Directly abutting Sleepy Hollow is the very private Rockefeller Family Cemetery. An imposing but handsome gate bars entrance to the public, and no graves can be seen from the gate. The cemetery contains a number of members of the powerful family, including Abby Greene Aldrich Rockefeller (1874–1948), who was married to John D. Rockefeller Jr. and mother of Abby, John D. III, Nelson, Laurance, Winthrop, and David Rockefeller; John D. Rockefeller Jr. (1874–1960), the only son of John D. Rockefeller; John D. Rockefeller III (1906–1978); and Nelson Rockefeller (1908–1979), former vice president of the United States from 1974 to 1977. There is also a simple marker memorializing Michael Clark Rockefeller (1938–1961), who was lost at sea off New Guinea and was presumed to have drowned or been attacked by a shark or crocodile. Since his body was never found, there has been much rumor and speculation that he was murdered, held captive, or eaten by cannibals. The patriarch of the family, John Davison Rockefeller (1839–1937), is buried in Lake View Cemetery in Cleveland, Ohio.

Rockefeller Family Cemetery Gate.
Photo by Jim Logan.

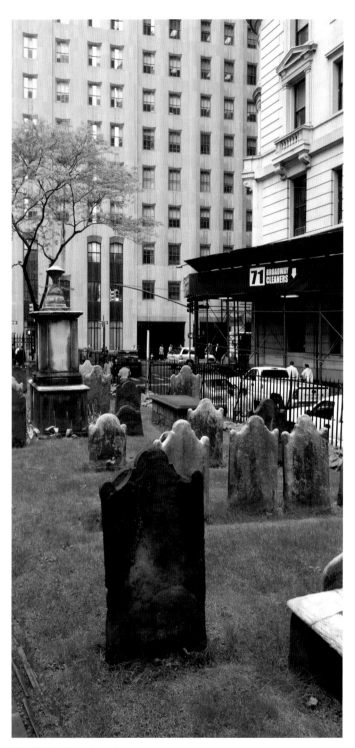

The Trinity Churchyard

MANHATTAN RESTING PLACES

O ne doesn't usually associate Manhattan with cemeteries. However, at one time there were dozens of burial grounds peppering the landscape. In 1823, a law was enacted that forbade cemeteries in lower Manhattan; then in 1886, a similar law drew the line south of 86th Street. As real estate became pricier, cemeteries disinterred the dead one by one and moved them to the outlying boroughs. What remains today are a few postage-stamp-sized graveyards that are oases of green nestled in the shadowy valleys cast by Gotham's looming cold steel and concrete skyscrapers.

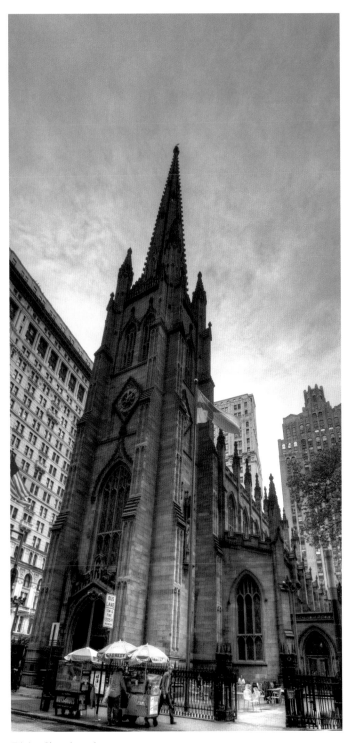

Trinity Churchyard

The Holy Trinitys

Three of the cemeteries are administered by the Trinity Church of Manhattan. They are the Holy Trinitys.

TRINITY CHURCHYARD

74 Trinity Place
New York, New York 10006
40° 42' 28.21" N 7°4 0' 42.49" W

The most well known of the three Trinitys is at 74 Trinity Place, on the corner of Wall Street and Broadway. It is often referred to as Trinity Churchyard. It has a significant array of death's head gravestones, many of which date to the eighteenth century. The most notable burials in the cemetery are Alexander Hamilton and Robert Fulton. The cemetery was established in 1697; however, the current church was constructed in 1846. It was the third church on the site; two previous churches were constructed in 1698 and 1790. The churchyard is a favorite lunch location for harried Wall Street brokers and other locals. Even before the third Trinity Church was constructed, the churchyard cemetery was essentially full and the parish began to look for burial property elsewhere in Manhattan. A sufficient parcel of land was found at 153rd Street and Broadway.

Alexander Hamilton
January 11, 1755/1757–July 12, 1804

Alexander Hamilton is one of the most interesting figures in the early history of the United States. He was one of America's Founding Fathers, the first Secretary of the Treasury, primary author of the Federalist Papers (the primary source for interpretation of the United States Constitution), and an all-around political mover and shaker. Hamilton's portrait graces the $10 bill and has appeared on a number of stamps. Alas, he is probably best remembered for his demise. In 1804, a feud developed between Hamilton and Vice President Aaron Burr over letters Hamilton wrote

opposing Burr's candidacy for governor of New York (Burr lost the race to Hamilton's friend Morgan Lewis). Insults and venomous letters flew back and forth until July 1804, when Burr challenged Hamilton to a duel. The two met in Weehawken, New Jersey, on July 11, 1804, and Burr's aim was better. Mortally wounded, Hamilton was taken back to New York where he died the following afternoon.

Robert Fulton
November 14, 1765–
February 24, 1815

Robert Fulton was an inventor who is widely credited with inventing the first commercially practical steamboat. On August 17, 1807, "Mr. Fulton's Folly," as the *Clermont* was deemed by naysayers, steamed up the Hudson River to Albany. The *Clermont* huffed and puffed along at five miles per hour, making the trip in 32 hours. Four years previous in 1800, Fulton was commissioned by Napoleon Bonaparte to build a practical submarine.

There are also others of note at Trinity Churchyard:

In the North Churchyard are William Bradford (1660–1752), who printed the first newspaper in the United States; Francis Lewis (1713–1803), the only signer of the Declaration of Independence who is buried in Manhattan; Caroline Webster Astor (1830–1908), whose cenotaph in Trinity Cemetery is a 39-foot-high monument; and Albert Gallatin (1761–1849), a financier and diplomat.

In the South Churchyard are James Lawrence (1781–1813), who is credited with the quote "Don't give up the ship" in the War of 1812, and John Watts (1749–1836), jurist and first judge of Westchester County.

John Watts

TRINITY CEMETERY AND MAUSOLEUM

550 West 155th Street
New York, New York 10032
40° 49'5 5.40" N 73° 56' 40.43" W (West 155th Street, east entrance)
40° 49' 56.17" N 73° 56' 53.75" W (West 153rd Street, west entrance)

In 1842, Trinity Churchyard and Mausoleum was established on 24 acres
of land that was carved out of John James Audubon's estate. The Battle
of Fort Washington was fought on the site during the Revolutionary
War. Nowadays, the cemetery seems like two cemeteries since it is
bisected by busy Broadway; a number of graves had to be relocated when

Trinity Cemetery and Mausoleum, East Entrance

Broadway was pushed through. The portion of the cemetery on the east side of Broadway has a recently constructed community mausoleum, which makes it the only active cemetery in Manhattan where people can be buried. The most notable burial in the cemetery is John James Audubon, who is buried in the section west of Broadway. A number of members of the John Jacob Astor family are also buried there.

John James Audubon
April 26, 1785–January 27, 1851
 40° 49′ 55.16″ N 73° 56′ 40.78″ W

The most prominent monument at Trinity Cemetery and Mausoleum is a towering Celtic cross memorializing John James Audubon, and he deserves the prime location. After all, the land that comprises the cemetery was part of his vast estate. Audubon was born in Haiti, the illegitimate son of French Lieutenant Jean Audubon and his mistress. Following the death of his mistress and political unrest in Haiti, Jean Audubon moved his family to France in 1788, where the boy was renamed Jean-Jacques Fougère Audubon. At age 18, Jean-Jacques Fougère Audubon moved to the United States, anglicized his name to

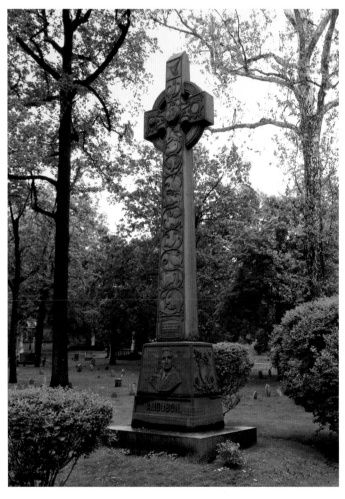

John James Audubon, and took up residence on land his father owned near Valley Forge, Pennsylvania. Over the years, he studied birds and wildlife, taxidermy, and Native American ways.

His investments and business skills enabled him to do what he really loved, which was to find and paint all of the birds of North America and have a folio of his drawings published. The folio, *Birds of America*, which is regarded as the greatest picture book ever published, was released in sections from 1827 to 1838 as a "Double Elephant folio" (39 x 26-inch plates) and included 435 separate illustrations of over 700 North American bird species. There are 119 known copies of the folio in existence. A copy in excellent condition sold for $8,802,5000 in March 2000. The National Audubon Society, which was incorporated in 1905, was named in his honor. Its headquarters are in New York City.

Also at Trinity Cemetery and Mausoleum are the following:

Trinity Cemetery mausoleums, a line of vault-like mausoleums, marches up the hillside on the east section of Trinity Cemetery and Mausoleum. The cemetery was one of the first in Manhattan to have a substantial number of showy mausoleums tucked into the terrain.

Also on the east side are Eliza Bowen Jumel (1769–1871), who married 78-year-old Aaron Burr when she was 61; Clement Clarke Moore (1779–1863), who wrote the poem "A Visit from St. Nicholas" (also known as "The Night Before Christmas" or "'Twas the Night before Christmas"); and Jerry Orbach (1935–2004), an actor who is interred in the Riverside Mausoleum.

On the west side is John Jacob Astor (1763–1848), who began to amass his substantial fortune in the fur trade.

Trinity Cemetery Mausoleums

ST. PAUL'S CHAPEL

209 Broadway
New York, New York 10007
40° 42' 40.20" N 74° 0' 32.12" W

World Trade Center and
St. Paul's Churchyard

The third cemetery administered by Trinity Church is St. Paul's Chapel, located on Church Street between Fulton and Vesey Streets. Built in 1764, St. Paul's Chapel is the oldest existing church building in Manhattan. It is best known as being directly across the street from the east wing of the World Trade Center. When the World Trade Center collapsed after being attacked by terrorists on September 11, 2001, St. Paul's was amazingly unscathed. Remarkably, not a single window was broken or a gravestone damaged by the falling debris. In the weeks that followed, St. Paul's became a focal point for rescue activities, and its walls and fences were used for impromptu memorials.

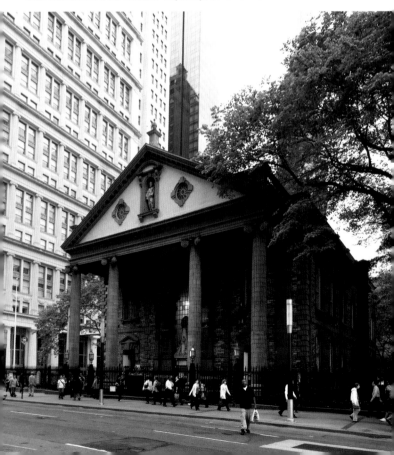

Bell of Hope

In 2002, The Lord Mayor of the City of London presented this bronze bell to New Yorkers on the first-year anniversary of the terrorist attacks on September 11, 2001. It was cast by the same foundry who did the Liberty Bell in Philadelphia and Big Ben in London. The bell represents the empathy and solidarity of the people of London with the people of New York.

Trinity Root

As a result of the terrorist attacks that leveled the World Trade Center on September 11, 2001, debris rained down all over lower Manhattan. A century-old sycamore tree that was in the churchyard of St. Paul's Chapel, directly across from the World Trade Center, was felled by the debris, but not before it had protected the chapel, the churchyard, and the people under the tree. When the sycamore finally fell down under the weight of the debris, it fell in such a way that none of the centuries-old gravestones or the chapel was harmed. As testament to the "connectedness and the strength" the tree represented, artist Steve Tobin crafted a sculpture representative of the tree's roots. The sculpture is in the Trinity Churchyard. The actual tree roots are on display in St. Paul's Chapel.

Among those spending eternity at St. Paul's are A-list British actor George Cooke (1756–1812), whose skull was allegedly used some decades later by Edwin Booth in his production of Hamlet, and newspaperman John Holt (1721–1784), whose *New York Journal*'s masthead bore Benjamin Franklin's illustration of a divided snake with the words "Unite or Die."

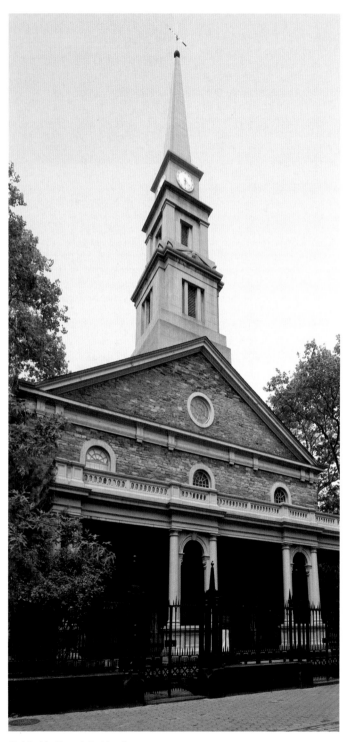

St. Mark's Church in-the-Bowery

St. Mark's Church in-the-Bowery

131 East 10th Street

New York, New York 10003

40° 43' 47.93" N 73° 59 '13.30" W

Although the churchyard adjoining St. Mark's doesn't look much like a cemetery, there are plenty of expired New Yorkers lurking below. St. Mark's Church and its churchyard were once part of the "Great Bouwerie" (Dutch plantation) that Peter Stuyvesant, who served as governor of New Amsterdam, purchased in 1651 from the Dutch West India Company. Upon his death in 1672, Stuyvesant's body was interred in a vault under the family chapel that he'd had built in 1660. Then in 1793, Stuyvesant's great-grandson Petrus Stuyvesant donated the chapel property to the Episcopal Church with the stipulation that a new chapel be erected. On April 25, 1795, the cornerstone of St. Mark's Church in-the-Bowery was laid. The churchyard has been essentially paved over, but the vaults remain below. Although traditional burials are no longer permitted in the churchyard, cremation burials are still permitted in the church vault in the west yard.

Peter (Pieter or Petrus) Stuyvesant
ca. 1612–August 1672

Peter Stuyvesant was an important figure in the early development and history of New York City. He was the last Dutch director-general of the colony of what was then known as New Netherland from 1647 to 1664. Stuyvesant's accomplishments as director-general included a great expansion for the settlement of New Amsterdam (later renamed New York) beyond the southernmost tip of Manhattan. Among the projects built by Stuyvesant's administration were the protective wall that was the northern

boundary of the settlement (Wall Street) and the Broad Canal that became Broad Street. Stuyvesant's bust-topped monument was given to St. Mark's in 1915 by Wilhelmina, Queen of the Netherlands. Its extremely lengthy epitaph details his life and accomplishments. The bust was designed by Dutch sculptor Toon Dupuis.

Daniel D. Tompkins
June 21, 1774–June 11, 1825

Daniel D. Tompkins was the fourth governor of New York, serving from 1807 until 1817, and the sixth vice president of the United States, serving under James Monroe from 1817 to 1825. Tompkins played an instrumental role in the War of 1812 by borrowing money and using his own money as collateral when the New York State legislature wouldn't approve the funds to help finance the war. It took years of litigation for him to be repaid. Reportedly, financial problems that resulted from the ongoing litigation took a toll on his health, and he slipped into

alcoholism and at times presided over the U.S. Senate when drunk. Nevertheless, he is well remembered in New York. A neighborhood on Staten Island named Tomkinsville is named after him, as is Tompkins Square Park in Manhattan, the town of Tompkins, New York, and the County of Tompkins.

Inspiration and *Aspiration*

Two sculptures of Native American men are displayed in the churchyard. *Inspiration* and *Aspiration* were carved by sculptor Solon Borglum, brother of sculptor Gutzon Borglum of Mt. Rushmore fame. The sculptures were acquired by Rector Norman William Guthrie in the 1920s.

St. Patrick's Cathedral

St. Patrick's Cathedral Crypts

460 Madison Avenue

New York, NY 10022

40° 45' 31.71" N 73° 58' 36.06" W

I n the United States, most people don't associate churches with burials. Certainly people were often buried in areas around old churches known as God's Acres, and funerals are often held in churches. But people aren't buried in churches. Or are they? In the older cathedrals in Europe, burial (or more properly, entombment) within churches was quite common up until the Reformation, when a series of edicts and a general slow-down in church construction put the brakes on burial within the church. Up until that time, it was quite common for church leaders as well as the well-to-do to be buried within the church's walls and floors. Even nowadays, deceased popes are buried in a crypt beneath St. Peters at The Vatican. Such is the case with St. Patrick's Cathedral.

The site at 50th Street and Fifth Avenue, where St. Patrick's is located, was purchased for $11,000 in 1810. A school and a monastery existed on the site; then in 1858, the construction of the cathedral began, designed by noted architect James Renwick. After a number of delays, St. Patrick's Cathedral was dedicated on May 25, 1879. St. Patrick's is the largest Gothic Revival–style Catholic cathedral in the United States. Over three million people visit the cathedral every year.

Beneath the former high altar (a major renovation in the 1930s and 1940s altered it) are the crypts. Although the crypts are not open to the public, on special occasions, such as offering prayers for a loved one, the church occasionally grants limited access. Among others, the crypts contain the eight deceased Archbishops of New York, six of them Cardinals. They are John Hughes (interred 1883), John McCloskey (interred 1885), Michael Corrigan (interred 1902), John Murphy Farley (interred 1918), Patrick Joseph Hayes (interred 1938), Francis Spellman (interred 1967), Terence Cooke (interred 1983), and John Joseph O'Connor (interred 2000).

Among the others buried in the crypt are Msgr. Michael J. Lavelle, rector of the cathedral in the 1930s; Joseph Flannelly, rector of the cathedral in the 1940s through the 1960s; and Pierre Toussaint (1766–1853, interred in 1990), ex-slave and Haitian-American philanthropist who helped raise money for the construction of the Old St. Patrick's Cathedral in Lower Manhattan, which was founded in 1809.

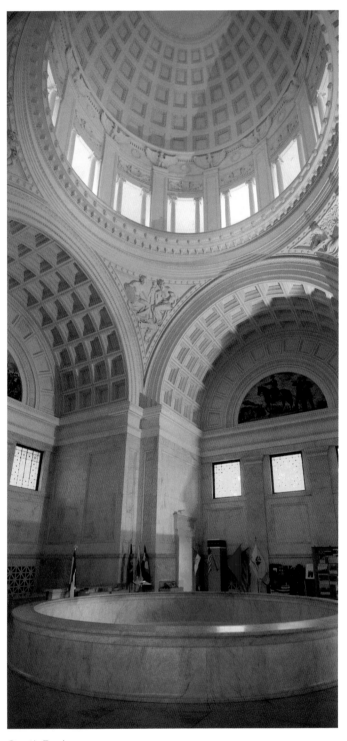

Grant's Tomb

Grant's Tomb

Riverside Drive at West 122 Street
New York NY 10024

Ulysses S. Grant
April 27, 1822–July 23, 1885

Julia Grant
January 26, 1826–December 14, 1902
40° 48′ 48.12″ N 73° 57′ 47.29″ W

Grant's Tomb, officially called the General Grant National Memorial, is
a mausoleum dedicated to General Ulysses S. Grant. How the largest
mausoleum in North America got constructed for an esteemed Civil
War general but a mediocre president (he was America's 18th) is an
interesting tale. Ulysses S. Grant, born Hiram Ulysses Grant, in Point
Pleasant, Ohio, entered the United States Military Academy at West
Point when he was 17. Although he graduated in the middle of his class,
he was noted as a fearless and expert horseman. He excelled at a number
of military positions, and after leaving the military at age 32, didn't find
civilian life to his liking. Grant reenlisted at the outbreak of the Civil War
and was quickly advanced through the ranks because of his leadership

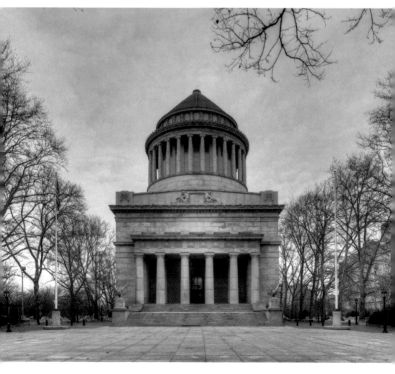

qualities. He amassed a number of victories, and in 1864, he became Commanding General of the United States Army. Most importantly Confederate General Robert E. Lee surrendered to Grant in April 1865 at Appomattox, which ended the Civil War. Ulysses S. Grant became the Union's hero.

After the Civil War, Grant retained control of the Union Army. The Army was instrumental in implementing plans in the South to allow blacks to vote and to begin Reconstruction. Grant was elected president in 1868 and reelected in 1872, largely based on his reputation as a general and not as his skills as a politician. Grant had the support of the Grand Army of the Republic (GAR), which essentially assured him of the presidency. Grant's time in office was marred by scandals and an economic downturn (The Panic of 1873). But when he died in 1885, the American collective memory of General Grant still ran high. Grant's Tomb is called the General Grant National Memorial, not the President Grant National Memorial.

Near the end of his life, Grant was asked where he would like to be buried. He mentioned Galena, Illinois, where he had spent his younger years; St. Louis, Missouri, where he lived before the Civil War; and New York City, where he lived in his later years. One firm request was that his wife be buried beside him. The mayor of New York, William R. Grace, offered to donate the land, and the family ultimately chose a promontory in the newly developed Riverside Park. When Grant died, his funeral in New York became one of the largest at the time. Over 60,000 people marched in the five-hour-long parade while over one million watched. After the funeral, Grant's remains were interred in a hastily built barrel-shaped vault in Riverside Park. Within days of the funeral the Grant Monument Association (GMA), which had actually been formed before his death, went into high gear in its quest to build a suitable monument. The GMA held competitions in 1888 and 1890 to find a suitable architect. Ultimately architect John H. Duncan was chosen. Duncan's design was based loosely on the tomb of Mausolus in Halicarnassus (and where we get the word "mausoleum"), one of the Seven Wonders of the Ancient World. Then there was the challenge of raising $600,000 to finance the construction of the monument. An estimated 90,000 people donated to the construction fund. At the time, it was the most money ever raised for a public monument. Ground was broken in April 1891; after six years, 8,000 tons of granite, Massachusetts marble for the floors, and fine Italian marble for the railings and trim work, the tomb was dedicated in April 1897. Although the final edifice paled in comparison to the initial design (Duncan's original design included monumental staircases that led down to a dock on the Hudson River, and the mausoleum itself was scaled down), it was one of the most visited buildings in the United States by the turn of the century.

Additions and improvements were made throughout the years, including the installation of busts and murals, and the relandscaping of the area surrounding the monument. Alas, in the last half of the twentieth century, Grant's Tomb entered a period of decline. It became a haven for graffiti artists, drug addicts, and the homeless. In 1972, the National Park Service spent a considerable sum of money for mosaic benches that have been widely criticized for not being sympathetic to the architectural design of the tomb. Things got so bad that at one point Grant's descendents and the Illinois state legislature threatened to move Ulysses and Julia Grant's remains to Illinois. However, thanks to some dogged determination by a small group of individuals, a major

cleanup began in the late 1990s. After the work was completed, the tomb was rededicated on April 27, 1997, the 100th anniversary of its original dedication. Much more remains to be done, but compared to the decaying edifice of a few decades ago, it is a glittering gem today. High above the entrance to the tomb is a plaque flanked by two mirror-image statues. The plaque contains the words from Grant's speech when he accepted the Republican nomination for president in 1868: "Let Us Have Peace." The General Grant National Memorial is open most days from 9 a.m. to 5 p.m., except for major holidays.

The domed interior of Grant's Tomb includes a main lobby surrounded by mosaic panels and educational displays. At the center of the tomb is an oculus, which overlooks the crypt where Ulysses and Julia Grant repose.

The twin red granite sarcophagi of Ulysses and Julia Dent Grant are surrounded by busts of Civil War generals William T. Sherman, George H. Thomas, James B. McPherson, Phillip H. Sheridan, and Edward Ord.

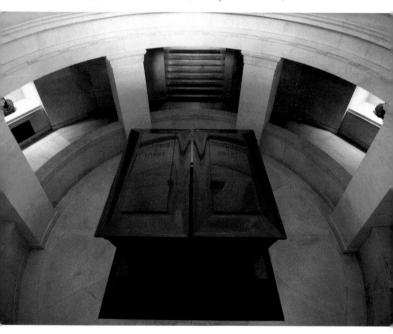

NOTABLE NEIGHBORHOOD SITES

There are a few other pocket cemeteries scattered throughout Manhattan. St. Bartholomew's Episcopal Church is at the corner of East 50th Street and Park Avenue, where actress Lillian Gish resides in a vault; The New York Marble Cemetery is just east of Greenwich Village at 41 1/2 Second Avenue; The New York City Marble Cemetery is at 52–74 East 2nd Street; and the First Shearith Israel Graveyard, also known as the Chatham Square Cemetery, is at 55–57 St. James Place in Lower Manhattan. Access to the cemeteries is limited. Of special note is the African Burial Ground inside the Ted Weiss Federal Building at 290 Broadway. The burial ground contains the remains of more than 400 free and enslaved men, women, and children, and has a visitor center and a website: http://www.africanburialground.gov/ABG_memorial.htm.

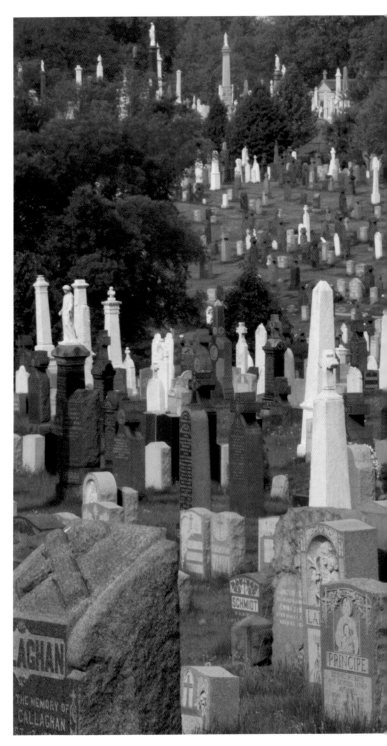

Calvary Cemetery

ETERNAL EXCURSIONS

T he greater New York City area has hundreds of cemeteries, from tiny churchyards to vast memorial parks. Refer to the cemetery gazetteer in this book, select a few, and take off on a cemetery adventure. There are more than a few spirits of notable New Yorkers lurking there as well as magnificent mausoleums and evocative statuary. The cemetery symbolism section of this book will help you identify those mysterious symbols carved in the stones, and the section on secret societies will help you decode the names and history of the clubs, organizations, and societies that were a large part of peoples' social networks.

What follows is a small selection of New York cemeteries to get you started on your eternal excursions. Each has its own unique character. All are a pleasant respite from the crowded and noisy urban environment.

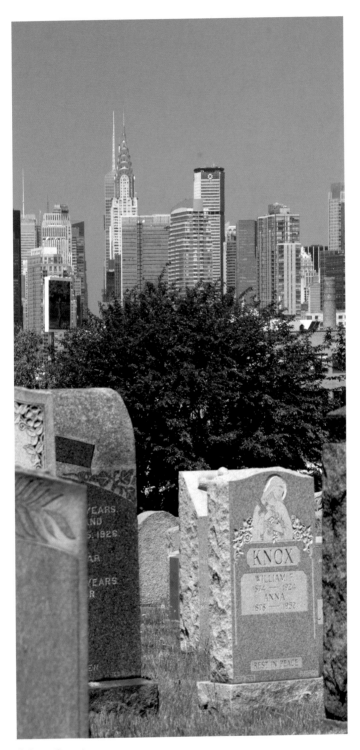

Calvary Cemetery

Calvary Cemetery

Mailing address:

49–02 Laurel Hill Boulevard

Woodside, Queens, NY 11377

(718) 786-8000

Maps posted throughout cemetery

40° 44′ 9.75″ N 73° 55′ 56.77″ W

(1st Calvary Entrance, Greenpoint Avenue)

More New Yorkers and New York visitors are familiar with Calvary Cemetery than any other cemetery. Why? Because thousands and thousands of people view it every day while motoring along the Long Island Expressway and the Brooklyn-Queens Expressway in Queens. Certainly Calvary is the best-sited cemetery in the New York City area for spectacular vistas of Manhattan.

Prior to the founding of Calvary in 1848, New York City Catholics were buried in special plots carved out of churchyards and small Catholic cemeteries. In 1829, land was purchased for a formal Catholic cemetery around what is now 50th Street in Manhattan, but that land was deemed to be too far out of town. Previously, land was developed for a cemetery between 11th and 12th Streets, from Avenue A to First Avenue. That cemetery operated until 1851 as the 11th Street Cemetery. (Approximately 5,000 bodies from the 11th Street Cemetery were disinterred in 1909 and transferred to Calvary.) As the population grew, the church trustees started looking for a larger tract of land, and in 1845, they purchased the 115-acre Alsop farm in Newton Township in Queens. The first interment in what is now called Calvary Cemetery was on August 4, 1848. Since the original Alsop farm (the Alsops were Protestants) had a small family graveyard, there are also a few non-Catholics buried there as well. There are also a few Protestants buried in what is now Section 4 in 1st Calvary. Over the years, another 200 acres has been added, and Calvary is now divided into four cemeteries: 1st Calvary/St. Callixtus (known as Old Calvary); 2nd Calvary/St Agnes; 3rd Calvary/St. Sebastian; and 4th Calvary/St. Domitilla—the four sections are collectively known as New Calvary. The cemetery sections are named after the names of the catacombs in Rome. In all, over 1.7 million Catholics call Calvary their permanent home. The most varied architecture and spectacular views are from 1st Calvary.

St. Callixtus Chapel
40° 43′ 55.62″ N 73° 55′ 55.62″ W

St. Callixtus Chapel was built in 1908 in a Byzantine Revival style. The chapel, which is located in a wooded area in 1st Calvary, is named after

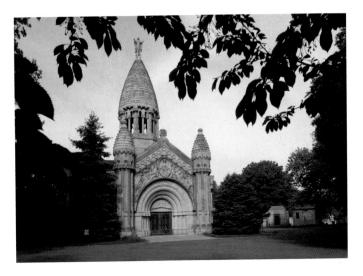

the St. Callixtus Catacombs on the Appian Way in Rome (at one time, these catacombs contained the remains of 16 popes and 15 martyrs).

Alfred E. Smith
December 30, 1873–October 4, 1944
40° 43' 55.00" N 73° 55' 54.30" W

Alfred Emanuel Smith Jr. grew up on Oliver Street in the Lower East Side. His father died when he was 13, and young Al dropped out of school and began to work to help support the family. Despite becoming a prominent politician, governor of New York, and presidential candidate, he never attended high school. He claimed he learned everything he needed to know about people by observing and interacting with them at his $12-a-week job at the Fulton Street Fish Market.

With support from the Tammany Hall political machine, he rose from his working-class beginnings, to Commissioner of Jurors, to election in the New York State Assembly, to the president of the Board of Aldermen of the City of New York. Alfred Smith was selected as the Democratic candidate for governor of the State of New York in 1919, won the election, and served for two years before being ousted by Republican Nathan L. Miller. However, Smith ran against Miller in 1923 and regained the governorship. Smith served for six more years and was succeeded by fellow Democrat and future U.S. president Franklin Roosevelt.

In 1928, Smith was selected by his party to be the candidate for president of the United States. He lost the election in a landslide victory by Herbert Hoover, who was still riding a wave of prosperity that would

implode after the Wall Street Crash in 1929. One political observer says that Smith lost because of the "Three P's": Prohibition (Smith supported relaxation of the Prohibition laws), Prejudice (Smith was Catholic), and Prosperity (Hoover was associated with a booming economy). After losing the election, Smith became president of Empire State, Inc., the company that built and maintained the Empire State Building. Smith oversaw the construction of the building that commenced on St. Patrick's Day in 1930. Thirteen months later, his grandchildren cut the ribbon to announce the building's opening on May Day 1931. After his presidential defeat, Smith continued to be involved in politics, and because of his disagreement with Franklin Roosevelt, he switched parties to support Republican candidates for U.S. president in 1936 and 1940. Alfred Smith spent his last years serving in a number of honorary positions. He died of a heart attack five months after his wife, Catherine Ann Dunn, succumbed to cancer.

Lupo the Wolf
March 19, 1877–January 13, 1947
40° 44' 24.23" N 73° 54' 31.90" W

The Mafia doesn't bestow titles like "the Wolf" on pussycats. Ignatius Lupo (he often used his mother's maiden name Saietta and sometimes changed his first name to Ignazio to avoid detection) was born in Corleone, Sicily. At age 12, he killed a man in Sicily and fled to the United States via England and Canada. Apparently his cold-blooded reputation preceded him, and he was greeted with open arms when he arrived in New York, quickly rising through the ranks of the Black Hand, an Italian extortion racket. By age 20, he was a Sicilian Mafia boss. Lupo eventually merged his organization with the Morello and Terranova families, which became known simply as the Morello crime family. Saietta earned his nickname "Lupo the Wolf" for his particularly ruthless behavior. Most Mafia members and families started with bribery to get

what they wanted and then resorted to violence if bribery didn't have the desired effect. Lupo the Wolf bypassed the social niceties of bribery and went to what he knew best. Although accurate body counts are impossible to plumb, experts peg the number of murders committed by Lupo the Wolf at around 60. And those murders were particularly violent. Reportedly, his favorite method was strangulation followed by burning them in East Harlem.

Lupo the Wolf went to prison on two occasions but was never convicted of murder. He first served 10 years for running a counterfeiting ring. Following his first release, he was assigned to a small Italian lottery scheme. After serving a second prison term for running a protection racket, he quietly faded away, dying at the relatively advanced age of 69.

Cypress Hills Abbey

Cypress Hills Cemetery

833 Jamaica Avenue

Brooklyn, New York 11208

(718) 277-2900

www.cypresshillscemetery.org

Map on website

40° 41' 21.09" N 73° 52' 28.58" W

The area where Cypress Hills Cemetery is located is known as the Cypress Hills complex and has 17 separate cemeteries. Cypress Hills is the most accessible of all the cemeteries in the area. It was founded on November 21, 1848, as a nonsectarian cemetery modeled on the rural cemetery template. It took three years of landscaping and road building before the cemetery was officially opened in 1851. In 1852, a law was enacted forbidding burials in Manhattan, and in the following years, approximately 35,000 bodies were disinterred and transferred to Cypress Hills. Cypress Hills continues to be an active cemetery and still has areas of undeveloped land.

Jackie Robinson
January 31, 1919–October 24, 1972
40° 41' 46.22" N 73° 52' 20.98" W

Jack Roosevelt "Jackie" Robinson was born into a family of sharecroppers in Cairo, Georgia. Soon after Jackie was born, his father left and his mother took her young family to Pasadena, California. Young Jackie briefly joined a gang, but he was encouraged to pursue athletics by his brothers, Mack and Frank. He excelled in almost everything he did.

While at John Muir High School in 1936, he played on the Pomona, California, All-Star team, which included future Baseball Hall of Fame Players Ted Williams and Bob Lemmon. Robinson continued his athletic achievements when he attended Pasadena Junior College, then transferred to UCLA where he became the school's first athlete to win letters in four varsity sports (track, football, baseball, and basketball). He played professional football briefly in Hawaii after dropping out of UCLA, then enlisted in the Army after the December 7, 1941, attack on Pearl Harbor. Despite rampant racism, he was able to achieve the rank of 2nd Lieutenant.

After being discharged from the Army, Robinson played briefly for the Kansas City Monarchs in the Negro Baseball Leagues, but he set his sights higher. After a series of fits and starts, Robinson was signed to the Brooklyn Dodgers organization. He played in the minor leagues for one season; then six days before the 1947 season was to start, he got the call from the Dodgers. On April 15, 1947, Jackie Robinson became the first black baseball player to play in the Major Leagues since the 1880s. More than 26,600 people showed up, including

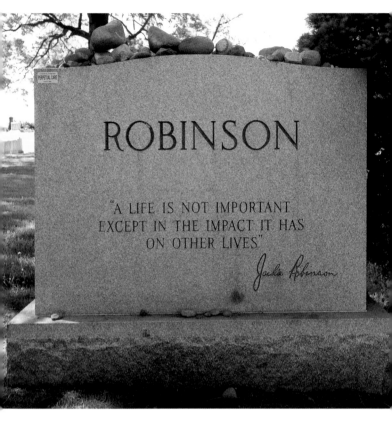

upwards of 14,000 blacks. Before Robinson was actually hired, Dodgers general manager Branch Rickey had a private conversation with him and detailed the sort of racist abuse Robinson would encounter, asking him if he would be able "to turn the other cheek." Robinson begrudgingly agreed, and the abuse began as soon as he played his first game. Ironically, some of the worst abuse came from other teams and even some from his own teammates. But Robinson endured and relations gradually got better, culminating in Robinson being awarded the 1947 Rookie of the Year Award. In 1949, he was selected as the National League Most Valuable Player. In 1962, he was inducted into the Baseball Hall of Fame. In 1997, his uniform number (#42) was retired by Major League Baseball for all teams.

Robinson's achievements did not stop on the playing field. When he retired after the 1956 season, he became actively involved in the NAACP, where he served on the board until 1967. He became vice-president of Chock full o'Nuts, becoming the first black person to serve as vice president of a large American corporation. He also became an analyst for ABC Television's Major League Baseball Game of the Week. From the early 1960s until his death, he was very active in politics. Unfortunately, Robinson suffered from diabetes and heart disease. Those ailments, combined with the stresses in his life, eventually led to his death from a heart attack at age 53. His gravestone at Cypress Hills is almost always adorned with an assortment of baseballs, bats, gloves, and other memorabilia. Interestingly, the cemetery is bisected by the Jackie Robinson Parkway.

Mae West

August 17, 1893–November 22, 1980

40° 41′ 48.99″ N 73° 52′ 40.65″ W (mausoleum entrance)

Mary Jane West was born in Bushwick, New York, to a prizefighter and former corset model. She began her entertainment career when she was five years old at a church social, and by age seven, she was appearing in amateur shows. At age 14, she started performing professionally in vaudeville. Early on she developed a sexy, bawdy persona, and by most accounts, her persona mirrored her real life. She got her first break as the character Mayme, where she danced the shimmy in the Shubert Brothers revue *Sometime*. She continued to play provocative roles, culminating in a 1926 play titled *Sex*, which she wrote and starred in. Although the critics panned it, the public loved it. Unfortunately, New York City officials took exception to the

material and raided the theater company, and West was indicted on an obscenity charge, spending eight days in jail. The publicity only increased her star power.

Despite her positively ancient age of 38, she was signed to a movie contract in 1932 as a sex symbol. She was an immediate hit, starting with a small role in *Night After Night* with George Raft in 1932, then starring in *She Done Him Wrong* in 1933, and also *I'm No Angel* in the same year. The success of those films likely saved Paramount from bankruptcy. Astoundingly, by 1935, Mae West was the second highest-paid person in the United States (William Randolph Hearst was number one). West may be best remembered for her role of Flower Belle Lee opposite W. C. Fields in the 1940 film *My Little Chickadee*. It was a tense pairing since West didn't drink and Fields was well down the road to alcoholism.

West continued to parlay her comic sex appeal for the rest of her life, including roles in the sexual farces *Myra Breckenridge* in 1970 and *Sextette* in 1978. She is forever immortalized in the slang term for chesty life preservers, "Mae West's," and her oft-repeated ribald quotations. Among the most memorable are "When I'm good, I'm very good. When I'm bad, I'm better"; "Is that a gun in your pocket, or are you just glad to see me?"; "It's not the men in my life, it's the life in my men"; and her oft-misquoted line "Why don't you come up and see me some time?" What she really said was "Come up sometime, and see me."

Gentleman Jim Corbett
September 1, 1866–February 18, 1933
40° 41' 48.99" N 73° 52' 40.65" W (mausoleum entrance)

James John Corbett was born in San Francisco to Irish emigrant parents. While still a teenager, he got a job as a bank clerk and later worked in an insurance company. He also sparred in amateur boxing matches. Corbett joined the Olympic Athletic Club in San Francisco, first to practice his baseball skills and then as a boxer. Jim Corbett was dubbed "Gentleman Jim" by the media, partly because he was the first boxer to fully develop the craft of "scientific boxing," which was based on the Marquis of Queensbury rules that took boxing from what was basically brawling to a legitimate sport.

By age 18, he was the club's heavyweight champion. When he was 19, he eloped with Olive Lake to Salt Lake City, Utah, and to earn money, he boxed the heavyweight champion of Utah. Corbett won $460, but he boxed under an assumed name so his parents wouldn't know that he boxed professionally. Three years later in 1889, he made his official professional boxing debut in San Francisco and defeated Joe Choynski. He followed that bout with more victories in the Pacific Northwest, New Orleans, and New York. Upon returning to San Francisco, he took a job at the Olympic Athletic Club but set his sights on the World Championship. He also took some bit parts as an actor, a skill that he would further develop in his later years.

The first step of his quest to be World Heavyweight Champion was to box the Australian champion Peter "Black Prince" Jackson. Reigning champion John L. Sullivan had refused to box Jackson because Jackson was black. The Corbett/Jackson match was staged in San Francisco on May 21, 1891. After 61 rounds, the fight was called a draw. Then on September 7, 1891, at the Olympic Club in New Orleans, Gentleman Jim Corbett got his shot at reigning champion

John L. Sullivan. Sullivan had 25 pounds on Corbett, but Corbett dispatched the champion in the 21st round by knocking him out.

The next few years were a mixture of triumph and tragedy for Gentleman Jim. In 1892, he starred in a play titled *Gentleman Jack*. In 1894, he successfully defended his title in a bout with Charley Mitchell. In 1896, he divorced his wife Olive and married Vera Stanwood (who is in the crypt adjoining his). In 1897, he starred in what is regarded as the first feature-length film (it lasted over 90 minutes), his defense of his Heavyweight Championship title against Bob Fitzsimmons, which Corbett lost. In 1898, Corbett's father, Patrick, shot and killed his wife in the couple's San Francisco home and then turned the gun on himself. After James Jefferies beat Bob Fitzsimmons, Corbett challenged Jefferies so as to regain his title but Corbett lost to Jefferies twice (in 1900 and 1903) and did not accomplish his goal. However, Gentleman Jim never lost his appeal with the public and went on to write his autobiography, to perform in theater, to act in low budget films, and to produce a series of instructional boxing films. He died of liver cancer while living in his home in the Bayside neighborhood of Queens.

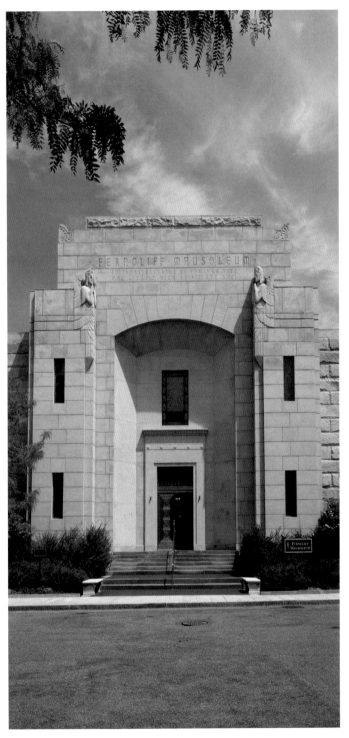

Ferncliff Mausoleum

Ferncliff Cemetery

280–284 Secor Road

Hartsdale, New York 10530

(914) 693-4700

www.ferncliffcemetery.com

Grave locator kiosks in mausoleum

Maps in office

41° 1' 36.06" N 73° 49 '47.33" W (main entrance)

Established in 1902, Ferncliff Cemetery was one of the first cemeteries in the New York area to embrace the memorial park landscape design ethos. The genesis of the memorial park design, which advocates vast lawns and flat markers, can be traced to Forest Lawn Memorial Park Cemetery in Los Angeles. Although the memorial park design is not one that cemetery lovers find particularly appealing, there is a certain white-bread-democracy about it. Where Ferncliff excels is in its community mausoleums. The Ferncliff Mausoleum, constructed in 1928 and expanded over the years, holds a number of notable residents. In 1959, Ferncliff added a second community mausoleum named the Shrine of Memories. A third community mausoleum, the Rosewood Mausoleum, was constructed in 1998. The mausoleums, and the Ferncliff Mausoleum in particular, have an impressive array of stained glass windows and sculpture, and you're sure to stumble across a celebrity or two. All of the community mausoleums have substantial areas for cremation urns, which assures that the cemetery will remain active for years to come. The Ferncliff Cemetery website has a page devoted to celebrities and notables that details the location of their resting places.

Béla Bartók
March 25, 1881–September 26, 1945
41° 1 '34.62" N 73° 50' 20.53" W

When most people are interred in a cemetery, their stay is usually eternal. Such was not the case with Béla Viktor János Bartók. He was born in what is now Sânnicolau Mare, Romania. He was a sickly child but displayed a talent for music. In his late teens, he studied music at the Royal Academy of Music in Budapest, Hungary, where he wrote his first major orchestral work. While at the academy, he met Zoltán Kodály, who became a lifelong friend and collaborator. They set out together to find ways of incorporating the music of the Magyar peasants into their compositions. Because of the complexity and innovation of his compositions, Bartók is widely regarded as one of the greatest composers of the twentieth century. He was one of the founders of ethnomusicology, which is the study of the social and cultural aspects of music making.

When war clouds were looming over Europe in the late 1930s,

Bartók reluctantly immigrated to the United States, where he was supported by a research fellowship from Columbia University in New York. When he died of leukemia, he was interred at Ferncliff Cemetery (reportedly only 10 people attended his funeral). After Hungary was wrested from Soviet control, Bartók's remains were reinterred at Farkasréti Cemetery in Budapest. His final interment was preceded by a state funeral in Budapest on July 7, 1988.

Madame Chiang Kai-Shek

February 12, 1898–October 23, 2003
Ferncliff Mausoleum, Unit 11, Alcove JJJ, Private Room 5, Crypt 3
41° 1' 38.44" N 73° 50' 5.99" W (mausoleum east entry)

Madame Chiang Kai-Shek was born May Ling Soong in the Kwangtung Province of China. She moved to the United States and received a degree in English literature in 1917 from Wellesley College in Massachusetts. In 1924, she married Chiang Kai-Shek (1887–1975), who served as president of the Republic of China in Taiwan from 1949 until his death. (Chiang Kai-Shek's forces were forced out of what is now known as Mainland China in 1949 by the communist forces of Mao Zedong.) Madame Chiang Kai-Shek took an active role in Chinese politics both before and after the communist takeover. She was an active artist, author, and goodwill ambassador for Taiwan. Beginning in the 1930s, she was from time to time referred to as the "Dragon Lady" because of her powerful position in the government. She appeared twice on the cover of *Time* magazine. Her husband is buried in Taiwan. There are plans to move both bodies back to the Chinese mainland when the communists lose their power.

Joan Crawford

March 23, 1905–May 10, 1977
Ferncliff Mausoleum, Unit 8, Alcove E, Crypt 42
41° 1' 40.08" N 73° 50' 9.21" W (mausoleum entrance)

Joan Crawford was born Lucille Fay LeSueur in San Antonio, Texas. Crawford's father, Hal LeSueur, abandoned the family a few months before Crawford was born. However, it would be some years before Crawford learned of the abandonment since her mother remarried while Crawford was very young. Crawford's new father ran a movie theater, and it was there that she fell in love with movies. Her first job in the entertainment industry was dancing in a chorus line in 1924. A couple years later, studio head Louis B. Mayer changed her name to Crawford, saying that LeSueur sounded like sewer. She hit her stride in the late 1920s playing Flapper roles and was then married in 1929 to Douglas Fairbanks Jr., the son of Douglas Fairbanks Sr. and Mary Pickford. Throughout the 1930s, she was box office gold. In 1937, *Life* magazine proclaimed her "First Queen of the Movies." But by the early 1940s, she was labeled "box office poison." However, she played a long-suffering mother in the Warner Bros. film noir *Mildred Pierce* in 1945, for which she earned the Academy Award for Best Actress. Crawford continued acting well into the 1960s, most notably in the 1962 film *Whatever Happened to Baby Jane* with Bette Davis, with whom she had a long-standing feud.

Crawford was married four times. Her last marriage was to Pepsi Cola president Al Steele. She shares her eternal home with him. After her death, Crawford's daughter Christina published a book titled *Mommie Dearest*, which detailed her childhood and portrayed Joan Crawford as an emotionally and physically abusive mother. The book was denounced by some and hailed by others. It was made into a movie of the same name starring Faye Dunaway in 1981.

Judy Garland

June 10, 1922–June 22, 1969
Ferncliff Mausoleum, Unit 9, Alcove HH, Crypt 31
41° 1' 40.08" N 73° 50' 9.21" W (mausoleum entrance)

The most visited grave at Ferncliff Cemetery is the crypt of Judy Garland. Born Frances Ethel Gumm in Grand Rapids, Minnesota, she was the youngest child of two vaudevillians, Francis Avent "Frank" Gumm and Ethel Marion Milne. Garland's first entrée into show business was at age two and a half, when she performed with her sisters as part of the Gumm Sisters. She changed her name to Judy Garland in the mid-1930s (there are a number of different stories on the name change). In her early teens, she was cast as the "girl next door," not as a beauty but as a plain Jane. Then her break came at age 16 when she was cast as Dorothy Gale in the 1939 film *The Wizard of Oz*. She also

sang the movie's signature song, which also became her signature song, "Somewhere Over the Rainbow."

Garland went on the make more movies in the 1940s. The most successful was the 1944 MGM film *Meet Me in St. Louis*. In 1945, she married Vincent Minelli (her second marriage). That union produced a daughter, Liza Minelli, who was born on March 12, 1946. Years of barbiturate and amphetamine use caught up with her, and in 1947, she suffered a nervous breakdown followed a few months later by a suicide attempt. She revived herself and went on to make numerous movies, television appearances, and stage shows. When she died at age 47, her *Wizard of Oz* co-star Ray Bolger (the Scarecrow) said, "She just plain wore out." In 1999, the American Film Institute named Garland number eight on their list of the Greatest Female Stars of All Time.

Moss Hart
October 24, 1904–December 20, 1961
Ferncliff Mausoleum, Unit 8, Alcove EE-FF, Column D, Niche 4
41° 1' 40.08" N 73° 50' 9.21" W (mausoleum entrance)

Kitty Carlisle Hart
September 3, 1910–April 17, 2007

Sharing a niche at Fernwood are husband and wife Moss Hart and Kitty Carlisle Hart. Moss Hart grew up in Manhattan. He was strongly influenced by his passionate but eccentric Aunt Kate, who steered him towards the entertainment industry. Hart tried acting but found his best success as a playwright and director. In 1930, Hart teamed up

with George S. Kaufman. Together they wrote screenplays for a string of hits, most notably the 1936 play *You Can't Take It With You*, which won the 1937 Pulitzer Prize for drama. Hart's biggest directing triumph was when he was the first director for *My Fair Lady* in 1956. He wrote a number of successful screenplays and is best known for writing the remake of *A Star is Born* (1956). He was married to Kitty Carlisle from 1946 until his death in 1961.

Kitty Carlisle Hart was born Catherine Conn in New Orleans, Louisiana. She was of German-Jewish heritage but made every effort to be accepted into "Gentile society." Her first step was to change her name. She was educated in Europe and studied acting in London. Although she had success acting in the 1930s, she drifted more towards the fine arts and became an active crusader and supporter. Still she continued to dabble in the performing arts, including roles in Woody Allen's *Radio Days* (1987) and *Catch Me If You Can* (2002). She is best known as a longtime panelist (becoming a household name) on the television shows *To Tell the Truth*, *What's My Line?* and others.

Jackie "Moms" Mabley
May 19, 1984–May 23, 1975
41° 1′ 38.30″ N 73° 49′ 54.58″ W

Loretta Mary Aiken (she claimed the name Jackie Mabley, which came from a boyfriend she said took so much from her that the least she could do was take his name) was born into a large family with 12 children in Brevard, North Carolina. After a number of personal misfortunes, she left North Carolina and began working in a traveling minstrel show out of Cleveland. She survived for decades by performing on the "chitlin' circuit," the African American equivalent to the "borscht belt." Then she finally hit it big in the 1960s in her role of "Moms" Mabley, a comedic wisecracking social commentator. Her signature persona was a disheveled toothless older woman in a frumpy housedress and rumpled hat. Because of her age and onstage persona, she was able to tackle sensitive topics such as racism and social injustice. She appeared on a number of television programs and in movies. She was also a successful recording artist with 20 comedy albums. Her rendering of the song "Abraham, Martin and John" reached #35 on the Billboard Chart in 1969 when she was 75, which made her the oldest person to have a U.S. Top 40 hit.

El-Hajj Malik El-Shabazz (Malcolm X)
May 19, 1925–February 21, 1965
41° 1' 42.66" N 73° 49' 38.52" W

Betty Shabazz (Betty X)
May 28, 1934–June 23, 1997

Malcolm Little (he changed his name to Malcolm X after he was released from prison in 1952) was born in Omaha, Nebraska, to Earl and Louise Little. His father was an active social activist who campaigned for equality of the races. However, despite how hard young Malcolm tried, he was continually thwarted in his quest for education and equality. His anger reached a breaking point after the family's home in Lansing, Michigan, was burned down in 1929 and his father was killed in a suspicious streetcar accident in 1931. After his mother had a nervous breakdown in 1938, Malcolm struggled through a series of foster homes and menial jobs, and then embarked on a life of petty crime. Sentenced to prison for larceny and for breaking and entering in February 1947, he was paroled in August 1952. While in prison, he started communicating with Elijah Muhammad, the leader of the Nation of Islam, and he converted to Islam shortly after his release. A few months later, the FBI opened a file on him.

Within a few years, Malcolm X became a spokesman for the radical elements of the Nation of Islam and actively butted heads with the leaders of other African American organizations. Malcolm X called Martin Luther King Jr. a "chump" and called leaders of the civil rights movement "stooges" of the white establishment. In 1963, he started writing his book, *The Autobiography of Malcolm X*, with author Alex Haley. In March 1964, Malcolm X officially broke with the Nation of Islam after repeated clashes with Elijah Muhammad. On February 21, 1965, just as Malcolm X was about to speak at a meeting of the Organization of Afro-American Unity in a Manhattan ballroom, shots rang out and he was mortally wounded. His body was penetrated by 16 gunshots. A few days later, a public viewing of his body attracted between 14,000 and 30,000 mourners.

Betty Dean Sanders (Betty Shabazz after she married Malcolm X) spent her early years in Detroit, Michigan (her birthplace is unclear),

where she became involved in social issues. When she graduated from high school, she enrolled at the Tuskegee Institute in Alabama and got her first dose of Southern racism. Seeking a better social climate, she enrolled at the Brooklyn State College School of Nursing. During her second year in nursing school, she went to one of Malcolm X's lectures. In mid-1956, she converted to Islam and then married Malcolm X in January 1958. After his assassination, she was able to earn enough money from the royalties of *The Autobiography of Malcolm X* to raise her family of 6 daughters. In late 1969, she enrolled in college, attained her master's degree, and then earned her doctorate in 1975. She became actively involved in health sciences and family planning. In 1975, President Gerald R. Ford asked her to serve on the American Revolution Bicentennial Council.

On June 1, 1997, Betty Shabazz's 12-year-old grandson Malcolm set fire to Shabazz's New York apartment, and she suffered burns on over 80 percent of her body. She underwent five skin-replacement surgeries but died on June 23. Her funeral was attended by many social and political leaders, including Maya Angelou, Coretta Scott King, and four New York City mayors. U.S. Secretary of Labor Alexis Herman delivered a tribute from President Bill Clinton.

Thelonious Monk

October 10, 1917–February 17, 1982
41° 1' 41.67" N 73° 49' 54.25" W

Thelonious Monk was born in Rocky Mount, North Carolina. The family moved to Manhattan in 1922, and shortly thereafter, young Thelonious started playing the piano. He had little formal training but was talented enough to play the church organ, and by his late teens, he found work playing jazz. Monk made his first studio recordings with the Coleman Hawkins Quartet in 1944, and Hawkins became one of Monk's biggest promoters. Monk has often been called the founder of bebop and was also well known for his distinctive fashion style, which consisted of interesting hats, suits, and sunglasses. From the late 1940s through the 1960s, Monk recorded and co-recorded over 40 albums. In 1964, he was

featured on the cover of *Time* magazine, one of only five jazz musicians to be so honored. He became well known in Europe, thanks to the patronage of a member of the Rothschild family, Baroness Pannonica "Nica" de Koenigswarter. When Monk's mental health declined in later life (he may have suffered from undiagnosed manic depression or schizophrenia), the Baroness took him in as a guest in her New Jersey home. Even though he only wrote about 70 songs, Thelonious Monk is the second most recorded jazz composer after Duke Ellington, who wrote over 1,000 songs.

Sir Basil Rathbone

June 13 1892–July 21 1967
Shrine of Memories Mausoleum, Unit 1, Tier K, Crypt 117
41° 1' 40.19" N 73° 49' 43.61" W (mausoleum entrance)

There are certain actors who will always have a signature character that no one else can ever fully embrace. Sean Connery will always be the quintessential James Bond. Basil Rathbone will always be Sherlock Holmes. Philip St. John Basil Rathbone was born in Johannesburg, South Africa, to a well-to-do family and was only three when the family fled after his father Edgar was accused of being a British spy. Basil was schooled in England and dabbled in acting afterward. After serving in World War I, he took up acting again, performing Shakespeare in Stratford-upon-Avon. He continued to perform Shakespeare as well as other works in England and the United States throughout the 1920s. He drifted into Hollywood, first in silent movies and then in talkies, often taking on roles as a suave villain. He was also an excellent swordsman. Rathbone appeared in 85 films from 1921 to 1967. He is best remembered as the super-sleuth Sherlock Holmes in the 14 Holmes films he did from 1939 until 1946. The first two films, *The Adventures of Sherlock Holmes* and *The Hound of the Baskervilles*, were set in Victorian times when they were written by Arthur Conan Doyle, while the other twelve were set in modern times. All the films co-starred Nigel Bruce as Dr. Watson. In 1949, King George VI made Rathbone a Knight Bachelor, which allowed him to use the title "Sir," although he rarely used it and never in movies or on stage. Rathbone received three separate stars on the Hollywood Walk of Fame in 1960: one for motion pictures, one for radio, and one for television.

Paul Robeson

April 9, 1898–January 23, 1976
41° 1' 39.94" N 73° 49' 53.17" W

Paul LeRoy Bustill Robeson was born in Princeton, New Jersey. He was the product of a socially active family where education was stressed. Robeson excelled in school and won a full academic scholarship to Rutgers University. He also excelled at Rutgers, where he was admitted into Phi Beta Kappa and the Cap and Skull honor society, and was the class valedictorian. He also won 15 varsity letters in sports and was hailed as the greatest football player of his era. After graduating from Rutgers, he enrolled in Columbia Law School and graduated in 1923. He worked briefly for a law firm in New York before quitting when a white secretary refused to take dictation from him.

In the early 1920s, he started doing professional theater, gaining fame for his acting ability as well as for his deep bass voice. This combination particularly lent itself to old spirituals. From the mid-1920s until the early 1940s, Robeson appeared in 11 films, seven of them produced in England. His most memorable roles were a 1933

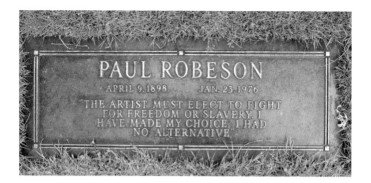

film version of Eugene O'Neill's *The Emperor Jones* (scenes of a black man killing a white man were deleted in the American release) and in the box office hit *Showboat*, where he won kudos for his singing of *Ol' Man River*.

Throughout his life Robeson was a strong social activist, campaigning for rights of workers, Socialism, and equality for all races. For the last three decades of his life, he was continually watched by the FBI, the CIA, and MI5 (a British agency). It has been said that his FBI file is one of the largest ever amassed on an entertainer. Robeson's political views were highly controversial and were even condemned by mainstream African American organizations. However, he stayed his own course and marched to his own drummer. The epitaph on his gravestone reads, "The artist must elect to fight for freedom or slavery. I have made my choice. I had no alternative."

Ed Sullivan
September 28, 1901–October 13, 1974
Ferncliff Mausoleum, Unit 8, Alcove G, Crypt 122
41° 1' 40.08" N 73° 50' 9.21" W (mausoleum entrance)

Edward Vincent "Ed" Sullivan was born in New York City. After a stab at being a boxer, he went into the media business, first as a sportswriter and then as an entertainment reporter. Sullivan became a rival to gossip columnist Walter Winchell, with Sullivan setting up his "headquarters" at the El Morocco Club and Winchell setting up his at the Stork Club. Both Sullivan and Winchell also did radio programs focusing on the entertainment industry.

In 1948, the new medium of television came calling. CBS asked him to do a weekly variety show called *Toast of the Town*. The first show debuted on June 20, 1948; the last aired on June 6, 1971. Although *Toast of the Town* was widely referred to as the *Ed Sullivan Show*, the name wasn't officially changed until 1955. Sullivan was a respected star-maker. An appearance on his show could catapult a new performer to stardom or help an established performer leapfrog over others.

The most widely referenced Ed Sullivan Shows are September 9, 1956, when Elvis Presley first appeared (Presley had previously appeared on shows hosted by Steve Allen, Milton Berle, and the Dorsey Brothers). Sullivan had vowed never to let Presley on the show, partly because of Presley's suggestive gyrations. But he later reversed his position and booked Elvis on the show. Ironically, when the show aired, Sullivan was recuperating from an automobile accident, and the show was hosted by Charles Laughton. There is a fair amount of media mythology that everything from Elvis's hips on down was blacked out. It was not. But Elvis did restrict his movements. However, it wasn't enough to quell

New York Times critic Jack Gould who said that Presley had "'injected movements of his tongue and indulged in wordless singing that were singularly distasteful. Over-stimulating the physical impulses of the teenagers was a gross national disservice."

Then there was the Beatles. In late 1963, Sullivan was at Heathrow Airport in London, where he noticed a group of crazed Beatles fans as they welcomed the band back from a performance in Stockholm. Sullivan thought that it was the Elvis mania all over again. He hastily negotiated with Beatles' manager Brian Epstein for three consecutive Sunday performances on the *Ed Sullivan Show*. The first performance on February 9, 1964, is considered a seminal moment in broadcasting history. The broadcast drew a record 73 million viewers plus a studio audience of screaming hysterical girls. It signaled what has become known as the "British Invasion" of popular music. Nothing would be the same, ever again.

As the years ticked on, Sullivan continued to introduce new acts and to break barriers. The show was particularly noted for introducing African American performers (The Supremes appeared 17 times). But by 1971, Sullivan's show was no longer in the top 20, and variety shows in general were on the wane. CBS pulled the plug in June 1971, and Sullivan died three years later of esophageal cancer. His star was added to the Hollywood Walk of Fame on February 8, 1960.

Ferncliff Mausoleum
41° 1' 40.08" N 73° 50' 9.21" W

There are a number of other notables spending eternity in Ferncliff's mausoleums and grounds. These noted resting places can be found in the Ferncliff Mausoleum:

Paul S. Althouse
(opera singer)
1889–1954
Unit 7, Private Alcove O, Crypt 31A

Leopold Auer
(violinist)
1845–1930
Unit 1, Alcove D, Crypt 31

Arthur "Bugs" Baer

(journalist)
1886–1969
Unit 6, Private Alcove D, Niche 4

Richard Semler Barthelmess

(actor)
1895–1963
Unit 8, Alcove BB, Column B, Memorial Niche 1

Sherman Billingsley

(nightclub owner, Stork Club; ex-bootlegger)
1900–1966
Unit 8, Alcove Y, Crypt 74

Alan Freed

(radio disc jockey; "The Father of Rock & Roll")
1921–1965
Unit 8, Alcove ST, Column B, Niche 2

Marion Lorne

(actress: *Bewitched,* "Aunt Clara")
1885–1968
Unit 3, Niche Panel EE, Niche 3

Hugh Marlow

(actor: *All About Eve*)
1911–1982
Unit 10, Alcove BB-CC, Niche 9A

Charles Revson

(founder, Revlon Cosmetics)
1906–1975
Unit 5, Alcove BBB, Private Room 4, Crypt 2

Frank Waterman

(founder, Pen Company)
1869–1938
Unit 1, Alcove M, Crypt 29

Rosewood Mausoleum

41° 1'39.70"N 73° 49'49.68"W

Aaliyah Haughton

(pop singer)
1979–2001
Unit 4A, Tier CC Private Section, Crypt 3

Ferncliff Grounds
41° 1' 36.06" N 73° 49 '47.33" W (main entrance)

Harold Arlen
(composer, "Over The Rainbow")
1905–1986
Hickory Plot, Grave 1666

James Baldwin
(novelist, essayist)
1924–1987
Hillcrest A Plot, Grave 1203

Adolph Caesar
(actor: *A Soldiers Story*)
1933–1986
Beechwood Plot, Grave 238

Betty Midgley Furness
(actress, consumer advocate, commentator)
1916–1994
Hillcrest Urn Garden, Grave 5C

Jason "Jam Master Jay" Mizell
(rap star, disc jockey)
1965–2002
Hillcrest Garden C Plot, Grave 1120

Khalid A. Muhammed
(civil rights activist)
1949–2001
Hickory Terrace Plot, Grave 6317

Malik Sealy
(NBA player)
1970–2000
Hickory Terrace Plot, Grave 5521

Bernard "Toots" Shor
(restaurateur)
1903–1977
Hillcrest A Plot, Grave 1204

Otto Soglow
(author, cartoonist, *New Yorker* Magazine)
1900–1975
St. Luke Plot, Grave 1773

Preston Sturges
(film writer and director)
1898–1959
Maplewood 4 Garden Plot Grave 74

Ferncliff Crematory

41° 1' 40.08" N 73° 50' 9.21" W

Fernwood has one of the most active crematories in New York. It accounts for upwards of 10 percent of all cremations in the state. Among those who had a brief stay at Fernwood before their ashes were interred elsewhere or entrusted to loved ones are the following:

Yul Brynner
(actor: *The King and I, The Ten Commandments*)
1915–1985

Jim Henson
(Muppets creator)
1936–1990

John Lennon
(musician, singer)
1940–1980

Christopher Reeve
(actor: *Superman*)
1952–2004

Nelson Rockefeller
(Governor of New York; 41st Vice President of the United States)
1908–1979

Ferncliff Crematory.
Photo courtesy of Jim Logan.

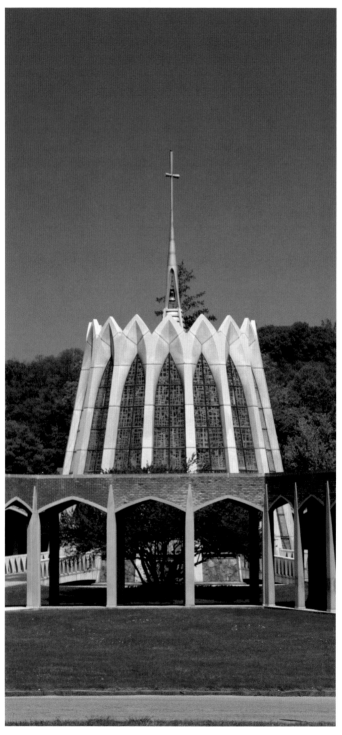

St. Francis of Assisi Chapel

Gate of Heaven Cemetery

10 West Stevens Avenue
Hawthorne, New York 10532
(914) 769-3672
Maps in office
41° 5′ 44.38″ N 73° 47′ 40.32″ W

The 250-acre Gate of Heaven Cemetery was established in 1918 by the Catholic Archdiocese of New York. Part of the land was acquired from the adjacent Kensico Cemetery. New York architect Charles Wellford Leavitt designed the cemetery, using the classic rural cemetery template with winding roads and landscaping that invites contemplation and meditation. The most visible feature of the cemetery is the neo-Gothic/Modern circular St. Francis of Assisi chapel with spectacular floor-to-ceiling stained glass windows. Circling the chapel is a series of eight spoke-like wings of an open-air community mausoleum.

Babe Ruth
February 6, 1895–August 16, 1948
41° 5′ 25.28″ N 73° 47′ 49.05″ W

While it is virtually impossible to determine which baseball player's grave is the most visited, George Herman "Babe" Ruth's is certainly near the top. Ruth was born in a rough neighborhood in Baltimore, Maryland, to German-American parents. When he was seven years old, his father sent him to a Catholic reform school, St. Mary's Industrial School for Boys, and signed papers to award custody of young George to the school (Ruth's mother was constantly ill and unable to care for him). He was introduced to baseball by one of the Brothers at the school and took to it instantly. First he learned about hitting and then about pitching. He remained at the school for the next 12 years. While playing for the school's team, he was spotted by a scout for the Baltimore Orioles (then a minor league team). In February 1914, owner-manager Jack Dunn signed him up and also became his legal guardian. Ruth was nicknamed "Jack's newest babe" and the term "Babe" stuck. Thereafter he was called Babe Ruth. After a series of trades, Ruth wound up playing a few games for the Boston Red Sox in the summer of 1914, then secured a spot in the Red Sox's pitching rotation the following spring. Ruth's first full year of pitching in 1915 was marked by a 23–12 record, a 1.75 ERA, and a trip to the World Series, which the Red Sox won by defeating the Brooklyn Robins.

Ruth continued with the Red Sox for the 1916, 1917, 1918, and 1919 seasons, and began to be used more as a utility player, which increased his at-bats. In December 1919, after a series of complex deals, Babe Ruth signed with the New York Yankees. In the next 15 years, he played over 2,000 games for the Yankees. He quickly became known for his ability to

power home runs of incredible distance. In 1921, his second year with the Yankees, he hit 59 home runs. However, an author has concluded that if modern-day rules and baseball field dimensions were applied to Ruth's 1921 season, Ruth would have hit 104 home runs. In 1927, he hit 60 home runs, the first player to hit that mark. The record would stand until 1961, when Roger Maris hit 61 home runs. Ruth's 714 lifetime home runs were finally bested by Hank Aaron in 1974. Ruth's .690 slugging percentage remains a Major League record. He tops many lists of "greatest ever" baseball players, and in 1993, the Associated Press said Ruth was tied with Muhammad Ali as the most recognized athlete alive or dead.

George Herman Ruth was a complex man. While his baseball statistics are certainly impressive and legendary, his off-field life was often fodder for the media. He was a big supporter of disadvantaged children, but he drank and ate to excess and was frequently unfaithful to his wife. A lifetime cigar smoker, he was found to have a malignant tumor in his neck in the fall of 1946. However, Ruth received some new treatments for cancer that were just being introduced in medicine, and he rallied for the next year. Eventually the cancer spread, and it was clear that he would succumb to the disease. His uniform number, #3, was retired on June 13, 1948. Two months later, George Herman "Babe" Ruth, the Bambino, the Sultan of Swat, was dead. After his death, his body lay in repose in Yankee Stadium (the House that Ruth Built), followed by a funeral at St. Patrick's Cathedral. His monument, which is always adorned with an assortment of baseball memorabilia, has an epitaph written by Cardinal Spellman. It reads, "May the divine spirit that animated Babe Ruth to win the crucial game of life inspire the youth of America."

Billy Martin
May 16, 1928–December 25, 1989
41° 5′ 23.79″ N 73° 47′ 49.24″ W

To describe Billy Martin as irascible is an understatement. Alfred Manuel "Billy" Martin Jr. was born in Berkeley, California. His father, Alfred (aka "the jackass," according to Billy's mother), abandoned the family, which may account for some of Billy's anger-control issues. Young Billy attended Berkeley High School, where he excelled as a baseball player. In late 1947, he was signed to the Oakland Oaks, a minor league team. In 1948, Casey Stengel managed the Oaks, and in 1950, when Stengel took over as manager of the New York Yankees, he recruited Billy Martin as an infielder. Martin played for the Yankees from 1950 until mid-season 1957, when he was traded to the Kansas City Athletics. From 1958 until 1961, he played for the Detroit Tigers, Cleveland Indians, Cincinnati Reds, Milwaukee Braves, and finished his career as a player with the Minnesota Twins.

Billy Martin is best remembered as a manager. He held a series of jobs with the Minnesota Twins organization and then was hired as manager of the team in 1969. The Twins won the division championship, but Martin was fired after the season ended because of a fight with one of the Twins' pitchers. Martin sat out the 1970 season. He was subsequently hired to manage the Detroit Tigers and shepherded the team through the 1971, 1972, and 1973 seasons. While managing the Tigers, Martin had a number of altercations and exhibited some unorthodox behavior, including recruiting prison inmate, Ron LeFlore, who turned out to be a stellar player. After being forced out by the Tigers at the end of the 1973 season, he was hired by the Texas Rangers for the 1974 season. He managed the Rangers until the middle of the 1975 season, when he was fired. Next up for Martin was the manager position with his old team, the New York Yankees.

Martin came on board with the Yankees less than two weeks after he was fired by the Rangers. In the 1976 season, he took the team to the World Series, something the Yankees had not done since 1964. In 1977, the Yankees won the World Series. Unfortunately, Martin engaged in some very well publicized battles with Yankees' owner George Steinbrenner and outfielder Reggie Jackson. That all culminated with Martin resigning under pressure from Steinbrenner during the 1978 season. Martin moldered away in the front office for a few months, then Steinbrenner brought him back in the middle of the 1979 season. Alas,

after the 1979 season ended, Martin got into a fight with a marshmallow salesman in Minneapolis, and Steinbrenner fired him again. Martin wasn't down for long. He journeyed back to his birth-state where he became manager of the Oakland A's in 1980. He was given a fairly free rein and developed a freewheeling managerial style characterized with aggressive base-running, hidden-ball tricks, and hit-and-runs. This style of play became known as "Billy Ball." Martin lasted through the 1982 season and then was fired because of the poor performance of the team. Back to New York he went. He was hired and fired by Steinbrenner three more times in 1983, 1985, and 1988. He was reportedly slated to return for the 1990 season when he died in a car crash on Christmas Day 1989.

Scholars have attributed much of Martin's erratic and combative behavior to his well-documented abuse of alcohol. It was widely reported that he was driving the automobile in the one-car crash that killed him, but while alcohol was certainly involved, after a detailed investigation by a forensic pathologist, it was proven that he was in the passenger seat. Martin's uniform number (#1) was retired by the New York Yankees in 1986. His epitaph reads, "I may not have been the greatest Yankee to put on the uniform but I was the proudest."

Sal Mineo
January 10, 1939–February 12, 1976
41° 5' 15.12" N 73° 47' 56.04" W

Salvatore Mineo Jr. was born in the Bronx to Sicilian casket makers. At an early age, he enrolled in acting and dancing school, and appeared on stage for the first time at age 12. His good looks and acting talent soon won him a role in the classic 1955 movie *Rebel Without a Cause* starring James Dean. Mineo's portrayal of John "Plato" Crawford resulted in an Academy Award nomination. Mineo soon attained Hollywood heartthrob status and was often mobbed by young women. He next appeared in another James Dean movie, *Giant*, where he played a Mexican boy. His Italian American features enabled him to take on a range of roles, including a Sioux Indian in the Disney movie *Tonka* (1958) and a Jewish emigrant in *Exodus* (1960), which garnered him an Academy Award nomination for Best Supporting Actor. Banking on his star appeal, he also recorded a record album and single records, two of which made the Billboard Top 40 chart.

Although his star waned in the 1960s, he did appear in a number of episodes of television shows throughout the 1960s and early 1970s.

Then on the night of February 12, 1976, while returning from a rehearsal, he was stabbed to death in an alley in back of his West Hollywood home. His attacker was a pizza deliveryman who was attempting to rob him. The man had committed a number of robberies in the area, and Mineo was simply in the wrong place at the wrong time. Sal Mineo's simple flat gravestone is shared with his brother, Michael Mineo (1937–1984), who also worked from time to time as an actor.

James Cagney
July 17, 1899–March 30, 1986
41° 5′ 42.92″ N 73° 47′ 41.00″ W

James Francis "Jimmy" Cagney Jr. was born in a room over his father's saloon on the Lower East Side of Manhattan. His father was Irish and his mother half Irish. He developed an interesting array of talents as the result of growing up in a rough neighborhood: street fighting to defend himself, baseball to have fun, and tap dancing to entertain his friends. After watching the filming of a movie in Brooklyn, he started working at various jobs in dramatic productions, though he didn't have any particular interest in acting. His break came when he applied his dancing skills and got a job in a male chorus line parody. He gradually transitioned to acting roles in Broadway plays. In 1930, he starred in a Broadway play opposite Joan Blondell titled *Penny Arcade*. Al Jolson bought the film rights with the stipulation that Cagney and Blondell could reprise their roles in the movie version. James Cagney went to Hollywood under contract with Warner Bros. His breakthrough role was that of a gangster in the 1931 movie *The Public Enemy*. The movie contains one of the most famous movie scenes, Cagney smashing a grapefruit into Mae Clarke's face. Gangster movies became all the rage in the 1930s, and Cagney as well as Edward G.

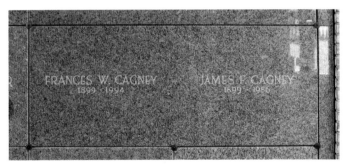

Robinson were the biggest gangster stars. In 1931, Cagney and Robinson played together in the movie *Smart Money*.

Although Cagney was well known for his gangster, bad guy, and psychotic portrayals, he easily went back and forth into roles in musicals and romantic films such as 1942s *Yankee Doodle Dandy*, putting his dancing skills to use and winning the Academy Award for Best Actor for his portrayal of George M. Cohan. After appearing in 39 films in the 1930s, 14 films in the 1940s, and 16 films in the 1950s, he went into semiretirement; he did appear in three films in the 1960s and had a starring role in what would be his last film, *Ragtime*, in 1981. In 1984, Ronald Reagan awarded him the Presidential Medal of Freedom.

Reposing next to James Carney in the double crypt is his wife, Frances Willard "Billie" Vernon Cagney, who died in 1994. The couple was married on September 28, 1922.

Moravian Cemetery

Moravian Cemetery

2205 Richmond Road

Staten Island, NY 10306

(718) 351-0136

www.moraviancemetery.com

Maps in office

40° 34' 50.69" N 74° 6' 50.56" W (main entrance)

The 113-acre Moravian Cemetery is the largest cemetery on Staten Island. Although the cemetery landscape design was executed in the late nineteenth century by master landscape designer Frederick Law Olmsted, who also designed Central Park, the earliest graves in the cemetery are those of British soldiers that date to around 1740. The nonsectarian cemetery embraces a classic rural cemetery design with winding roads, ponds, and well-tended landscaping. Adjacent to Moravian Cemetery but off-limits to the general public is the Vanderbilt Cemetery. Among the Vanderbilts interred there is family patriarch Cornelius Vanderbilt (1794–1877).

Kunhardt Plot
40 34' 54.65" N 74 7' 6.31" W

One of the most ostentatious plots at Moravian Cemetery belongs to the Kunhardt family. The kingpin of the family was banker and sugar importer Henry Rudolph Kunhardt (1826–1895). The pathway to

a majestic multi-columned mausoleum is lined with members of the extended Kunhardt family. Among those resting along the rock pathway is Dorothy Kunhardt, whose gravestone is emblazoned with a quill. She authored the children's book *Pat the Bunny*, which has sold over seven million copies since it was published in 1940.

Receiving Tomb
40° 34' 46.02" N 74° 7' 1.38" W

Like most large historic cemeteries, Moravian Cemetery sports a substantial receiving tomb. Receiving tombs were used for temporarily storing bodies when a mausoleum was being constructed or in extremely cold weather when the frozen ground did not permit digging a grave. Nowadays, there are gas-fired ground-thawing devices that allow digging in frigid weather. Most receiving tombs in older cemeteries have either been boarded up or used for storage.

Martin Scorsese
November 17, 1942–
40° 35' 2.76" N 74° 7' 8.43" W

There is nothing like planning ahead. And when it comes to one's last address, there is a certain comfort about knowing exactly where it will be and what it will look like. Nowadays, most people leave the decision to loved ones on what their last address will look like, but such was not always the case. In decades past, many people bought their plot, grave marker, and monument or mausoleum well ahead of time. Borrowing from a past tradition, that's what Martin Scorsese did. The Scorsese Mausoleum was constructed in the 1990s of Barre granite, quarried from the Rock of Ages quarry in Barre, Vermont. Rock of Ages also built the mausoleum. Since Scorsese has been married five times and has three daughters, it's unclear who will actually call the multi-crypted Scorsese mausoleum their permanent home.

Film director, producer, screenwriter, and sometime actor, Martin Scorsese was born in New York City to Italian-American parents. When he was young, his parents would take him to movies, and he soon developed a passion for cinema. He was particularly fond of historical epics and neo-realism. He went to New York University's film school and made short films when he was there. After that, he made a number of low-budget B movies. In 1973, Scorsese directed the movie *Mean Streets,* which set the stage for his breakthrough movie *Taxi Driver* in 1976. This movie was a rousing success, and it enabled him to make a big-budget Hollywood-style production *New York, New York* in 1977. This film was a box office failure, and Scorsese went back to the gritty films he was more adept at making. In the ensuing years, he churned out one success after another, including *Raging Bull* (1980), *The King of Comedy* (1983), *The Color of Money* (1986), *The Last Temptation of Christ* (1988), *Goodfellas* (1990), *Cape Fear* (1991), *The Age of Innocence* (1993), *Casino* (1995), *Kundun* (1997), *Bringing Out the Dead* (1999), *Gangs of New York* (2002), *The Aviator* (2004), *The Departed* (2006), and *Shutter Island* (2010). After being nominated numerous times, Martin Scorsese finally won the Academy Award for Best Director for his 2007 movie, *The Departed*.

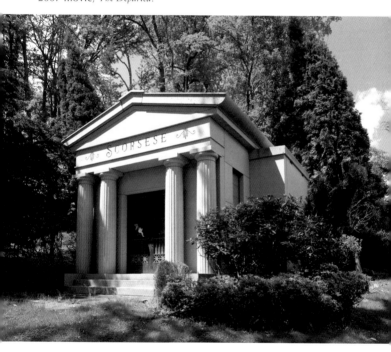

St. Raymond's New Cemetery

St. Raymond's Old & New Cemeteries

NEW CEMETERY

East 177th Street and Lafayette Avenue

Schuylerville, Bronx, NY 10465

(718) 792-1133

40° 49′ 34.73″ N 73° 49′ 54.41″ W

OLD CEMETERY

1201 Balcom Avenue

Schuylerville, Bronx, NY 10465

(718) 792-2080

40° 50′ 8.71″ N 73° 50′ 10.86″ W

St. Raymond's is actually two cemeteries nestled northeast and southeast of the junction of the Cross Bronx Expressway and the Bruckner Expressway. St. Raymond's Old Cemetery was active from its founding in 1875 until it was essentially filled in 1963. St. Raymond's New Cemetery was founded in 1953 and is still a very active cemetery. The main gate to the old cemetery at Whittemore Avenue is where John F. "Jafsie" Condon paid Bruno Hauptmann a $50,000 ransom for the return of Charles Lindbergh's kidnapped son in 1932.

Billie Holiday
April 7, 1915–July 17, 1959
40° 49′ 27.00″ N 73° 50′ 2.14″ W (New Cemetery)

Eleanora Fagan (also known as Elinore Harris) was born in Baltimore, Maryland, to Sarah Julia "Sadie" Harris; the name of her biological father has never been positively established. Eleanora Fagan changed her name to Billie Holiday by combining the names of Ziegfeld Follies dancer and actress Billie Dove and her probable father Clarence Holiday. Billie had a troubled childhood that included dealing with an often-absent mother, living with a Madame, and being raped at age 11. A couple of years later, Billie started earning money as a prostitute. However, during the time she worked in a brothel, she was introduced to the records of Bessie Smith and Louis Armstrong, and by 1929, she was working as a singer. She made her recording debut with white clarinetist and bandleader Benny Goodman in 1933. Throughout the 1930s, she was accompanied by a number of musicians, most notably tenor saxophonist Lester Young, who named her "Lady Day." Her star continued to rise in the 1930s, culminating with the release of one of her signature songs, *Strange Fruit*, which was adapted from a poem about lynchings in the South.

The 1940s were a triumphal and troubled time for Holiday. Although she wrote one of her popular songs, *God Bless the Child*, she continued to have abusive relationships with men, and she frequently used narcotics. She was arrested for narcotics use in 1947 but spent less than a year in

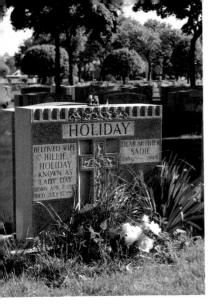

prison. On March 27, 1948, 11 days after being released from prison, she played to a sold-out crowd at Carnegie Hall. However, her narcotic use and drinking continued to increase, wreaking havoc on her body and voice. She married Louis McKay, a mafia enforcer in 1952. He was abusive but tried to get her off drugs. Despite her failing health, she penned another signature song, *Lady Sings the Blues*, in 1956 and performed two more sold-out Carnegie Hall appearances. *Lady Sings the Blues* became the title of Billie Holiday's 1959 autobiography and the title of a 1972 film, with Diana Ross playing Holiday. On May 31, 1959, Billie Holiday checked into Metropolitan Hospital in New York City. She never checked out, dying of cirrhosis of the liver and other ailments on July 17, 1959.

Frankie Lymon

September 30, 1942–February 27, 1968
40° 49' 33.53" N 73° 49' 52.09" W (New Cemetery)

Franklin Joseph "Frankie" Lymon's physical star shone briefly and then sputtered out, but his musical star will shine forever. Frankie Lymon was born and died in Harlem. When he was 12 years old, he joined a do-wop group called the Coupe De Villes (also called The Ermines and sometimes The Premiers). After Lymon joined the group, two of the members, Herman Santiago and Jimmy Merchant, adapted some love letters into a song they called *Why Do Birds Sing So Gay*. With Lymon's input, the

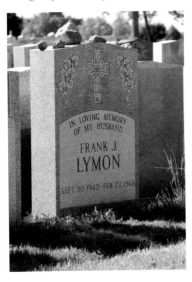

song was retitled *Why Do Fools Fall In Love*. Santiago was the original lead singer, but when the group, now called The Teenagers, got a chance to formally audition the song before record producer George Goldner, Santiago was late and Frankie Lymon sang the lead vocals. Goldner immediately signed the group, and in January 1956, *Why Do Fools Fall In Love* soared to number six on the Billboard top singles chart and number one on the Billboard R&B singles chart. The renamed Frankie Lymon and the Teenagers' next pop hit was *I Want You To Be My Girl*, which charted number 13

on the Billboard Hot 100 chart followed by *Goody Goody*, which rose to number 20.

In early 1957, barely a year after the release of *Why Do Fools Fall In Love*, Lymon split from the group and went solo. Although he had some modest success, he fell under the spell of heroin. He entered a drug rehabilitation program in the early 1960s, but it didn't take. In 1965, he was drafted into the Army but was dishonorably discharged after going AWOL multiple times. He retuned to New York where Sam Bray of Big Apple records signed Lymon and scheduled a recording session for him that was to begin on February 28, 1968. Lymon went back to his grandmother's house in Harlem, where he had been staying, and died of a heroin overdose. Although the tenure of Frankie Lymon and the Teenagers was brief, Lymon's soprano voice was a major influence on other performers, including Ronnie Spector, The Chantels, The Temptations, Smokey Robinson, and The Beach Boys. Frankie Lymon and the Teenagers were inducted into the Rock and Roll Hall of Fame on January 12, 1993.

Mad Dog Coll
July 20, 1908–February 8, 1932
40° 49′ 56.63″ N 73° 50′ 2.89″ W (Old Cemetery)

Nobody winds up in the cemetery on a winning streak. That was certainly the case with Vincent Mad Dog Coll. He was born Uinseann Ó Colla in County Donegal, Ireland. He came to the United States with his family when he was a year old. He didn't seem to want to assimilate into mainstream society, preferring to make his living in less-than-acceptable ways. After being expelled from multiple Catholic reform schools, he looked for a role model and found one in the person of mobster Dutch Schultz. It was apparently a good fit for young Vincent Coll. Schultz's business sense and Coll's ruthlessness worked well when collecting from speakeasy owners.

Coll rose up through the ranks from an enforcer to a higher-ranking assassin job. As with many employer/employee relationships, there were differences of opinion about how to run the business, so Coll broke away from Schultz and recruited some new business partners. Unfortunately, this resulted in some business

rivalries, which ended in a shooting war between the Schultz gang and the Coll gang. It all came to a head on July 28, 1931, when Coll tried to kidnap Schultz gang member Joey Rao. A shootout ensued, and five-year-old Michael Vengalli and several other neighborhood children were caught in the crossfire. Little Michael died soon thereafter. Things had gone too far, even for Mayor James J. Walker, whose first act was to give Coll the name "Mad Dog." His second act was to start a manhunt for Coll.

Somehow, killing a child

didn't hurt Coll's marketability as a hired killer. Within a few weeks after the Vengalli killing, Salvatore Maranzano, the boss of bosses in New York, contacted Coll to arrange the murder of Maranzano's rival, Charles "Lucky" Luciano. But before Coll could complete the job, Luciano got wind of the plot and his men killed Maranzano. A few weeks later, Coll stood trial for the murder of little Michael Vengalli, but amazingly, Coll was acquitted. Getting away with killing a child didn't sit well with some of the other New York mobsters, and Hell's Kitchen kingpin Owney Madden put out a contract for Mad Dog Coll. On February 1, 1932, gunmen burst into an apartment Coll was known to frequent and machine-gunned the six occupants, killing three of them instantly. Alas, Coll was not among the dead or the wounded. However, the local mobsters persisted, and a week later, with the aid of Coll's old rival Dutch Schultz, they finally succeeded in their mission. The coroner reportedly dug fifteen bullets out of Mad Dog Coll's perforated body. No one was ever prosecuted for the crime.

Typhoid Mary

September 23, 1869–November 11, 1938
40° 49' 57.90" N 73° 50' 12.98" W (Old Cemetery)

Mary Mallon was the first person in the United States to be identified as a healthy carrier of typhoid fever. Unfortunately, this earned her the title of Typhoid Mary. Typhoid fever is a gastrointestinal illness accompanied with a high fever and is transmitted via human feces, usually by persons with improperly washed hands. Nowadays, it results in about 216,000 deaths worldwide. It once ran rampant through the United States.

Mary Mallon was born in Ireland and immigrated to the United States in 1884. Historians speculate that she may have been born with the typhoid virus since her mother had typhoid fever when she was pregnant with Mary. Little is known about Mary Mallon in the first few decades after she moved to the United States, except that she was often employed as a cook and there were reports that members of some

of the families she worked for developed typhoid fever. She was also known to have a fiery temper. However her history is well documented starting in 1906. That year, she found employment as a cook for a family on Long Island. Within a couple of weeks, six of the eleven household members were in the hospital with typhoid fever, but by the time authorities investigated the matter, Mary Mallon had disappeared. She quickly found a series of other jobs as a cook, and three more families became infected. Mary was eventually located in

1907 and was detained by the Board of Health. Her Irish temper flared when she was asked for a stool sample, claiming she could not possibly be a typhoid carrier since she had never had the disease. That resulted in her being sent to Riverside Hospital on North Brother Island. There she remained until 1910, when she was released with the admonition to not work as a cook and to observe proper hygiene.

Alas, Mary was happiest as a cook, and in 1915, she was discovered working in that capacity at the Sloane Hospital for Women in Manhattan. She was promptly escorted back to North Brother Island, where she lived out the remaining 23 years of her life. Although urban myths often state that she was responsible for thousands of deaths (in 1906 there were only 600 total deaths from typhoid fever in the entire state of New York), there were only 33 verifiable instances of people infected by Typhoid Mary and three deaths. Nevertheless, an autopsy after she died detected the typhoid virus in her gall bladder, and she was cremated just to make sure the virus was truly killed.

St. Raymond's Neighborhood
While you're in the neighborhood here are a few notables worth a visit:

Peter Coll
(brother of Mad Dog Coll; foot soldier in Coll's gang;
shares the same plot and gravestone)
1907–1931
40 49' 57.90" N 73 50' 12.98" W (Old Cemetery)

Anthony DeMassi
(David Bowie's bodyguard)
1933–1991
St. Matthew Section, Range 11, Grave 76 (New Cemetery)

Father Francis Patrick Duffy
(inspiration for the 1940 movie *The Fighting 69th*)
1871–1932
Section 9, Range 99, Grave 10 (Old Cemetery)

Jackie Jackson
(singer with The Chantels)
1941–1997
St. Matthew Section, Range 19, Grave 26 (New Cemetery)

Anthony "Fat Tony" Salerno
(mobster and boss of the Genovese crime family)
1911–1992
Mausoleum (near NE corner of Balcom and Whitmore Avenues)

Guadalupe "La Lupe" Yoli
(salsa singer, "the Latina Judy Garland")
1939–1992
St. Matthew Section, Range #7, Grave #88 (New Cemetery)

Hartsdale Pet Cemetery

HUMANE
REMAINS

Many cemeteries are tailored to a specialized clientele. There are cemeteries that cater to departed members of specific faiths like Jews and Catholics. There are also cemeteries as well as cemetery plots within cemeteries that are reserved for members of clubs and secret societies, such as the Freemasons, Odd Fellows, Friars Club, and various actors' unions. The most specialized cemeteries are reserved for non-humans. There are over 600 pet cemeteries in the United States. The granddaddy of them all, The Hartsdale Pet Cemetery and Crematory, is in Westchester County.

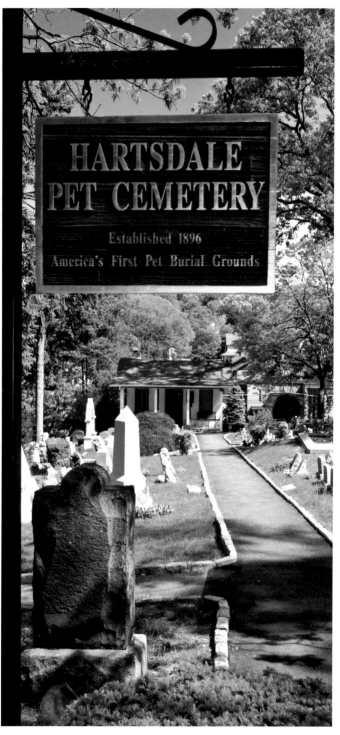

Hartsdale Pet Cemetery

Hartsdale Pet Cemetery

75 North Central Avenue

Hartsdale NY 10530

(914) 949-2583

www.petcem.com

41 1' 17.33" N 73 47' 49.81" W

(War Dog Memorial at center of cemetery)

One day in 1896, a distressed woman walked into the 120 West 25th Street office of veterinarian Dr. Samuel Johnson (Johnson was one of the early promoters of the ASPCA). The woman's dog had just died, and she didn't want to dispose of her beloved canine like so much garbage. She wanted her dog to have a proper burial. Dr. Johnson wasn't aware of any way to have a pet buried in one of New York's cemeteries, but he did tell the woman that she could bury her dog in his apple orchard not far away in the tiny hamlet of Hartsdale in Westchester County. Thus began the Hartsdale Canine Cemetery, America's first pet cemetery. Alas, the woman's name, the name of her dog, and the exact location of the grave were never recorded.

A short time later, Dr. Johnson was having a casual conversation with a newspaper reporter about the burial, and to Johnson's surprise, a few days after that a story about the burial of the woman's beloved dog appeared in print. Almost immediately, Dr. Samuel Johnson's veterinary office was flooded with requests from pet owners. Not long after, he carved out a three-acre area in his apple orchard as a burial ground for pets. Soon little headstones, wire fences, and elaborate floral arrangements were peppering the grounds. It all came to a climax in 1899 when a spaniel named Major was put to rest in a glass-topped satin-lined casket while mourners sang an expressive doxology. Since the pet cemetery hadn't been formalized, for the first few years grieving pet owners brought their deceased four-legged friends to Dr. Johnson's offices where they were fitted for a casket; then the pet owners would travel to Hartsdale (about a one-hour train ride) to attend the burial.

In 1905, the prestigious *New York Times* devoted a large amount of print to describing the cemetery and the epitaphs of the permanent residents. The paper did note that the name Hartsdale Canine Cemetery was a misnomer since a variety of animals, including cats, birds, and monkeys, had already taken up residence. Most noted among the non-canines was the grave of a cat named Mignon. The grave had its own enclosure: two perfectly pruned box shrubs and an impressive $2^1/_2$-foot-high gravestone that read "Mignon Dearest and Best Beloved Friend of Ada Van Tassel of Billington, Died Sept. 27, 1900." Four years later, the *Times* reported that news of the pet cemetery was beginning to spread far and wide and that recently a deceased hound was shipped to the cemetery via rail from Kalamazoo. By 1913, there had been hundreds of interments, and the Hartsdale Canine Cemetery was formally incorporated. After

incorporation, word spread rapidly, and from 1914 to 1917, more animals were buried in the cemetery than the previous 18 years. In 1915, a Mrs. M. F. Walsh paid $23,000 ($400,000 today) for the land and a 50-ton Barre granite mausoleum, the cemetery's first mausoleum. Five members of the Walsh family's pet population are buried there. By 1920, over 3,000 four-legged friends called the cemetery home.

War Dog Memorial

Without a doubt the most significant event in the history of the Hartsdale Pet Cemetery occurred in 1923. It was the dedication of the War Dog Memorial. During World War I—The Great War—The War to End all Wars—tens of thousands of military dogs were used for a variety of tasks, from pulling machine guns, to running telephone wire, to rescuing wounded men. Thousands of those dogs were killed. The United States did not have a formal canine program and relied on the British and French to supply dogs. Nevertheless, many soldiers came back from the war with harrowing tales of the services the dogs provided. In 1921, plot owners at Hartsdale mounted a campaign to raise $2,500 for a memorial to war dogs. A design competition was held and was won by Walter A. Buttendorf. His design depicted a German Shepherd perched high on a granite boulder, a helmet and canteen at its feet. The monument was sculpted by Robert Caterson, who had previously worked on a number of buildings in the New York area, including Grand Central Station. Caterson started with a 10-ton rough granite boulder he carved out from his Vermont quarry. The bronze statue depicts the shepherd with a Red Cross vest, alertly looking in the

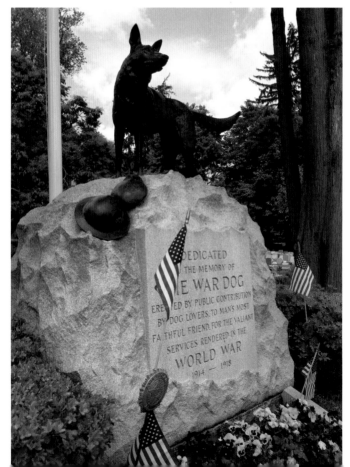

distance and tail straight. Look closely and you'll see that the helmet at the dog's feet is dented, indicating that the dog has found a wounded soldier. When the War Dog Memorial was officially dedicated in 1923, the event was attended by representatives of every nation that fought in the Great War. Eventually, the dog soldiers became known as the K-9 corps, and over 12,000 "dogs for defense" served in World War II. Over the years, there have been other memorial plaques placed at the base of the memorial, including one for the dogs who rescued victims from the rubble of the Oklahoma City bombing in 1995. Curiously, when the Oklahoma City dogs could find no more bodies, they became depressed, so some of the rescue workers purposely buried themselves so the dogs could find them and experience the joy of doing what they were trained to do. Buried elsewhere in the cemetery is Sirius, the only dog to lose his life during the search-and-rescue effort following the World Trade Center terrorist attacks on September 11, 2001.

The Hartsdale Pet Cemetery, now five acres, is the final resting place for over 70,000 beloved pets. From perfectly preened pedigreed pups to mangy mutts, Hartsdale has room for them all. In 1917, the faithful dog of a coal yard night worker in White Plains, had gotten sick and died. The man just couldn't bear to "toss him in the street," which was the practice at the time. He contacted the cemetery, and after being told that a simple unadorned plot would cost $15, he boxed up his old friend and took him to the cemetery for burial. When he arrived at the cemetery, he saw all the beautiful monuments and proclaimed that no dog deserved a monument more than his did. The cemetery allowed him to purchase a $20 tombstone on the time payment plan for 50 cents a week. The tombstone simply reads "Bum; Ever Faithful; At Rest; December 10, 1916." Reportedly, the 2 x 3-foot plot was one of the best-tended in the cemetery. The coal yard worker's dog certainly isn't the only dog whose owner deemed him "top dog." Just ask Tony LaMura (see page 242)

Mausoleum

Hartsdale Pet Cemetery is home to America's first dog mausoleum. The 50-ton, 10 x 10-foot mausoleum was built in 1917 by Mrs. M. F. Walsh, the wife of a wealthy New Yorker. The land and mausoleum were purchased in 1915 for $23,000. The inscription reads, "My Little True-Love Hearts, Who Would Lick the Hand That Had No Food to Offer."

Dotty

The oldest gravestone in the cemetery memorializes Dotty. It reads, "Dotty, Beloved pet of E. M. Dodge. Died Sept. 16th 1899 in her fourteenth year."

Metzie

The old saw goes that "a dog is man's best friend." A dog is loyal, obedient, and loves its master no matter what the circumstances. In the humanoid world, old friends may desert us and our reputations may be tarnished following an ill-considered action, but the dog doesn't care. Even in the most intolerable situations, the dog remains our friend. And in the case of Mrs. Reinhardt, her dog Metzie was her only friend.

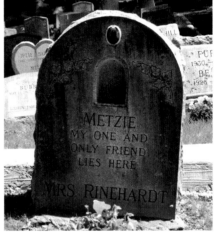

Molly

Lovers of Labrador Retrievers know this look. With apologies to owners of other breeds, the Labrador Retriever has one of the sweetest dispositions. Molly's epitaph reads, "With her smiling soul and her appetite for life, she made our hearts sing and brought joy's light in all colors. We are blessed to love her and be part of her pack."

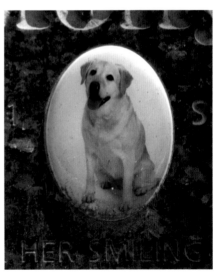

Grumpy

Before taking a tumble and breaking in two, the tombstone for Grumpy (August 4, 1913–September 20, 1926) was Hartsdale's tallest monument. His

epitaph, penned by his owners Emma and Henry Bizallion, reads, "His sympathetic love and understanding enriched our lives. He waits for us."

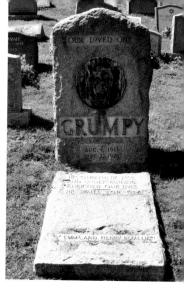

Rini Rinty

Hartsdale contains a number of award-winning show dogs. Among the most interesting is Rini Rinty, who apparently had a gift for song. It's likely that Rini Rinty was named after Rin Tin Tin, a shell-shocked German Shepherd puppy found by American serviceman Lee Duncan in Lorraine, France, in World War I. Duncan brought the dog home with him to Los Angeles at war's end. He taught the dog a number of tricks, and through a twist of fate, the dog started appearing in movies. Rin Tin Tin appeared in a number of films until his death in 1932 and was then replaced by a succession of other dogs with the same name. In October 1954, he got his own show on ABC, which ran until May 1959. On the show, the dog was often called Rinty for short. The first Rin Tin Tin has a star on the Hollywood Walk of Fame.

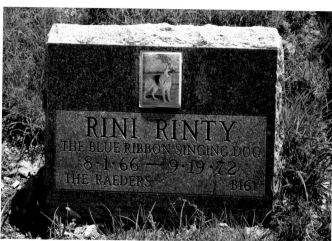

Queenie

There are a number of highly individualized memorials at Hartsdale. Among the most interesting are a marble dog bed/ basket and a granite doghouse for Queenie (1929–1944), "My shadow faithful till

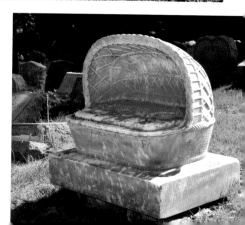

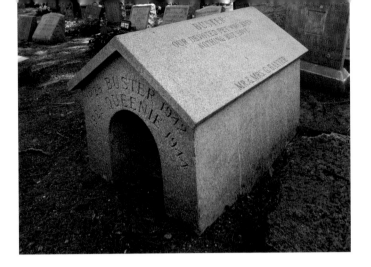

the end;" and for Buster (1929–1942), "Our devoted pet who knew nothing but love."

Clarence

Hartsdale Pet Cemetery is home to a number of pets of celebrities. Among the celebrities who have chosen to bury their pets at Hartsdale are Gene Krupa, Joe Garagiola, Elizabeth Arden, Kate Smith, George Raft, Evelyn Nesbitt, and James S. Sherman (27th Vice President of the United States under William Howard Taft). One of the more recent arrivals is one of singer Mariah Carey's Jack Russell Terriers, Clarence (1979–1997). His epitaph reads "My eternal friend and guardian angel you'll always be a part of me forever. Love –M." Carey's pampered pooches often travel with her, sometimes chauffeured in a limousine, sometimes flying first class.

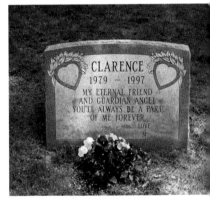

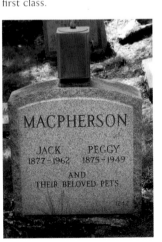

Jack and Peggy MacPherson

Some celebrity pet owners have chosen to be buried with their pets. While burial with a pet is technically illegal in human cemeteries, if people are cremated, they can spend eternity with their pet in a pet cemetery. Hartsdale buries the cremated remains of 5 to 10 people a year. The ashes of Jack MacPherson (1877–1962), whose television persona was the "Magic Chef," and Peggy MacPherson (1875–1949) reside in an urn perched atop a gravestone dedicated to their pets.

Princess Lwoff and Goldfleck

Not all pet owners choose to spend eternity with their beloved pets, but some try to be buried close by. Princess Elisabeth Vilma Lwoff-Parlaghy (April 15, 1863–August 28, 1923) was eccentric, to say the least. Elisabeth von Parlaghy was born in Hungary, where she became known as a portrait painter. In 1899, she married Russian Prince Lwoff, and though the couple divorced a few years later, she kept his name (and apparently a fair share of his riches). When the princess arrived in New York in 1908, she was reportedly accompanied by two attachés, two couriers, a footman, first and second butlers, first and second lady's maids, a cook, a valet, and a Swedish nurse. A great animal lover, she also arrived with an assortment of pets, including a small Pomeranian dog, an Angora cat, a guinea pig, an owl, two small alligators, and a bear. When the princess arrived at the Waldorf Astoria Hotel, she was informed of their pet policy, which must not have included the assortment the princess possessed; but arrangements were made for her, her menagerie, and her attendants to stay at the Plaza Hotel. And there she stayed.

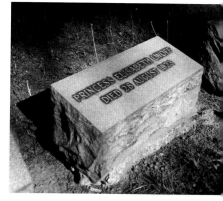

One day she visited the Ringling Brothers Circus and fell in love with a little lion cub. After some spirited negotiations with the Ringling Brothers and the Plaza, the little lion cub moved in. The princess originally named the cub General Sickles after a Civil War general's portrait she painted, but it was eventually named Goldfleck. Alas, Goldfleck was not long for this world. Before he reached full adulthood, he became sick and died. Despite his rather abbreviated time in this realm, he did go out in style. Princess Elisabeth Vilma Lwoff-Parlaghy arranged for a formal wake and a tombstone with a flowery epitaph. It reads, "Beneath This Stone Is Buried The Beautiful Young Lion Goldfleck, Whose Death Is Sincerely Mourned By His Mistress Princess Lwoff-Parlaghy, New York 1912." The princess' gravestone (40 53' 3.72" N 73 52' 36.72" W) is a simple one at Woodlawn Cemetery. It only reveals her death date since true princesses are forever young.

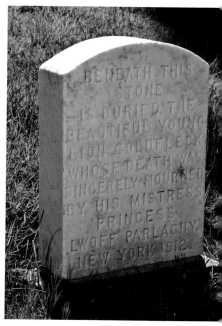

Irene and Vernon Castle and their pets

Among others who are buried at Woodlawn and have their pets buried at Hartsdale are Irene Castle (April 17, 1893–January 25, 1969) and Vernon Castle (2 May 1887-15 February 1918). The Castles were a popular dance duo from 1910 until 1918, when Vernon died in a military flight-training exercise. The couple were fashion icons as well. As a dance team, they introduced a number of dances, such as the Castle Walk, Turkey Trot, Grizzly Bear, and a hands-free version of the Tango. They were also great animal lovers, and a number of their pets are buried around the Castle Monument, including their dog Zowie and her pet monkey, Rastus. After Vernon's death, Irene Castle became a staunch animal-rights activist, eventually founding the Illinois animal shelter, Orphans of the Storm. Their monument (40 53' 26.01" N 73 52' 37.67" W) at Woodlawn Cemetery is named "At the End of Day." Near the end of her life, she said in a magazine interview, "When I die, my gravestone is to say 'humanitarian' instead of 'dancer.' I put it in my will. Dancing was fun, and I needed the money, but Orphans of the Storm comes from the heart. It's more important."

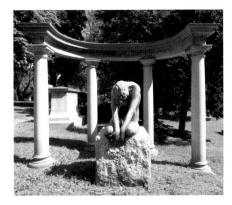

Irene and Vernon Castle

Castle Pets

Dr. Samuel Johnson

Dr. Samuel Johnson, founder of the Hartsdale Pet Cemetery, is also buried at Woodlawn. His rusticated Classical Revival mausoleum (40 53' 12.21" N 73 52' 30.91" W), which was called L'Art Nouveau at the time, contains a number of members of Johnson's family but, curiously, not his wife.

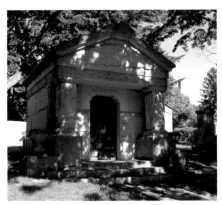

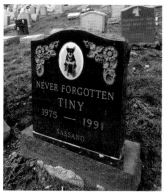

Tiny

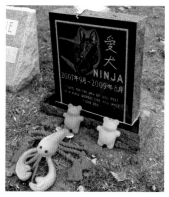

Ninja

Coochie

Duchess and Panda

Babe

Peggy and Carlo

Inky

Led Zeppelin

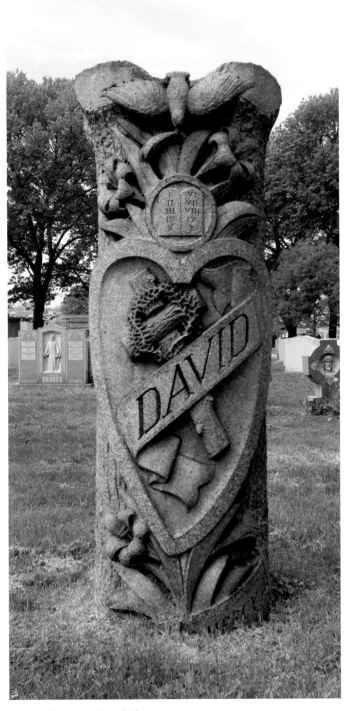

Calvary Cemetery, Woodside

CEMETERY SYMBOLISM

Cemeteries are virtual encyclopedias of symbolism. The symbols on a person's tomb may help to tell us something about the life of its inhabitant. Dead men may tell no tales, but their tombstones do. Besides informing us of the person's name and dates of birth and death, their tombstones often tell us their religion, ethnicity, club memberships, occupations, and philosophy of the afterlife. Most symbols in a cemetery have some connection with a religion, but many are overwhelmingly religion-specific. For an in-depth examination of funerary symbols, consult Douglas Keister's book *Stories in Stone: A Field Guide to Cemetery Symbolism and Iconography*, published by Gibbs Smith.

Mortality Symbols

HOURGLASS (USUALLY WITH WINGS)
The symbolism is clear: time is passing rapidly, and every day, everyone comes closer to the hour of death.

Hourglass (usually with wings), Woodlawn Cemetery, Bronx

TORCH (INVERTED)
The inverted torch with flame burning symbolizes death but suggests that the soul (fire) continues to exist in the next realm.

Torch (inverted), Kensico Cemetery, Valhalla

URN (DRAPED)

The draped cinerary urn is probably the most common nineteenth-century funerary symbol. The drape can be seen as either a reverential accessory or as a symbol of the veil between earth and the heavens.

Urn (draped), Moravian Cemetery, Staten Island

BROKEN COLUMN

In its purest symbolic form, a broken column means a life cut short, but it often simply means a life that has ended.

Broken Column, Kensico Cemetery

DICKINSON

HANDS TOGETHER

Hands that appear to be shaking are usually a symbol of matrimony and can represent a heavenly welcome or an earthly farewell. Usually one cuff is feminine and the other masculine.

Hands Together, Green-Wood Cemetery, Brooklyn

BOOK

An open book is a favorite device for registering the name of the deceased. In its purest form, an open book can be compared to the human heart, its thoughts and feelings open to the world and to God.

Book, Moravian Cemetery, Staten Island

EDWARDS

GEORGE P.
1907 — 1934

Nature Symbols

BUDS AND SEEDPODS

Buds, especially those that are broken, almost always decorate the grave of a child. Rosebuds are the most commonly used.

Buds and Seedpods, Trinity Cemetery, Manhattan

MADONNA LILY (EASTER LILY)

The Madonna lily is a symbol of purity, which can be extended to mean casting off earthly things and attaining heavenly/spiritual qualities. It can also be used as a symbol of chastity.

Madonna Lily (Easter Lily), Calvary Cemetery, Woodside

PASSIONFLOWER

This flower symbolizes Christ's Passion, Redemption, and Crucifixion: the corona ends in thorns reminiscent of Christ's crown of thorns, the white color of the flower reflects his innocence, the stamen and stigma represent the nails that were driven through his hands and feet, and the tendrils represent the whips.

Passionflower, Green-Wood Cemetery, Brooklyn

ROSE

The rose has become the queen of flowers because of its fragrance, longevity, and beauty

In Christian symbolism, the red rose became a symbol of martyrdom, while the white rose symbolized purity. Roses are most often used on a woman's grave.

Rose, Kensico Cemetery, Valhalla

IVY

Because ivy is eternally green even in harsh conditions, it is associated with immortality and fidelity.

Ivy, Moravian Cemetery, Staten Island

WEEPING WILLOW

Although the form of the weeping willow certainly reflects grief and sorrow, in many religions it suggests immortality because the tree will flourish and remain whole no matter how many branches are cut off.

Weeping Willow, Trinity Cemetery, Manhattan

WHEAT

A sheaf of wheat on a tombstone is often used to denote someone who has lived a long and fruitful life.

Wheat, Moravian Cemetery, Staten Island

PALM FRONDS

Palm fronds are a symbol of victory and a triumph over death.

Palm Fronds, Calvary Cemetery, Woodside

Christian Symbols

ANCHOR

The anchor is a symbol of hope. Another type of anchor is the *crux dissimulata*. This anchor is actually a cross in disguise (the bottom open curve represents receptivity to spiritual matters). It is, understandably, a more popular symbol in cemeteries in coastal cities, but it has no direct link to the seafaring life.

Anchor, Moravian Cemetery, Staten Island

CROSS, ANCHOR, AND HEART

The symbols represent the three theological virtues of faith, hope, and charity. The symbol is almost exclusively seen adorning the graves of Catholics.

Cross, Anchor, and Heart, Calvary Cemetery, Woodside

EUCHARIST

The chalice with wafer, grapes, and wheat combined into a single scene are collectively a symbol of the Eucharist.

Eucharist, Calvary Cemetery, Woodside

OSTENSORIUM

In the cemetery, the ostensorium, also known as a monstrance, will mark the grave of a member of the clergy. Ostensoria have an opening in the middle that houses a Consecrated Host.

Ostensorium, Calvary Cemetery, Woodside

HOLY GHOST

A dove dive-bombing from the heavens, with an olive branch, a cross, or a flower in its beak, is the symbol for the Holy Ghost. A similar-looking tableau, but with the dove holding the earth in its beak, is a symbol for the fourth, or highest, degree of a Knight of Columbus, a fraternal organization for Catholics.

Holy Ghost, Calvary Cemetery, Woodside

DOVE AND OLIVE BRANCH

The dove is the most frequently seen bird or animal symbol in the cemetery. It is portrayed in a number of poses, but most frequently it is seen holding an olive branch, a reference to the dove sent out by Noah to search for land. The dove is a symbol of purity and peace because God has made peace with man.

Dove and Olive Branch, Kensico Cemetery, Valhalla

LAMB

Lambs usually mark the graves of children and particularly infants, symbolizing innocence.

Lamb, Trinity Cemetery, Manhattan

AGNES DEI (LAMB OF GOD)

A lamb with a cross or with a banner or halo or with all of the accessories is the symbol for the Lamb of God.

Agnes Dei (Lamb of God), Calvary Cemetery, Woodside

ALPHA AND OMEGA

Alpha and Omega are the first and last letters of the Greek alphabet, symbolizing the beginning and the end.

Alpha and Omega, Trinity Cemetery, Manhattan

IHS

This symbol is often seen emblazoned on crosses. IHS, or IHC (derived from the lower-case Greek letters for *iota, eta,* and *sigma*), is an abbreviation of Jesus' name in Greek: *Ihsus, Ihsoys,* or *Ihcuc.*

IHS, Calvary Cemetery, Woodside

INRI, Trinity Cemetery, Manhattan

INRI

This symbol is very straightforward. It's the first letters of the Latin words *Iesus Nazarenus Rex Iudaeorum,* meaning "Jesus of Nazareth The King of the Jews."

SPES AND FIDES

These letters frequently appear together on religious tableaus. They are the Latin words for hope (*spes*) and faith (*fides*).

SPES and FIDES, Woodlawn Cemetery, Bronx

Gate, Calvary Cemetery, Woodside

GATE

In Christian funerary symbolism, gates represent the passage from one realm to the next.

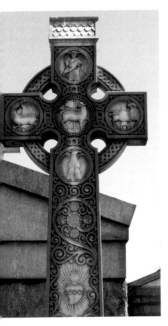

Calvary Cemetery, Woodside

THE EVANGELISTS

The four evangelists who wrote the respective Gospels—Matthew, Mark, Luke, and John—all have winged attributes. When a depiction of a flying cow or an aeronautical lion is seen in the cemetery, it's not the musings of a whimsical artist but the symbol of a saint. Usually all four of the fluttering creatures appear together: an ox, a lion, an eagle, and an angel.

Saint Matthew

Before he became one of Christ's disciples, Matthew was a tax collector, at which time he may have had the name Levi. As a scribe, he is said to have written a detailed account

of the incarnation of Christ in Judea. In art, he is most often portrayed as a man with wings, an angel, because his gospel begins with the human incarnation of Christ.

Saint Mark

Saint Mark's most frequently portrayed attribute is the winged lion because his writings emphasize the dignity of Christ, "the Lion of Judah," and because his Gospel begins with "a voice crying in the wilderness," a reference to John the Baptist. Saint Mark is often

portrayed with a pen in his hand, denoting his service as Peter's secretary.

Saint Luke

Saint Luke is best known for the Gospel of Saint Luke, but he is also well known for writing the Acts of the Apostles. Luke became the constant companion of the apostle Paul and wrote a

detailed account of Paul's life. He is frequently portrayed with a paintbrush in works of art, and he is the patron saint of painters as well as physicians. His most frequently portrayed attribute, and the way he is symbolized in the cemetery, is that of a winged ox. Since the ox has long been a symbol of sacrifice, the angelic ox refers to Luke's emphasis of the priesthood of Christ.

Saint John

John was the youngest of all the apostles. In depictions of the Last Supper, he is the one leaning on Christ's chest. John was present at the Crucifixion, where Christ essentially appointed him to take His place as Mary's son. In the cemetery and in works of art, John's most frequently portrayed attribute is that of an eagle, the symbol of highest aspiration, because his gospel contains the

most vivid account of ascending to heavenly heights.

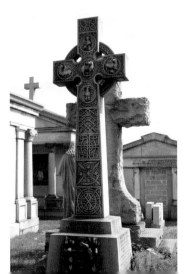

THE CROSS

It's hard to think of a symbol more closely associated with a religion than the cross is with Christianity. But long before Christians utilized the cross as their supreme symbol, other cultures were employing it and modifying it to fit with their cultures. The ancient Druids were known to cut off all the branches of a giant oak tree except for two branches

Calvary Cemetery, Woodside

on either side of the trunk, thus forming a huge natural cross. Other cultures took the basic cross form and added to it. One of the earliest modifications of the cross was by Eastern civilizations who added arms to the end of the cross to form a swastika, or fylfot, cross. Unfortunately, the swastika was also used by power-hungry rulers such as Charlemagne and Hitler, and is now associated with evil.

Although there are dozens of types of crosses in cemeteries and thousands of types of religious crosses, there are basically three types that others evolved from: the Greek cross, which looks like a + sign; the Latin cross, which looks like the letter "✝"; and the Celtic cross, which has a circle ⊕ (nimbus) connecting the four arms of the cross.

Greek Cross

Greek-style crosses and other crosses with equidistant arms are more likely to appear as part of a decoration on a tomb rather than as freestanding crosses. The Saint Andrew's cross looks like an X. The Maltese cross looks like a + sign with flared ends that are usually indented to form eight points. These eight points represent the Beatitudes. This cross is often associated with such fraternal orders as the Knights Templar. Many of the Greek-style crosses are associated with heraldry, and many Christian warriors wore these crosses as they marched off to the Crusades.

Latin Cross

The cross most commonly associated with Christianity is the Latin cross. Some of its many variations are the Cross of Calvary, which is a Latin cross with a three-stepped base, representing the Trinity; the Cross of the Resurrection, which is a simple Latin cross with a spiked end; and the Crucifix, or Rood, that has Christ nailed to it. Cemetery wanderers will also spy many Latin crosses with more than one cross arm. The most common of these is the Cross of Lorraine, which has a shorter arm above the long one. A variation of the style of the Cross of Lorraine is the Russian Orthodox cross, or Eastern Orthodox cross. This cross has an angled crossbar below the main crossbar

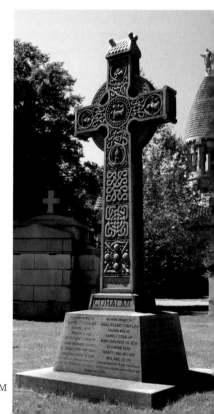

Celtic Cross

Celtic crosses are, without a doubt, the most effervescent of all crosses. Of the dozens of varieties of crosses, the Celtic cross is most intensely associated with a person's roots. The basic form of a Celtic cross is one that is enclosed in a circle (nimbus).

Celtic Cross, Calvary Cemetery, Woodside

Chi-Rho Cross

The Chi-Rho cross is one of Christendom's oldest crosses. The Chi (X) Rho (P) represents the first two letters of XPIETOE (*Christos*) in Greek.

Chi-Rho Cross, Gate of Heaven Cemetery, Hawthorne

Floré Cross

A simple version of the floré (floriated) cross has three-pronged tips that represent the Trinity of the Father, the Son, and the Holy Ghost.

Floré Cross, Green-Wood Cemetery, Brooklyn

Maltese Cross

The Maltese cross has symmetrical flared arms with usually indented tips.

Maltese Cross, Moravian Cemetery, Staten Island

Cross and Crown

The cross with a crown is a Christian symbol of the sovereignty of the Lord. When the crown is combined with a cross, the crown means victory and the cross means Christianity. The cross with a crown can also denote a member of the York Rite Masons.

Cross and Crown, Kensico Cemetery, Valhalla

Crusader's Cross

Greek crosses are usually found applied to tombstones as a

Crusader's Cross, Moravian Cemetery, Staten Island

decoration rather than as freestanding crosses. When surrounded by four smaller crosses, the symbol is known as a Crusader's or Jerusalem cross.

Eastern Orthodox Cross

The Eastern Orthodox cross, also known as the Russian Orthodox cross, has a slanted bar underneath the main cross member. It often denotes burials of people of eastern European descent.

Eastern Orthodox Cross, Kensico Cemetery, Valhalla

Latin Cross

The simplicity of the Latin cross makes it a blank canvas for adding symbols and inscriptions. It is one of the most recognized religious symbols.

Latin Cross, Woodlawn Cemetery, Bronx

THE ANGELS

Besides tombstones, the feature most often associated with cemeteries is angels. While some are draped over tombs in grief, others seem ready to take flight with heavenly joy and aspiration.

Most angels in cemeteries are generic, but with a little sleuthing, a cemetery visitor can usually find an example of Gabriel, since he is portrayed with a horn; statues of Michael with his sword or shield are also fairly common; and cherubs are often found adorning children's graves.

Cassard Monument, Green-Wood Cemetery, Brooklyn

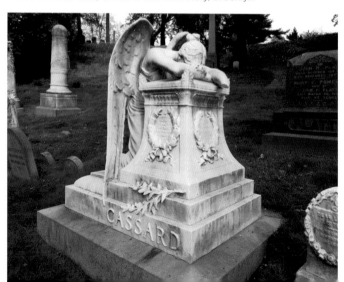

Acea Mausoleum, Green-
Wood Cemetery, Brooklyn

Pell Mausoleum, Kensico
Cemetery, Valhalla

Bachmann Monument, Moravian
Cemetery, Staten Island

O'Donohue Monument, Green-
Wood Cemetery, Brooklyn

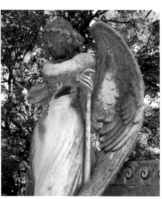

Woodlawn Cemetery, Bronx

Gurnee Mausoleum, Sleepy
Hollow Cemetery, Sleepy Hollow

Kelly Monument, Calvary
Cemetery, Woodside

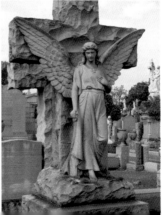

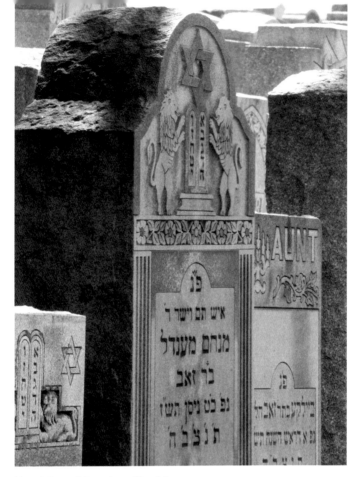

Mount Carmel Cemetery, Glendale

Jewish Symbols

There are over one million Jews living in the Greater New York City area. Many of their ancestors are buried in the dozens of Jewish cemeteries. Unfortunately for tombstone tourists, many Jewish cemeteries have a rather skittish attitude toward visitors. Some cemeteries require visitors to sign in at the cemetery office; others only allow those who have relatives buried in the cemetery. Some are only open by permission while others have a more open-arms approach. Like their nonsectarian and Catholic counterparts, some Jewish cemeteries have been financially mismanaged and have gone into receivership or filed for bankruptcy.

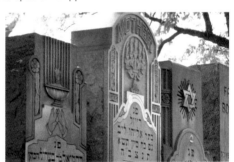

There also seems to be a disproportionate amount of vandalism

in Jewish cemeteries. Among the most spectacular Jewish Cemeteries is Salem Fields in Brooklyn. It has an impressive array of spectacular mausoleums. The cemetery doesn't allow photography, but it is still worth a visit. For an extensive list of cemeteries see the gazetteer.

Jewish people have been memorializing their dead far longer than Christians. Jewish tombstones do not have nearly the vocabulary of symbols as Christian tombstones, but their brevity is deceiving. The father of the deceased person is written on many Jewish tombstones. This piece of information gives genealogists a step back one generation.

HERE LIES

This sign is found on almost every Jewish tombstone. It is the Hebrew words *po nikbar* or *po nitman* ("here lies").

Here Lies, Mount Carmel Cemetery, Glendale, Queens

MENORAH

The menorah is a seven-branched candelabra. It is usually seen on the tombstone of a "righteous" woman.

Menorah, Mount Carmel Cemetery, Glendale, Queens

STAR OF DAVID

The Star of David, a symbol of divine protection, is probably the most well known Jewish symbol. It didn't become a major symbol until the late 1880s, when it was used by Zionists to identify themselves.

Star of David, Sharon Gardens, Valhalla

YAHRTZEIT

The *yahrtzeit* is an oil-filled basin with a floating wick. During Yahrtzeit, a yahrtzeit candle is burned to commemorate the dead. The yahrtzeit is also called a Ner Neshamah, a "Lamp of the Soul."

Yahrtzeit, Kensico Cemetery, Valhalla

EWER (LEVITE PITCHER)

A pitcher signifies a Levite who, according to scripture, was responsible for cleaning the hands of the Temple priest (the Cohanim) prior to a religious service. Aside from these cleansing duties, Levites were also musicians, choir singers, and gatekeepers. In today's world, the Levites are the ones called on after the Cohanim to read the Torah.

Ewer (Levite pitcher), Mount Carmel Cemetery, Glendale

MOSAIC DECALOGUE

Thanks to Charlton Heston and Cecil B. DeMille, almost everyone knows these tablets as the Ten Commandments. In the cemetery, the two tablets are always joined. Sometimes they are seen with the Hebrew figures (five on each side) for the numbers 1–10, while other times the commandments are written out in an abbreviated form. Christians liked the idea of the tablets so much that they modified it with Roman numerals, and it has become a popular Christian symbol as well as a Jewish symbol.

Mosaic Decalogue, Mount Carmel Cemetery, Glendale

COHANIM (KOHANIM) HANDS

These hands with thumbs, and sometimes forefingers, joined are a symbol of the members of the ancient priestly tribe of Aaron, who was a Levite. The Cohanim hands often mark the graves of fallen Cohns, Cohens, Cahns, Cowens, and their families.

Cohanim (Kohanim) Hands, Sharon Gardens, Valhalla

PEBBLES

All cultures have ways of continuing to memorialize their dead by leaving something at the gravesite. Because Jews were originally a nomadic people, it was difficult to leave flowers, so they started using pebbles and bits of rock to note that they had visited, and the tradition became ingrained.

Pebbles, Machpelah Cemetery, Flushing

Asian Symbols

Asian Symbols, Kensico Cemetery, Valhalla

Asian Symbols, Green-Wood Cemetery, Brooklyn

Although Chinese and Japanese tombstones do not have the vast repertoire of funerary symbols as do those from European cultures, they do have some interesting and significant symbols and traditions. The New York area has longtime populations of people with roots in Japan and China. In recent years, there has been an influx of emigrants from Southeast Asia and Korea.

Chinese symbolism is seen more in the funerary rituals than on symbols that appear on tombstones. The most significant Chinese tradition is the observance of Ching Ming, translated roughly as "pure brightness." On the first day of Ching Ming, a priest conducts a 34-step ceremony called the "Three Presentations Ceremony" at the oldest grave in the cemetery.

Another name for Ching Ming is "tomb-sweeping [or cleaning] day" and refers to the cleaning and maintenance of the graves of one's ancestors.

Like the Chinese, the Japanese also have a period of days for remembering the dead. This time is called Obon or Urabon (upside down). Japanese tombstones often have family crests called *mon* or *monsho*, not unlike European crests except they are more stylized. Most crests are strongly tied to nature, and the most popular designs are plants, flowers, and trees followed by birds and beasts.

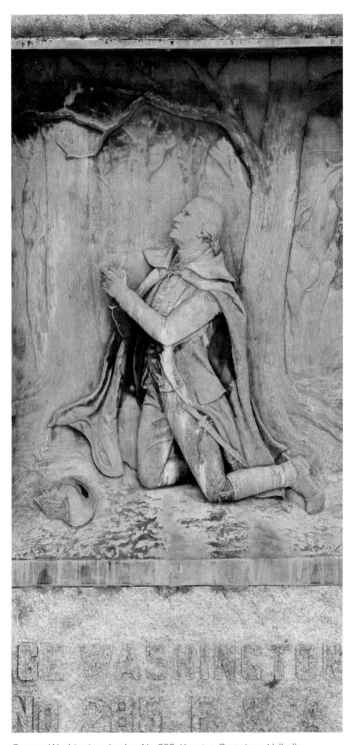

George Washington, Lodge No 285, Kensico Cemetery, Valhalla

SECRET SOCIETIES, CLUBS, AND ORGANIZATIONS

W e are a nation of joiners. Sociologists say that we humans are herd animals—if enough of us are thrown together for any length of time, sooner or later we'll form a club or start a competition and appoint leaders. Most of us have little if any contact with so-called secret societies. At most we'll recall seeing men in funny hats skittering along in parades in miniature cars (Shriners) or seeing an emblem on a sign welcoming us to a town. We may have heard of the Masons or Odd Fellows, but we really aren't sure what they are. However, if we dig just a bit into our personal genealogy, it's likely one or more of our grandparents or great-grandparents was a member of a secret society. Baby boomers may recall seeing episodes of *The Honeymooners* where Ed Norton and Ralph Kramden, outfitted in their International Order of Loyal Raccoon regalia, trundled off to the Lodge (Kramden was the treasurer) or their African American counterparts, Amos Jones and Andy Brown in the *Amos 'n' Andy* show, being squeezed by the Kingfish to participate in one of his schemes as the Great Supreme Kingfish, the leader of Mystic Knights of the Sea.

The greater New York City area didn't tend to have as many secret societies as other parts of America, simply because there are so many social options in New York. As a rule, the farther from the hub of Manhattan, the more secret societies, clubs, and organizations you'll find. Although many of the organizations are now defunct, a surprising number are still active. The best place to find evidence of both the active and extinct societies is in the cemeteries. You'll probably find entire sections devoted to some of the larger organizations, like the American Legion, Grand Army of the Republic, Freemasons, Elks, and Odd Fellows.

Renowned Associations

THE GRAND ARMY OF THE REPUBLIC (GAR)

The GAR was an organization with built-in extinction, since membership was limited to honorably discharged veterans of the Union Army, Navy, Marine Corps, or Revenue Cutter Service who had served between April 12, 1861, and April 9, 1865. The final Encampment of the Grand Army of the Republic was held in Indianapolis, Indiana, in 1949, and the last member, Albert Woolson, died in 1956 at the age of 109 years.

In 1881, the GAR formed the Sons of Veterans of the United States (SV), better known as the Sons of Union Veterans of the Civil War (SUVCW). There is also a women's auxiliary—the Daughters of Union Veterans of the Civil War (DUV or DUVCW). Both organizations are still active today.

The Grand Army of the Republic, Kensico Cemetery, Valhalla

DAUGHTERS OF THE AMERICAN REVOLUTION (DAR)

The Daughters of the American Revolution was founded on October 11, 1890, by a group of women who wanted to acknowledge their patriotism but had a hard time doing it because they weren't allowed into male-only patriotic organizations. Membership in the DAR is open to women at least 18 years of age who can prove lineal bloodline descent from an ancestor who aided in achieving United States independence

The DAR utilizes a seal, an emblem, and a ribbon as symbols of the organization. The insignia is most commonly used to mark the graves of DAR members. The primary part of the insignia consists of a spinning wheel mounted over a distaff—homage to Abigail Adams, who told her husband, John Adams, that the best way for her to help the revolutionary cause was to work with wool and flax. On the wheel's edge is the society's name, Daughters of the American Revolution, surrounded by thirteen stars representing the thirteen original colonies.

Daughters of the American Revolution, Trinity Cemetery, Manhattan

DAUGHTERS OF AMERICA (D OF A)

Daughters of America was formed in 1891 as an auxiliary to the Jr. Order of United American Mechanics. Its first charter was issued in Allegheny County, Pennsylvania, as The National Council Daughters of America. Although intended as an auxiliary organization, it did not

receive recognition from the male order until 1926. The eagle and stars signify patriotism, and the Holy Bible signifies religion. In 1930, it had over 160,000 members.

Daughters of America, Sleepy Hollow Cemetery, Sleepy Hollow

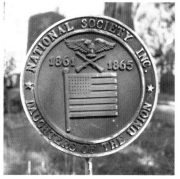

Daughters of the Union, Sleepy Hollow Cemetery, Sleepy Hollow

DAUGHTERS OF THE UNION

The National Society Daughters of the Union 1861–1865 was founded October 9, 1912, in New York City by Mrs. Frank Crowell. The Society is a hereditary society formed to honor the soldiers and patriots who served the Union during the Civil War. The organization is still active and has 22 chapters in 11 states.

ELKS (BPOE)

EMBLEM CLUB (EC)

BLACK ELKS (IBPOEW)

Tombstones of Elks are easy to identify. They have an emblem with an elk in the center, surrounded by a clock frozen at the eleventh hour, and the letters BPOE (Benevolent Protective Order of Elks). Sometimes the words *Cervus Alces*, which is a large extinct European elk, are also on the emblem.

The Elks were an offshoot of a New York drinking club called the Jolly Corks (JC) that was formed by actors in 1866. The purpose of the club was to avoid a New York law that prohibited the sale of spirits on Sundays. The name Jolly Corks must have seemed a bit too explicit, and the Elk was adopted as their name and symbol. Today the Elks have over 1,500,000 members, and it is now one the largest of the "animal clubs." The Emblem Club is the ladies auxiliary of the Elks.

In early 1898, two African Americans, B. F. Howard and Arthur J. Riggs, tried to join the all-white organization. After being denied membership, they formed the Improved Benevolent Protective Order

Elks Plot, Kensico Cemetery, Valhalla

of the Elks of the World on November 17, 1898. The IBPOEW currently claims a membership of approximately 500,000.

MOOSE (LOOM)

WOMEN OF THE MOOSE (WOM) (WOTM)

Dr. John Henry Wilson founded the Loyal Order of the Moose (now known as Moose International) in 1888 in Louisville, Kentucky. The Loyal Order of the Moose met in lodges called "watering places," a reference, no doubt, to the alcoholic beverages that were consumed.

Today, membership hovers around 1.8 million. Two of Moosedom's proudest achievements are Mooseheart (a campus-like environment that provides care for the families of fallen Moose) and Moosehaven (a retirement community in Florida). The Moose emblem usually contains the letters P A P (Purity, Aid, Progress). The female auxiliary, the Women of the Moose, was established in 1913. Its emblem is essentially the same but contains the letters H F C (Hope, Faith, Charity).

Moose, Moravian Cemetery, Staten Island

EAGLES (FOE)

LADIES AUXILIARY OF THE EAGLES

The Fraternal Order of Eagles, originally named "The Order of Good Things," was founded in Seattle, Washington, in 1898 by a group of theater owners. According to the Eagles, their first organizational meetings revolved around a keg of beer, and before long, the wishy-washy name of the Order of Good Things was changed to the more authoritarian Fraternal Order of Eagles. A constitution and bylaws were drawn up, and the name Aerie was adopted as the designation for their meeting places and groups. The Eagles were originally composed of people working in the theater business (actors, stagehands, playwrights, etc.), and word of the organization spread rapidly because of the mobile nature of its members.

The L T J E acronym that sometimes appears in their emblem stands for Liberty, Truth, Justice, Equality. The Eagles still thrive. Much of their work revolves around lobbying for improvement of workman's compensation and social security, and sponsoring a number of health-related charities.

AMERICAN LEGION (AL)

The American Legion was founded in Paris, France, in 1919.

Eagles, Sleepy Hollow Cemetery, Sleepy Hollow

American Legion, Sleepy Hollow Cemetery, Sleepy Hollow

It is primarily an association for ex-servicemen, and it works especially hard for veterans' rights for the wounded, infirm, and elderly. Because of its substantial membership, it also exercises quite a bit of political clout. The American Legion has gone to great lengths to explain the symbolism of their emblem:

The Rays of the Sun form the background of our proud Emblem, and suggest that the Legion's principles will dispel the darkness of violence and evil.

The Wreath forms the center, in loving memory of those brave comrades who gave their lives in the service of the United States, that liberty might endure.

The Star, victory symbol of World War I, signalizes as well honor, glory and constancy. The letters U.S. leave no doubt as to the brightest star in the Legion's star.

Two Large Rings, the outer one stands for the rehabilitation of our sick and disabled buddies. The inner one denotes the welfare of America's children.

Two Small Rings set upon the star, the outer pledges loyalty and Americanism; the inner is for service to our communities, our states and the Nation.

The words American Legion tie the whole together for truth, remembrance, constancy, honor, service, veteran's affairs and rehabilitation, children and youth, loyalty, and Americanism.

WOODMEN OF THE WORLD (WOW)

Treestones, also known as "tree-stump tombstones," often mark the resting place of a Woodman of the World. Joseph Cullen Root, a native of Lyons, Iowa, founded Woodmen of the World in Omaha, Nebraska, on June 6, 1890. Root's organization was originally open to white males, aged 18 to 45, from the 12 healthiest states, and it specifically excluded men in hazardous vocations like train brakemen, gunpowder factory employees, bartenders, and even professional baseball players. Eventually, Woodmen of the World relaxed most of its restrictions and today totals more than 800,000 members. It is now known as the Woodmen of the World Life Insurance Society/Omaha Woodmen Life Insurance Society.

On tombstones, there are usually the Latin words *Dum Tacet Clamet*, roughly translated as "Though Silent, He Speaks" or in popular language as "Gone But Not Forgotten." Also usually embossed on the tombstone are a dove with an olive branch (peace) and an axe, beetle, and wedge that, according to Root, symbolize workmanship and progress of culture.

Like many organizations,

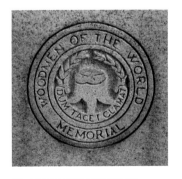

Woodmen of the World, St. Raymond's Old Cemetery, Bronx

the Woodmen had internal problems, and a number of schisms and splinter groups developed. Some of them are Women of Woodcraft (WOW), Neighbors of Woodcraft (NOW), Woodmen Circle (WC), Royal Neighbors (RN), Supreme Forest Woodmen Circle (SFWC), Modern Woodmen of the World (MWW), and Woodmen Rangers and Rangerettes (WRR).

FREEMASONS

PRINCE HALL FREEMASONS (PHF) BLACK SOCIETY

The primary symbol of the Freemasons is the square and compass. Often inside the symbol is the letter G, which some say stands for geometry while others say it stands for God. The square and compass represent the interaction between mind and matter, and refer to the progression from the material to the intellectual to the spiritual. The

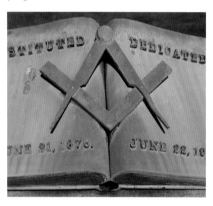

Freemasons, Kensico Cemetery, Valhalla

Freemasons have a gift for clouding the origins of their organization, but historians say the roots of Freemasonry were among the stonemasons who built the great cathedrals in Europe. Since they went from job to job and were essentially self-employed, they were "free masons." When they worked on a large job, they banded together to form lodges. The Masons have grown to become the largest fraternal organization in the world. They are noted for their wide use of symbols and secret handshakes. A free black named Prince Hall started the black equivalent of the Freemasons in 1775 in Boston after being refused membership in the Masons. That organization, which is still quite active, is known as the Prince Hall Freemasons.

Conspiracy theorists love to point to George Washington's Masonic background, citing the Freemasons' input on the layout of Washington, D.C., influence in politics and the mysterious symbols on the dollar bill. What is known for sure is that Washington was a Freemason as were 33 of his generals, plus the Marquis de Lafayette, Ethan Allen, Benjamin Franklin, John Hancock, John Paul Jones, Paul Revere, 10 of the signers of the Articles of Confederation, 9 signers of the Declaration of Independence, and 13 signers of the Constitution.

Besides the square and compass, also be on the lookout for other Masonic symbols such as the all-seeing eye, often with rays of light, which is an ancient symbol for God.

SHRINERS (AAONMS)

The Imperial Council of the Ancient Arabic Order of the Nobles of the Mystic Shrine (AAONMS), better known as the Shriners, was founded in 1872 by New York City Freemasons Walter M. Fleming (a medical doctor) and William J. Florence (an actor). The pair attended regular lunches at the Knickerbocker Cottage restaurant at 626 6th

Avenue with other Masons. Fleming, Florence, and others often complained that they weren't having enough fun at Freemason functions, so along with the other 11 members of their lunch group, they formed the Mecca Temple (Mecca Shriners). The Shriners were only open to 32nd-degree Master Masons and Knights Templar. They adopted many of the symbols of Islam but

Mecca Shriners, Moravian Cemetery, Staten Island

in a parody form, which, understandably, has irritated followers of that religion. They routinely wear amusing garments, including fezzes, and give themselves titles like Most Illustrious Grand Potentate. At one time, the Freemasons considered banning any member who was also a member of the Shriners. When the letters of the Ancient Arabic Order of the Nobles of the Mystic Shrine are rearranged, they spell "A MASON."

The emblem of the Shriners contains a scimitar, from which hangs a crescent, "the Jewel of the Order." In the center is the head of a sphinx (not always seen in simple emblems) and a five-pointed star. On elaborate renditions of the emblem, the crescent contains the motto *Robur et Furor* ("Strength and Fury").

KNIGHTS TEMPLAR (KT)

SOCIAL ORDER OF THE BEAUCEANT (SOOB)

In cemetery symbolism, the Knights Templar is part of the convoluted Freemasons structure. The Knights claim to have been founded by a group of warrior monks in 1118, whose job was to keep the roads safe for pilgrims traveling to Jerusalem. So many of their affairs have been shrouded in secrecy that it is impossible to put together an accurate

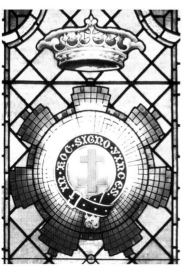

Knights Templar, Kiralfy Mausoleum, Green-Wood Cemetery, Brooklyn

history, except to say that in the cemetery, the Knights Templar emblem is almost always seen in its Masonic form, which is the symbol for York Rite Templarism: a crowned Passion cross laid upon a *cross pattée*, often with the phrase *In Hoc Signo Vinces* ("in this sign conquer"), mistakenly thought to be the origin of the Christian monogram IHS, resting on crossed swords.

The female auxiliary of the Knights Templar is the Social Order of the Beauceant. The emblem of the SOOB, a cross and a crown, is the same as the Knights Templar except it has the letters S O O B around the outside.

EASTERN STAR (OES) (ES)

PRINCE HALL EASTERN STAR (PHES)— BLACK WOMEN'S ORGANIZATION

PRINCE HALL GRAND CHAPTER (OF THE) EASTERN STAR (PHGCES)—BLACK WOMEN

The Order of the Eastern Star has a convoluted history, but simply put, it is the female counterpart to Freemasonry. There are three organizations that use the name Eastern Star: the General Grand Chapter, Order of the Eastern Star; the Prince Hall–affiliated Eastern Stars; and the Federation of Eastern Stars. The original group, the General Grand Chapter, Order of the Eastern Star, was formed in 1876. It has been in decline in recent years, no doubt because of its powerful patriarchal rules. All degrees must be administered by a Master Mason (male).

A five-pointed star with the tip pointing down marks the grave of a member of the Eastern Star. Each symbol within the star points represents a heroine: Adah, Ruth, Esther, Martha, and Electa. They also symbolize the tenets of the Eastern Star: fidelity, constancy, loyalty, faith, and love. On tombstones, sometimes between the points

of the star and other times in the center of the star, are the letters F A T A L. This refers to a double meaning of an oath taken by a member of the Eastern Star when a degree is bestowed on her. The first meaning is simply the word "FATAL," which means that it would be fatal to the character of a lady if she disclosed any of the secrets of the order. The other meaning of FATAL is an acronym meaning "Fairest Among Ten-thousand Altogether Lovely."

Eastern Star, Moravian Cemetery, Staten Island

KNIGHTS OF COLUMBUS (KC) (K OF C)

The Knights of Columbus, founded in 1882, has often been described as the "Catholic Masons" because Catholics were forbidden by a Papal edict from joining the Freemasons. The purpose of the fraternal organization, which was originally open to Catholic men over the age of 18, was to provide assistance to widows and orphans of the parish.

The emblem of the Knights of Columbus incorporates a medieval knight's shield mounted on a *formée* cross, an artistic representation of the cross of

Knights of Columbus, Gate of Heaven Cemetery, Hawthorne, Westchester County

Christ. Mounted on the shield are three objects: 1) a fasces, an ancient Roman symbol of authority composed of a bundle of rods bound together around an axe; 2) an anchor, which is the mariner's symbol for Columbus; and 3) a short sword, which is the weapon of the knight when engaged in an "errand of mercy."

INDEPENDENT ORDER OF ODD FELLOWS (IOOF)

GRAND UNITED ORDER OF THE ODD FELLOWS (GUOOF) BLACK SOCIETY

Sometimes the Odd Fellows are known as the "poor man's Freemasonry." The primary symbol of the Independent Order of Odd Fellows is three links of a chain. The links represent Friendship, Love, and Truth. On tombstones, the letters F L T are often enclosed within the links of the chain.

Independent Order of Odd Fellows, Sleepy Hollow Cemetery, Sleepy Hollow

The IOOF is an offshoot of the Odd Fellows, which was formed in England in the 1700s as a working-class social and benevolent association. The United States branch was founded in Baltimore, Maryland, on April 26, 1819, when Thomas Wildey and four members of the Order from England instituted Washington Lodge No. 1. By 1915, there were 3,400,000 members. The Great Depression and lack of interest in fraternal orders took their toll, and by the 1970s, there were fewer than 250,000 members. Death care, including funerals, was one of the major benefits of Odd Fellows membership. After a lodge was established in a new town, one of the first orders of business was to purchase plots in an existing cemetery or to establish a new cemetery where plots were sold to members at a modest fee. The Grand United Order of the Odd Fellows was a black fraternal order modeled on the Odd Fellows.

Daughters of Rebekah, Sleepy Hollow Cemetery, Sleepy Hollow

DAUGHTERS OF REBEKAH (DR)

The Daughters of Rebekah was formed in 1851 as a female auxiliary of the Odd Fellows. Like other women's auxiliaries of fraternal organizations, they were subservient to the male organization, and understandably, their numbers have fallen off in modern times.

In the cemetery, look for a circular emblem with a half moon sometimes containing seven stars on the right, which, according to the Rebekahs, represents "the value of regularity in all our work." The emblem also consists of a dove (peace), a white lily (purity), and the intertwined letters D and R. Sometimes the emblem also contains a small beehive, which symbolizes "associated industry and the result of united effort."

FORESTERS OF AMERICA (F OF A)

The Foresters of America was an offshoot of the Group Ancient Order of Foresters that had its beginnings in Brooklyn in 1841. However,

Foresters lore traces its beginning to medieval times in the royal forests of England. The Forest Charter of 1217 set the titles of the various officers in charge of different aspects of the forests, all of which were royal preserves. Any peasant caught hunting in them was subjected to huge penalties by law. According to Forester history, guilds and fraternities began organizing during the reign of Richard II (1377–1399) to care for the sick and to alleviate suffering. Whether the folklore is true of not, the Foresters of America used it to gain credibility as a mutual benefit society.

Foresters of America, Sleepy Hollow Cemetery, Sleepy Hollow

COMPANIONS OF THE FOREST OF AMERICA (CFA)

The Companions of the Forest of America, a women's auxiliary of the Foresters of America (F of A) was formed in 1885. Sometimes the name of the organization is abbreviated as C of F of A on an emblem. The letters S S C may also appear, which stand for Sociability, Sincerity, and Constancy.

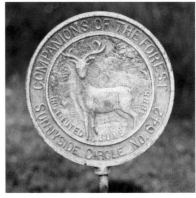

Companions of the Forest of America, Sleepy Hollow Cemetery, Sleepy Hollow

Renowned Jewish Associations

The five boroughs of New York City and Westchester County have the largest Jewish population in America (Miami is second). Approximately 1.2 million of the area's 8.1 million population are Jews. While many Jews were welcomed into secret societies, other societies excluded them. There were also large numbers of new Jewish emigrants who felt more comfortable in organizations that were exclusively Jewish. Like their predominately Anglo counterparts, the heyday of Jewish secret societies was in the early twentieth century.

Prior to the establishment of secret societies, there were "burial societies" (*Chevra Kadisha*) to care for the dead. The tradition of having a formal group to tend to the dead goes back two thousand years and is mentioned in the Talmud (the central text for mainstream Judaism). A burial society was one of the first institutions established in a Jewish community. The Chevra Kadisha was responsible for everything related to burial, from pronouncing death, to preparing the body, to cemetery maintenance. The Chevra Kadisha had the responsibility of providing burial for all the members of the community, despite their status. The family of the deceased was charged for the burial on a sliding scale depending on their financial ability. Even poor families with little or no financial means were tended to, often for no charge. The tasks and duties of the Chevra Kadisha is considered highly commendable, since tending to the dead is an act of kindness that the recipient cannot return, thus making it entirely devoid of hidden intentions. In the past, membership in the Chevra Kadisha was usually handed down from father to son. In New York, the oldest burial society was established in 1802 by the Portuguese-Jewish congregation. It was called the *ebrah Hesed ve-Emet* ("loving kindness and truth").

WORKMEN'S CIRCLE

DER ARBETER RING (AR)

The Workmen's Circle was founded in 1900 as a response to the poor labor conditions that existed for Jewish emigrants. It soon became very influential in the labor movement and labor politics. By 1923, it had 81,000 members in 678 lodges. The society still exists. According to its website, its mission "fosters Jewish identity and participation in Jewish life through Jewish, especially Yiddish, culture and education, friendship, and the pursuit of social and economic justice." The society seems to have adopted the treestone (see page 17) as the tombstone of choice for its members. In some

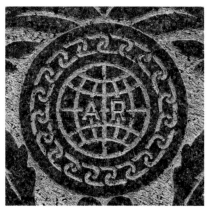

Workmen's Circle

cemeteries, the society purchased plots for its members. The plots, which are liberally peppered with treestones, tend to look like a forest of granite tree-stumps.

B'NAI B'RITH (IOBB)

The Independent Order of B'nai B'rith (*B'nai B'rith* is Hebrew for Children of the Covenant) was established in New York City on October 13, 1843. It was formed by 12 German-Jewish emigrants. The meetings, which originally were conducted in German, were held at Sinsheimer's Café on the Lower East Side. The IOBB borrowed many of the traditions of other contemporary secret societies such as secret handshakes, passwords, and elaborate regalia, much like the Freemasons and the Odd Fellows. It also adopted the motto "Benevolence, Brotherly Love and Harmony." In 1843, the order consisted of six degrees, each illustrated by examples from Jewish history. In 1879, the IOBB adopted a single degree and formalized the society's symbols. A white, blue, and red-striped cord symbolizes the bondage suffered in Egypt, the bond of fraternal brotherhood, the standards of the tribes of Israel, and patriotism and loyalty to country. A shepherd's staff symbolizes vigilance and industry. The tablets of the law (commandments), ark, cherubim, and seven-branched menorah symbolize light, justice, peace, benevolence, brotherly love, harmony, truth, and the temple of the Holy City.

Originally, the society provided an insurance policy to members, which included a death benefit that awarded $30 to widows of fallen members to pay for funeral expenses. The insurance policy also included a stipend of a dollar a week for the rest of the widow's life. The organization is now simply called B'nai B'rith and has evolved into a large charitable organization that claims about 225,000 members in 50 countries. Its well-known Anti-Defamation League, serves to combat anti-Semitism.

INDEPENDENT ORDER TRUE SISTERS (IOTS)

UNITED ORDER TRUE SISTERS (UOTS)

The Independent Order of True Sisters was founded in 1846 in New York City by Henrietta Bruckman, the wife of a prominent New York physician. The organization claims to be the oldest women's philanthropic organization in America. It was strictly for women and not associated with any male fraternal society. Originally, the IOTS conducted its meetings in German; then in 1918, English became the official language of the order. At that time, the name was changed to the United Order True Sisters (UOTS). Its Grand Lodge headquarters was in New York City for over 150 years, but it is now located in Delray Beach, Florida. Small chapters, which concentrate on cancer research, continue to exist in New York, Maryland, Florida, Massachusetts, Ohio, and Arizona. Its symbol is a laurel wreath containing the letters U O T S.

FREE SONS OF ISRAEL (FSOI)

INDEPENDENT ORDER OF FREE SONS OF ISRAEL

The Independent Order of Free Sons of Israel was founded by 11 men on January 10, 1849, in New York City. The first lodge, named Noah Lodge No 1, held its meetings in a building at the corner of Ridge and Houston Streets. The initiation fee was $1. A motto of "Friendship

Love and Truth" (the same motto as the Odd Fellows) was adopted, and measures were introduced to provide insurance benefits for the sick and aid to widows and orphans. In the next few years, other lodges were chartered in the New York City area. By 1862, the order had approximately 900 members in 10 lodges and two lodges for women. By 1875, the organization had 47 men's lodges and six women's lodges in a number of states, with a combined membership of 4,655. Although the official name of the organization is the Independent Order of Free Sons of Israel, it gradually became known as simply the Free Sons of Israel. The FSOI still exists and also has a Junior order and an Improved Order. The emblem of the order depicts a widow and an orphan.

ORDER OF B'RITH ABRAHAM (OBA)

IMPROVED ORDER OF B'RITH ABRAHAM (IOBA)

The Order of B'rith Abraham was established in New York City on June 12, 1859. It was organized in a lodge system and provided the usual sick and death benefits to its members and survivors of members. The OBA was modeled on the B'nai B'rith and the Sons of Israel as well as the Freemasons. A schism developed in 1887, and then a breakaway order, the Improved Order of B'rith Abraham, was formed. By 1927, the Order of B'rith Abraham finally went defunct, but the Improved Order of B'rith Abraham survived, eventually merging with B'nai Zion in 1981.

INDEPENDENT ORDER OF THE SONS OF BENJAMIN (IOSB)

The Independent Order of the Sons of Benjamin was founded in New York City in 1877. It was founded by members of the Order of B'rith Abraham, the Masonic Fraternity and the Independent Order of Odd Fellows, and incorporated some of their rituals into the order. Lodges that were exclusively for women were also established. By 1899, the IOSB had 18,000 members in 200 lodges, but it is now defunct.

B'NAI ZION (BZ)

B'Nai Zion (Sons of Zion in Hebrew) was originally founded as Order Sons of Zion in 1908 in New York City. It became B'nai Zion in 1945. It continues today as a life insurance society, promoting Jewish causes and providing insurance. In 1981, the organization absorbed the Independent Order of B'rith Abraham. The organization publishes a quarterly, the *B'nai Zion Voice*.

A number of other Jewish societies were founded in the latter part of the nineteenth and early twentieth century. These societies were often formed by Jewish members of the Freemasons and Odd Fellows or by members of existing Jewish societies. Among them were the Kesher Shel (founded 1860), Ahavas Israel (founded 1890), American Star Order (founded 1884), Independent Order of American Israelites (founded 1894), and Independent Order Free Sons of Judah (founded 1890).

IN SUMMARY

There are literally hundreds of secret societies, clubs, and organizations. Many no longer exist while others remain strong. When you see an emblem with an acronym that you aren't familiar with or simply find an acronym without an emblem, enter it into an Internet search engine. You may be pleasantly surprised with how many results you get.

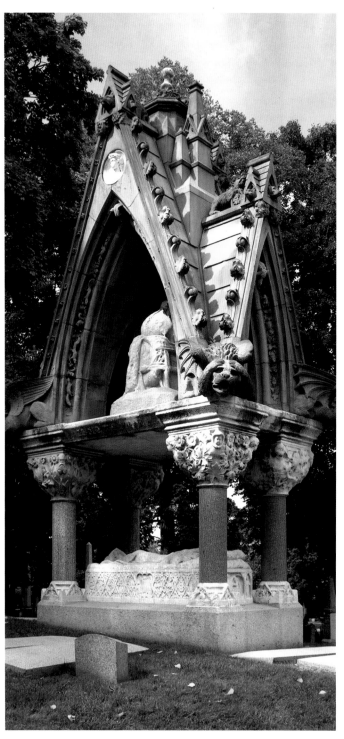

Matthews Monument

STORIES IN
STONE

The old saw goes, "You only have one chance to make a first impression." Conversely, you only have one chance to make a last impression. Most gravestones, monuments, and mausoleums tell us little about the occupant's life beyond birth and death dates. Others contain symbols that may point us to the person's religious beliefs and secret societies, clubs, and organizations they belonged to. Some monuments are unique personal statements. When we see them, we are drawn to them, knowing that their form surely must tell a story—a story in stone. What follows are a selection of stories in stone, including two from outside the New York City area, and one mystery that still remains unsolved.

The Soda Water King

Matthews Monument
The Green-Wood Cemetery
Brooklyn, New York
40° 39' 19.26" N 73° 59' 51.15" W

One of the most effervescent tombs gracing Green-Wood's grounds is the monument to John Matthews (1808–1870). Its spectacular array of ornamentation looks like it just bubbled up out of the ground in a terra-cotta and marble ooze. And well it should bubble, for John Matthews brought soda water to America. He was born in England, and as a teenager, he apprenticed in the shop of inventor Joseph Bramah, where he learned how to make machinery and, most importantly, learned how to make carbonic acid gas, the essential ingredient for soda water. In 1832, he left England for America and soon set up shop at 55 Gold Street in Manhattan, where he began to manufacture carbonating machinery and sell soda water to local retailers.

Matthews' business took off when he realized he could use marble chips to make soda water and that there was an ample supply, thanks to the many construction projects taking place in the booming burg of New York. In fact, there were enough scrap marble chips from the construction of nearby St. Patrick's Cathedral to make 25 million gallons of soda water. Matthews' other advantage over his competitors was his rather ingenious human-safety-valve in the form of an ex-slave named Ben Austen. At the time, safety valves were unreliable, and there were frequent explosions. Ben Austen had a large and powerful thumb that he held over the pressure cock. When the pressure blew Austen's thumb off the pressure cock, the pressure in the tank had reached the desired limit of 150 pounds and the pressurization was stopped. Austen's thumb was

so valuable that when a number of blacks were lynched during the Irish riots during the Civil War, Austen was hidden in a shipping crate to avoid detection. The term "Ben's thumb" was part of the jargon in the soda water manufacturing industry, meaning the soda water was at the proper pressure.

John Matthews' business continued to prosper, and he opened up numerous soda fountains, sold soda water, added flavoring to soda water, and licensed soda water apparatus. By the time he died, Matthews owned over 500 soda fountains. The Soda Water King's final resting place is in the form of a catafalque/sarcophagus encompassed in a *castrum doloris* (Latin

for "castle of grief"), a type of elaborate tomb usually reserved for royalty, popes, and the elite. These tombs are adorned with funerary symbols, allegorical figures, and often scenes from the person's life. The Matthews tomb has the faces of his daughters carved into the gables, his wife (some accounts say it is a statue of grief) seated above him, gargoyles, and various woodland animals scampering around the edges. Prostrate and almost melting into his sarcophagus, Matthews looks up at relief panels, which depict events in his life—apprenticing at the shop in England, leaving England for America, pondering the idea of soda water, and finally being crowned for his achievements. The area around the Matthews tomb is peppered with the graves of other members of the Matthews family.

The tomb, which was crafted by Karl Muller, won an award as the Mortuary Monument of the Year soon after it was built in 1870. However, noted art critic Effie Brower had other words for it. In her 1878 book *In Memoriam: Greenwood Leaves*, she said that "[it reflected] the hideousness of morbid taste."

The Lightning Boys

Demmerle Monument
Woodlawn Cemetery
Bronx, New York
40° 53' 28.15" N 73° 52' 28.49" W

It was a dark and stormy night, but not nearly as dark and stormy as the afternoon that preceded it. July 30, 1905, started as a typical sultry New York City summer day. Thousands flocked to Coney Island and Brighton Beach to cool off by beach bathing. Men, women, and children frolicked in the saltwater. They swam, they bathed, and they waded in the tepid Atlantic waters. Around 3:00 p.m., opaque clouds broiled up in the southeast and started making their way toward Coney Island. Distant thunder rolled and lightning flashed, but few heeded the warning. An hour later, the sky over Coney Island darkened to an eerie twilight glow, and a torrential rain poured down on the beachgoers. Despite the thundering wall of rain, few sought shelter. After all, they were already

wet from their bathing, and the cool fresh rainwater was a welcome antidote to the warm saltwater. Even hundreds of non-bathers ran out into the open, dancing and reveling in the cool rain.

That changed at 4:30 when a monster thunderclap followed by a drenching rain sent the revelers to the shelter of hotels and the large bathing pavilion. Minutes later as the sky grew even blacker, even the hardiest bathers had had enough. About 200 of them ran to an area underneath the elevated boardwalk, an area right next to a 90-foot flagpole. Witnesses said they heard a deafening splintering crash accompanied by an enormous flash. The flagpole shattered, sending the shredded flag to flutter at half staff. Some women screamed while others fainted. Men, women, and children ran from the scene. Some lay stunned and blackened on the sand and others wobbled away. The ones that were stunned eventually crawled away. But there were others who did not walk away. Five young men lay dead, their blackened bodies motionless on the sand. Among the five were brothers Charles R. and Frank Demmerle and their cousin Robert T Wasch.

Their story is told by an evocative monument at Woodlawn. The plot was purchased by Charles R. and Frank Demmerle's father, Charles H. Demmerle, on August 1, two days after the terrible tragedy. Demmerle commissioned a monument to be carved by Anna S. Mayer. The bronze panels were crafted by noted New York sculptor George Brewster, who was particularly known for his military works.

Unlike most monuments that tell little about the resident's death, this one tells a story—a story in stone. Worked into the stone are reliefs of the boys with their names in script, their birth dates, the date of the tragedy, the inscription "Our fondest hopes lie buried here!" and another inscription, "Taken suddenly in an hour of happiness, Struck by a bolt of lightning." Above the bronze panels of the boys are the words "our jewels." The monument and smaller stones in front that mark the individual graves are awash with funerary symbols. The rustic treestone motif features broken branches, signifying lives cut short; a rose on the marker of Emilie Demmerle, the boys' mother, signifies love; and oak leaves on the stone of Charles H. Demmerle symbolizes a long life and the strength he needed to cope with the deaths of the young men and his wife, who died five years before him. The monument is also ringed in twisted vines of ivy, representing immortality. The most evocative

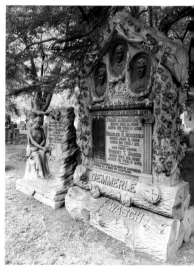

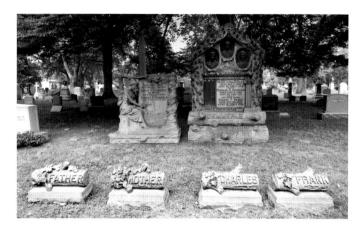

feature of the monument is a low-relief bronze panel that depicts the site of the tragedy. On it are power poles, the Coney Island boardwalk, and the shattered flagpole with the flag fluttering at half-staff. The Demmerle Monument is in a secluded area in the Holly plot and is one of Woodlawn's hidden treasures. A smaller monument to Charles H. Demmerle (July 8, 1854–November 14, 1923) and his wife, Emilie (February 8, 1856–June 18, 1918), is just off to the left.

Boneyard Bonanza; Boneyard Borasco*

Jones Gravesite
Cypress Hills National Cemetery
Brooklyn, New York
40° 41' 9.51" N 73° 52' 52.53" W

In 1968, pop artist Andy Warhol was famously quoted as saying, "In the future, everyone will be world-famous for 15 minutes." James Jones got his 15 minutes in January 1923. Too bad he had been dead for two years.

At the beginning of the twentieth century, Mother Russia was in turmoil. The final blow to the Tsarist regime came in July 1918, when the Bolsheviks assassinated the royal family of Tsar Nicholas II. The family had been taken to the basement of the Ipatiev house in Yekaterinburg, where they were dispatched by a firing squad. Four of the children, Anastasia, Tatiana, Olga, and Maria survived the first volley of bullets because they were wearing over 1.3 kilograms of diamonds and precious gems sewn into their clothing. Their glittering body armor was part of the crown jewels of Russian.

For a number of years, the Bolshevik government had been rounding up the crown jewels and slowly selling them off to help finance the new government. By the early 1920s, the Bolsheviks were selling off the jewels by the crate-load. By 1922, they had sold approximately $80 million of the jewels. Security was rather haphazard, and various caches of the jewels were spirited out of the country by means other than official government channels. Hardly a day went by without some sort of report about caches of the jewels finding their way onto the open market. One of the most interesting ways of transporting the jewels was purportedly via African American seaman James Jones.

In the summer of 1920, the United States army transport *Edellyn* was steaming its way from Vladivostok, Russia, to New York City. On board were crewmember messman James Jones and, reportedly, various items

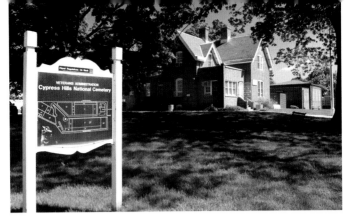

ABOVE: The office where James Jones's casket was opened

LEFT: Somewhere in Cypress Hills rests the body of James Jones

of contraband, including seven bags of jewels that had formerly been part of the crown jewels of Russia. The *Edellyn* ping-ponged its way along a route that took it from Vladivostok to Honolulu to the Canal Zone to Gibraltar. On August 22, 1920, just off Gibraltar, James Jones expired under what was described as mysterious circumstances. Interestingly, there was an embalmer aboard, and Jones was promptly embalmed and placed in a coffin, and the lid was screwed down tight. The *Edellyn* steamed on with the embalmed body of James Jones, finally docking in New York on September 7.

Apparently U.S. Treasury Department agents had been alerted that the jewels were on the ship, and after docking, the *Edellyn* was searched from stem to stern. The agents found a number of items of contraband, but they did not find any of the jewels. James Jones's coffin was not searched. His coffin stayed on the *Edellyn* for 23 days while a search for family members was conducted. All the investigation yielded was that Jones had a son who was last seen in France during World War I, but he could not be located. On September 23, 1920, James Jones was finally laid to rest with 5,000 others who had served their country at Cypress Hills National Cemetery in Brooklyn. And there he rested for over two years.

At the end of 1922, Treasury Department agents received word from a disgruntled conspirator who had been double-crossed by some of his smuggler accomplices that the jewels had indeed been aboard the *Edellyn* and that the treasure was buried at Cypress Hills National Cemetery. The conspirator told the agents that he had information that while James Jones reposed in the *Edellyn*'s hold, one of the smugglers stole in at night, unscrewed the coffin's lid, ripped open the padding, and slipped the seven bags of jewels from beneath Jones's body. He said that the smuggler then cabled his co-conspirators, who were posing as customs agents, that a new plan had been set in motion. But something went awry and the scheme could not be completed.

Treasury Department special agent William B. Williams soon mounted an investigation. The press got wind of the story, and at first, Williams was rather vague on the investigation. In a story that ran on

January 5, 1923, he poetically told the *New York Times* that: "We are always looking for the Russian crown jewels. They are hardy perennials and bloom the year round. We count the day lost when we don't get a report about them." But when pressed by the *Times* further, Williams finally admitted that he would be seeking a court order to open a grave in Cypress Hills. Although Williams would not disclose the name or location of the grave, it was the grave of Seaman James Jones. Soon after the story was reported, an armed squad of men, machine guns at the ready, was seen standing guard at the cemetery. As the days ticked on, more and more members of the press and the public were craning their necks at Cypress Lawn to see what was going on there.

Speculation continued to mount, with some reports saying that Jones's coffin contained upwards of $4 million worth of the jewels. Finally the necessary court order was obtained, and it was announced that the grave of Seaman James Jones would be opened on February 14, 1923. That morning, as a crowd gathered, it was kept at a distance by a detachment of the Eighteenth Infantry from nearby Fort Hamilton and an assortment of military, government, and Treasury Department officials; the frozen ground was penetrated, and the coffin was brought to the surface. Jones's coffin was then spirited away to the administration building under heavy guard. Although no reporters were allowed, officials said that the hermetically sealed coffin was opened and was poked and prodded; the lining was cut open, and all that was found in Jones's coffin was the remarkably preserved body of James Jones. End of story. Or is it?

Upon questioning, agent William B. Williams speculated that a switch might have been pulled and that the jewels may have been taken from Jones's coffin while it was still aboard the *Edellyn* and somehow smuggled out, eluding the initial inspection. Further adding to the mystery is that the records at the cemetery clearly state that James Jones was buried in Section 2S Grave 76. The marble tablet of Francis Joseph Garvin marks that grave. It remains a mystery as to where Seaman James Jones reposes or, for that matter, where the jewels that were supposedly in his coffin are located.

**Borasco* is an Old West mining term for an unproductive claim.

The Eccentric Dr. Dunlop

Dunlop Mausoleum
Woodlawn Cemetery
Bronx, New York
40° 53' 27.11" N 75° 52' 13.32" W

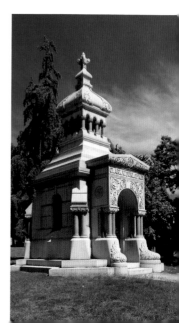

Dr. Clark W. Dunlop, MD, certainly had an interesting life and, unfortunately, a tragic and contentious death. Born in 1845, he graduated from the Eclectic Medical College of the City of New York and then set up offices on Bond Street. By 1884, he had founded and installed himself as president of the United States Medicine Company, where he published a handbook titled *Dr. Dunlop's Family Practice*, describing the symptoms and treatment of 100 common diseases. The manual, which was designed for use by families, also contained advertisements for some of

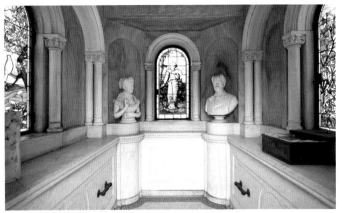

Dr. Dunlop's nostrums, including Dr. Dunlop's King of Pain, Dr. Dunlop's Cascara Compound (a laxative), and other patent medicines and remedies.

Apparently Dr. Dunlop did very well with his medical practice and business as well as other investments (over his lifetime he also acquired real estate in Chicago and Kansas City). He and his wife, Eliza, installed themselves at a palatial home at 112 West 86th Street in Manhattan. By 1894, he had amassed enough money to buy a large plot and to commission a fanciful mausoleum in Woodlawn Cemetery in the Bronx. The mausoleum, which is more of a confection than a piece of architecture, was built by prominent mausoleum

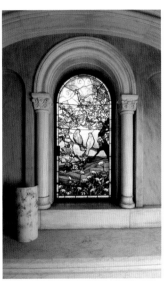

Two birds represent the love between Clark and Eliza Dunlop.

A mosaic of the Dunlop family crest adorns the floor of the mausoleum.

A lockable steel box contains a glass-topped, fabric-lined casket of the Dunlops' pet parrot.

Eliza Dunlop holds a delicate feathery fan in her right hand and a pair of opera glasses in her left.

A beautifully carved marble bust depicts a dapper and mustachioed Dr. Clark W. Dunlop.

builders C. E. Tayntor & Company. The company quarried granite in Maine and Vermont, and had offices in New York. It is difficult to put the Dunlop Mausoleum into any specific architectural category. It has elements of Islamic, Byzantine, and Classical Revival architecture. Then there is the curious feathery plinth flanking the steps.

The stylized feathers are most likely an homage to the Dunlops' pet parrot (name unknown). The skeleton of the parrot reposes on a fabric bed in a glass-topped mini-casket inside a steel box that rests atop a marble shelf inside the mausoleum. Most cemeteries have rather strict regulations that prohibit pet burials, but somehow the parrot slipped under the radar. According to a tag attached to the parrot's eternal home, it expired in March 1921 after being in the family for 30 years. It is unknown if the parrot died peacefully. Dr. Clark W. Dunlop certainly did not.

In late 1907, a "commission in lunacy" declared the good doctor "an incompetent," due largely to a condition called "paresis," a debilitating mental and physical disease usually triggered by syphilis. Usually hearings of this sort are a simple affair, but money tends to muddy the waters. Dunlop's wife, Eliza, was pitted against 22 nieces and nephews (the Dunlop union did not produce any children) who all wanted a piece of Dunlop's considerable fortune of upwards of one million dollars (approximately 22 million today). As the battle raged in the courts, Dr. Clark Dunlop was babbling quietly at the Hilgert Curative Foot Gear Institute on West 26th Street while strapped into a pair of "magic boots."

The late nineteenth and early twentieth century was a time of patent medicines, remedies, and tortuous-looking medical contraptions. Enter shoemaker and now self-proclaimed "Professor" Matthew Hilgert, who invented "magic boots." Hilgert claimed that his footwear restored balance in the body by starting from the bottom (the feet) and moving upward, using special lasts to curve the arch of the foot. He also claimed he added secret chemicals to the boots that were absorbed into the body. His "magic mechanico-physiological" boots were advertised to cure all physical ailments. Hilgert claimed to have numerous satisfied customers, including celebrity endorsers from baseball team owners to businessmen to bishops. At the height of their popularity, the boots reportedly sold for $1,000 to $5,000. Understandably, most purchasers of the boots were the well-to-do. Hilgert claimed that his magic boots could cure "locomotor ataxia, paralysis, hip joint disease, sciatica, rheumatism, gout, neuritis, neuralgia, tic doloureux, not to mention nervous prostration."

Apparently Dunlop's paresis was unaffected by the magic boots or, for that matter, various electrical treatments and saltwater injections he was receiving while at the Hilgert Institute. Instead, his condition deteriorated. In late December 1907, Dr. Clark Dunlop was removed from the Hilgert Institute and taken back to his home on West 86th Street. In early January 1908, he was declared hopelessly insane by an "alienist" (an archaic term for a mental health doctor), Dr. William Bradford Noyes. Dr. Clark Dunlop (1845–1908) died a few weeks later, no doubt without his magic boots on.

The parrot soldiered on until its death in 1921, while Eliza Cisco Dunlop (1836–1932) lived well into her nineties. What became of her considerable fortune is not known. In 1908, Professor Matthew Hilgert (whom some say had designs on Eliza Dunlop) was sued for $50,000 by Henry Lubbe, a dissatisfied customer from Flushing. Lubbe settled for $1,550 in 1911. Shortly thereafter, Professor Matthew Hilgert and his magic mechanico-physiological boots disappeared from the scene.

The ownership of the Dunlop Mausoleum has reverted to Woodlawn Cemetery. During special events, it is often open to the public and is a popular must-see feature during cemetery tours.

Tomb Raider

Glaser-Bernheim Mausoleum

40° 41' 20.49" N 73° 52' 53.34" W
Salem Fields Cemetery
775 Jamaica Avenue
Brooklyn, New York 11208
40° 41' 18.96" N 73°52' 33.33" W

It was the classic inside job.

Anthony Casamassima loved cemeteries. He loved the bucolic landscape, a sanctuary of calm and peace in the midst of the teaming New York City metropolis. He especially loved the artful statuary and funerary architecture that peppered the cemeteries near his home in Queens. He learned to drive in St. John's Cemetery, a few blocks from his home, piloting the family car while sitting on his father's lap. In his backyard, he fashioned a miniature tabletop cemetery with small-scale tombstones, pathways, and bonsai trees.

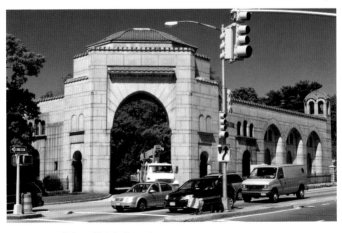

Entrance to Salem Fields Cemetery

His appreciation for cemeteries took a quasi-criminal turn in 1982 when some friends told him they saw a scrap pile at the nearby Lutheran cemetery piled high with broken statuary, ironwork, and marble pedestals. He took some of the pieces home (apparently without asking permission) and figured out ways of restoring them. His access to cemeteries improved in 1987 when he took a job as a caretaker in St. John's Cemetery. It was a dream job for him, having daily contact with so much beautiful artwork. But why limit his appreciation to just daylight hours, he reasoned. What could be wrong with taking a few pieces home with him from time-to-time? After all, many of the families who owned the sculptures were either long gone or didn't have the decency to visit the cemetery and maintain their family plots. During the next few years, Anthony Casamassima became a trusted caretaker and acquired the keys to a number of cemeteries, cemeteries that were outdoor art galleries. And just like art galleries, some of the objects they contained were quite valuable—very valuable, as he later found out.

Casamassima began to collect little scraps of stained glass from broken and damaged stained glass windows. Later he took home entire damaged windows. As his interest in stained glass piqued, he even took a six-week class in stained glass at an adult education center in Queens. He says he became quite adept at glass cutting, foiling, and general repair. In the next few years, he made a few thousand dollars selling his finds and restorations. He thought of his acquisitions as rescuing and "liberating" art rather than stealing. He rationalized selling his liberated objects, thinking that the artwork was going into the hands of people who truly appreciated it rather than moldering away in neglected family plots.

Then one day Anthony Casamassima stumbled on a book titled *Tiffany Windows: The Indispensable Book on Louis C. Tiffany's Masterworks*, penned by one Alastair Duncan, who was one of the world's experts on Tiffany stained glass and Art Deco, who had been a consultant for Christie's auction house and worked with the FBI on its investigations of art thefts. It was a match made in heaven: Anthony Casamassima knew where plenty of neglected and unsecured Tiffany windows were, and Alastair Duncan knew plenty of appreciative and willing buyers with deep pockets. In fact, as it turned out, Anthony Casamassima had a very nice Tiffany window ready to go.

It so happened that one night a few years earlier, Anthony Casamassima snaked his way along a back road near a reservoir just off the Jackie Robinson Parkway. The narrow road skirted the reservoir, eventually leading to a little-used back entrance with a porous fence on the northwest corner of Salem Fields Jewish Cemetery in Brooklyn. The cemetery was the final resting place of a number of prominent members of the Jewish community, including William Fox, founder of the Fox Film Corporation; newspaper magnate Harry F. Guggenheim; theatrical entrepreneurs Jacob, Levi, and Samuel Shubert; and financier/philanthropist Felix Warburg.

Dozens of ostentatious mausoleums dotted the landscaped grounds, but Anthony Casamassima had his eye on just one. Less than 200 yards from the back gate was the Glaser-Bernheim Mausoleum. Casamassima described the mausoleum as being in very poor condition, with grass growing inside and calcium deposits on the ceiling. However, it also had a nine-foot tall Tiffany stained glass window that begged for liberation. Casamassima pried the 500-pound window from its housing, and the next day, aided by three friends, he sandwiched the window between sheets of plywood and spirited it out of the cemetery.

Sketch of Glaser-Bernheim Mausoleum

The window remained in Casamassima's workshop for nearly six years until Alastair Duncan purchased it from him via antiques dealer Lawrence Zinzi for $60,000. Duncan subsequently did some repairs and modifications to the window and sold it to Takeo Horiuchi, a wealthy collector in Japan, for $219,980 (the window is purportedly valued at around one million dollars). An innocent purchase and nice return on an investment by Duncan? Not so, said Zinzi after the operation was discovered by the FBI. Zinzi said that Duncan was well aware that the Tiffany window had been "swagged" (stolen). Zinzi, along with Casamassima, agreed to testify against Duncan in return for lighter sentences.

And the FBI had some evidence of its own. Shortly after Duncan shipped the window to Japan, Duncan asked Casamassima if more Tiffany windows were available. Not a problem, said Casamassima. Unfortunately for Duncan and Casamassima, the FBI was already onto the scheme. Not long after Casamassima made his deal with Duncan, Casamassima was making a scouting trip to Kensico Cemetery in Valhalla, which he knew had a number of mausoleums with Tiffany windows. Accompanying Casamassima was a sleazy individual he had teamed up with. The pair made their way through Kensico Cemetery, taking pictures and measuring windows. Casamassima told his partner in crime all about his cemetery exploits and adventures. His partner listened intently and asked questions–enough questions, it turns out, to indict Casamassima, Duncan, and Zinzi. The sleazy individual was an undercover FBI agent. Shortly afterwards, Anthony Casamassima started referring to himself as "Anthony Big Mouth."

At the trial in the fall of 1999, Alastair Duncan claimed he was framed, but it did little good. On March 9, 2000, he was convicted on two counts of conspiring to export stolen property, one count of exporting stolen property, one count of structuring a currency transaction, and one count of witness tampering. He was sentenced to 27 months in prison and ordered to pay $220,000 in restitution. Casamassima and Zinzi were convicted on similar charges of exporting stolen property. The window eventually made its way to the Tiffany Museum in Nagoya, Japan. That museum closed in 2007. In 2003, the BBC series *Art Crime* featured the story in a program titled "Tiffany Tomb Raiders."

In 2006, a story appeared in a Cleveland newspaper about the theft of a bronze bust of the Greek poet Virgil. The bust had been lifted off of a tall column in a decrepit section of downtown Cleveland in the 1960s. In 1999, a Cleveland antiques dealer purchased it at a scrap metal sale and then sold it via an online auction site to one Anthony Casamassima of Middle Village, Queens, New York. Casamassima claims he later sold it at a flea market and knew nothing about the bust's provenance.

A Man's Best Friend Goes Out in Style

Sandy the Dog

ca. 1991–April, 2007
Hartsdale Pet Cemetery
Hartsdale, New York
41° 1′ 17.33″ N 73° 47′ 49.81″ W

LaMura Mausoleum

Woodlawn Cemetery
Bronx, New York
40° 53′ 11.08″ N 73° 52′ 26.48″ W

Let's get one thing straight from the get-go: man's best friend is the dog. With all due respect to the pet proclivities of lovers of ferrets, finches, hamsters, horn toads, pythons, parrots, cats, and other critters, no other creature holds a candle to the dog. Dogs rule. Just ask Tony LaMura.

Tony LaMura comes from a family of thoroughbreds—Thoroughbred Italians—100 percent Italian on both sides, with lots of Emestinas, Fedricos, Giuseppis, Assuntas, and Anthonys. When Tony was a kid, he had a purebred German Shepherd with the fitting name of Major. Young Tony became very attached to Major, but Major died when Tony was 12, and the young boy was devastated. Not long after Major died, Tony asked his mother if they could get another dog, but his mother said no, not out of meanness but out of compassion for Tony. She just didn't want to have him go through the inevitable loss of another pet. "You get too attached," she told him.

And so it was. Tony LaMura went on with his life, doing what people do, dabbling in the family construction and contracting business, eventually becoming a real estate developer and investor in New York. Then one rainy April day in 1992, while he was inspecting one of his commercial properties in the Bronx, he spied a medium-sized sandy-colored dog wandering around the loading dock. A stray. And a mutt to boot. It was love at first sight. Can a person and a dog have a special unspoken affinity for each other just like people do? You bet. Just ask anyone who has gone to the local pound to find a dog. It's a feeling. A look. A special something. A certain *je ne sais quoi*. What could he do? He scooped her up and took her home. Home to the family. Like any proper Italian family, there were always plenty of people around, and it was a good thing. Sandy (which is what Tony eventually named her) was a people dog. It didn't matter who you were, Sandy wanted to know you. Whether you were a family member or just someone walking down the street, it didn't matter to Sandy.

Of course there was one special person in Sandy's life, and that was Tony LaMura. "She was incredibly smart," he said, "she really didn't need to be trained in the traditional sense. Tell her something a couple times and she just knew what to do." He explained, "Tell her 'sleep' and she put her head down. Tell her 'bed' and off she went to my bed." He said that even the vet was impressed. And Sandy even liked fireworks. "My other dog, Major, like most dogs would cower on the 4th of July. Not Sandy. She loved fireworks. Mostly, I think because there were so many people around."

The vet told Tony that Sandy was about three months old when he found her and that she was exceptionally alert. The vet said she might have had a bit of pit bull in her, which wouldn't be unusual for New York, but she also had a very fox-like face, maybe a bit like a terrier. Okay, she

was a mutt. Sometimes Tony would take Sandy with him when he visited the family mausoleum in Woodlawn Cemetery in the Bronx. Occasionally, Sandy would want to get out of the car and Tony obliged. After all, dogs do need to do certain things. And Tony was a lot owner. There are certain privileges that go with property ownership at Woodlawn. One day their walk through the cemetery's bucolic grounds took a turn. Tony and Sandy ran into Amos and Ole, Woodlawn's Historical Preservation director Susan Olsen's industrial-sized cats. Amos and Ole constituted Woodlawn's rodent eradication team, and they had their home turf—turf that the unsuspecting Sandy was about to invade. Sandy may have had a bit of pit bull in her, but she was no match for Olsen's mega-felines (each weighed around 17 pounds). In short order, Amos and Ole dispensed with Sandy, and off went Tony LaMura and the bloodied Sandy to the vet. After hearing about the incident, Olsen feared the worst. Thoughts of revenge and lawsuits haunted her. Then she got a call from "Mr. LaMura." She cautiously picked up the phone expecting the worst. But all he wanted to know was if the cats had their shots. And he apologized saying that Sandy had invaded Amos' and Ole's territory.

It was the beginning of a long friendship. A friendship that centered on their love for their pets. Tony would often take Sandy to special events at Woodlawn, making sure to give Amos and Ole a wide berth. They also had a friendly rivalry, verbally sparring about which animal was superior to the other (as long as Olsen's ferocious felines were allowed to go one on one with Sandy rather than ganging up on her). Inevitably those talks sometimes focused on cemeteries and memorialization and the inevitable. The years were ticking on. The time would come when Tony would have to say goodbye to another beloved pet. Tony and Susan talked about Hartsdale Pet Cemetery just a few miles away. Hartsdale was established in the late nineteenth century and had a solid reputation. Tony told Susan that when Sandy was only three years old, he purchased a plot for her. Susan told Tony that she planned on getting a plot for her cats.

As the years went by, the bond between Tony and Sandy grew stronger, and he made a decision about Sandy's eternal home. Sandy would not spend eternity in the cold, cold ground; she'd spend it just like the LaMuras would, in a mausoleum. LaMura contacted Peacock Memorials

LaMura Mausoleum, Woodlawn Cemetery, Bronx. Woodlawn is just a few miles from Hartsdale.

in Valhalla, New York. Peacock had built the LaMura Mausoleum in 1967 and had fabricated other mausoleums in Woodlawn, including the original Helmsley Mausoleum. After a bit of head-scratching over the design, Peacock fabricated a mausoleum for Sandy in 2005. The mausoleum is constructed of five tons of Barre granite and rests on top of a seven-foot-deep reinforced-concrete foundation. The bronze door is 90 percent copper and has a door handle in the shape of an S. Sandy's mausoleum is

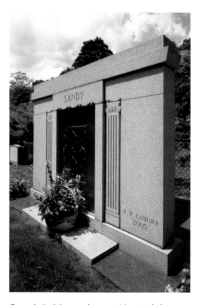

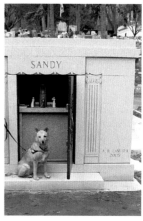

Sandy in front of
her mausoleum.

Sandy's Mausoleum, Hartsdale
Canine Cemetery, Hartsdale

sympathetic to the design of
the LaMura Mausoleum, but
Sandy's mausoleum has just
one crypt while the LaMura
has a dozen. On special days,
Tony would take Sandy to the LaMura Mausoleum in Woodlawn and also
to her mausoleum in Hartsdale.

Then the day came. After being ravaged by bladder cancer and
suffering the effects of a stroke, it was time for Sandy to be put down.
And on a rainy April day in 2007, Tony brought Sandy to the vet to say
goodbye. They had come full cycle–into and out of each other's lives
on rainy April days. Tony put Sandy to rest in her own mausoleum. Six
months earlier, Susan Olsen's cat Amos was cremated at Hartsdale. Tony
LaMura used Lincoln Park Funeral home in Yonkers, the same funeral
home the LaMuras have used for years, to get Sandy's casket. Joe Casario,
the owner and funeral director helped Tony select a child's casket.

Tony LaMura doesn't know if he will get another dog. "I'm not going
out looking for one," he says. "If I'm supposed to have another one, God
will put one in front of me. My mother said I get too attached. Yeah,
that's true. But that's what love is all about. Getting attached. I'm a very
respectful person. Everybody has a life to be remembered. A story to
tell. My mother died in the fall of 2009 at age 101 and a half. I told her
that when she died, I was going to get her the best casket money could
buy. She said she didn't want that. But I got her the same casket Harry
Helmsley and George Steinbrenner had. She's my mom and deserves at
least as much respect as them. When dad died in 1973, mom put him in
the same casket Tommy Manville had. And Sandy, she deserves respect
too. She loved everybody. She was special and I wanted to give her a last
special gift. I wanted to send her out in style."

The Tomb with the Broken Heart

Blocher Mausoleum
Forest Lawn Cemetery
Buffalo, New York
42° 55' 25.47" N 78° 51' 56.83" W

It's impossible to stroll by the Blocher Mausoleum in Buffalo's Forest Lawn Cemetery without wondering what the story is behind this one-of-a-kind tomb. Indeed, the circumstances that led to the tomb's construction are an intriguing mix of fact and fable. It's a tale of love and passion and loss and sorrow. The center of attention inside the tomb is Nelson Blocher, laid out for viewing, clutching a Bible. Looking at his prostrate form are his parents, John and Elizabeth Blocher. Hovering above is an angel who, some say, bears a striking resemblance to a maid employed by the Blocher family. It's said that Nelson died of a broken heart. Accounts of the day say that his mother, Elizabeth, goaded her husband, John, into constructing the tomb as a memorial for their heartbroken son.

John Blocher was born in 1825 in the small town of Scipio, New York. At age 10, he became "the man of the family" following the death of his father. This left him with little formal education, but the adult responsibilities that he assumed at a young age charged him with entrepreneurial spirit. At age 18, he opened a tailoring business in Buffalo, which he soon developed into a general store, supplying ready-made clothing, dry goods, and groceries to Buffaloans. At age 20, John married 19-year-old Elizabeth Neff. The union produced one son, Nelson, who was born in 1847. John Blocher enlisted in the Union Army at the outbreak of the Civil War and served one year in the 78th New York Regiment before being discharged for ill health. Returning to Buffalo after his stint in the army, Blocher turned the war to his advantage and proceeded to manufacture shoes and boots for the army. His prosperous footwear business and some shrewd real estate investments soon turned John Blocher into one of Buffalo's wealthiest citizens. Fittingly, he installed his family in an elegant residence on Delaware Street, Buffalo's answer to Manhattan's Fifth Avenue.

The Blocher residence, of course, needed the usual complement of servants. One young maid in particular, 20-year-old Katherine, ultimately became the force behind the construction of the Blocher Mausoleum. And herein lies the tale. It seems that Nelson Blocher either wasn't

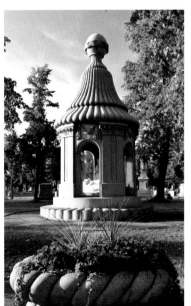

inclined toward marriage or was inept at the social skills necessary to secure a bride. Not only was he still a bachelor at age 34, but he was also living at home. Nelson made frequent buying trips to Europe to purchase leather goods for the family business along with art and furniture for the family home. But when he returned to Buffalo, he was assigned to the rather mundane day-to-day duties of attending to the Blocher business.

Then one day in the spring of 1881, the Blochers hired a new maid. Katherine was 20 years old, pretty, and unattached. Nelson was immediately smitten and made no attempt to hide

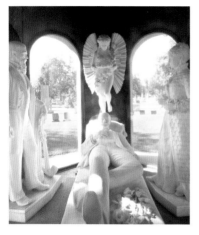

it. During the spring and summer of 1881, he found ways to be near Katherine and to spend time with her. There is reference to an injured kitten Nelson and Katherine nursed back to health. Some say that Katherine wasn't particularly attracted to Nelson but encouraged and continued the flirtation to keep her job, while others say they fell in love. But, whatever the case, it's clear that it simply wasn't proper for a well-bred man about town to consort with a lowly maid, no matter how charming she may be. Nelson's parents did not approve of the romance and quickly made plans to put an end to it. In the fall of 1881, Nelson's father announced that there was business to be attended to in Europe and that Nelson needed to make plans to leave for an extended trip.

Plainly, Nelson's father wanted to separate the couple and put an end to the romance. One story says that Nelson proposed marriage to Katherine on the eve of his departure to Europe, but Katherine said she needed time to think, while other accounts say that Nelson barely had time to say good-bye.

After Nelson left for Europe, one account says that Katherine had second thoughts about marriage and used the opportunity to depart for parts unknown. But a more accepted account says that immediately after Nelson's departure, the Blochers fired Katherine with a strict admonition never to return. What is true, however, is that in the spring of 1882, when Nelson returned from his travels, Katherine was gone and nobody seemed to know where she went. John and Elizabeth Blocher told their son that two weeks after Nelson left for Europe, Katherine had stolen away in the middle of the night, leaving nothing behind but her Bible. Whatever the reason for Katherine's departure, Nelson was heartbroken. He couldn't believe she had left without even leaving a note. There must have been a reason, and he was determined to find her and convince her to come back.

Throughout the remainder of 1882 he searched for her. And like the lovelorn for eons before him, he neglected his business and health in pursuit of love. By the fall of 1883, Nelson was tired and worn out from his search. Broken in spirit and sick with a fever, Nelson took to his bed. By early winter of 1884, he was drifting in and out of sickness and depression. Soon he became bedridden. His only solace was the Bible that Katherine had left behind. Then on January 24, 1884, Nelson's time in this realm was over. He died with Katherine's Bible clutched to his breast. Nelson's mother, Elizabeth, no doubt driven by a maternal blend of love and guilt, insisted that a suitable memorial be erected to her son. The task of designing the monument would fall to the creative hand of John Blocher. At the time of Nelson's death, John Blocher was semiretired. He had taken up sculpting as a hobby and would use those skills in designing the Blocher Mausoleum.

The spirit of the Blocher Mausoleum belongs to an architectural style all its own. The closest category of architecture that it can be

compared to is the "follies" of nineteenth-century Victorian architecture. Penguin's *Dictionary of Architecture* defines a folly as "a costly, but useless structure built to satisfy the whim of some eccentric and thought to show his folly . . ." Supposedly John Blocher just couldn't find a monument designer to correctly interpret his vision, so without any formal training in construction, he took it upon himself to craft the mausoleum. Blocher's design, which looks more like an elaborate confection rather than a mausoleum, may have been ahead of its time. Nowadays, it would be easy to imagine a structure like the Blocher Mausoleum gracing an avenue of pillowy-shaped buildings in Disneyland's Toontown.

Blocher had two elements to design. The first design was for the exterior of the mausoleum. The other design was for statues of the Blocher family and an angel (which some folks say looks a lot like the maid), which would be sealed behind glass in the mausoleum's interior. He contracted with the firm of John McDonnell to cut and assemble the pieces of the mausoleum from quarries in Quincy, Massachusetts. Blocher ingeniously designed the mausoleum so that the entire structure could be built with only twenty stones, thus minimizing maintenance problems. The roof, which is frequently a maintenance nightmare in stone structures, is formed by just one piece, a bell-shaped affair. Another stone shaped like a ball is used for the capstone. The bell was cut from a 90-ton slab of granite whittled down to 29 tons. It is supported by five pilasters. The pieces of the mausoleum were hoisted into position by massive rigging equipment. All of the elements were precisely set in place. But as the ball, the tomb's crowning glory was being lowered into its nest at the top of the bell, the timbering gave way and the ball came crashing down, cracking the bell.

A lawsuit ensued; the contractor claimed that Blocher's design was at fault, resulting in an inherently weak structure. Blocher claimed that it was a simple case of negligence. Eventually Blocher prevailed and another bell was manufactured. The capstone was finally, ever so gently, lowered into place without incident. In the openings between the pilasters, Blocher specified four one-inch-thick panes of glass, which were manufactured in Paris, and another one-inch-thick piece of glass with hidden hinges to serve as a door. Before the mausoleum was assembled, work had already begun on the statuary.

For the statues on the inside of the mausoleum, Blocher originally commissioned Paul Roche of Westerly, Rhode Island, to come to Buffalo and carve the statues out of Carrara marble. Blocher fashioned a plaster model of Nelson Blocher lying on a couch and instructed Roche to carve a life-sized replica. Roche chiseled away under John Blocher's constant supervision, but Blocher was less than pleased with Roche's carving skills. In fact, when Roche unveiled the finished sculpture, Blocher took an axe to it and chopped it to pieces. After sending Roche packing, Blocher contracted with noted Swiss-born Italian sculptor Frank Torrey in Carrara, Italy. Torrey wasn't about to travel to Buffalo, so Blocher supplied the sculptor with photographs, models, and measurements of Nelson, Elizabeth, and himself.

For close to three years, Torrey toiled away, chiseling and shaping the statues. They were finally completed in 1888 and shipped to Buffalo, where they were installed in the mausoleum. The first resident of the mausoleum was Nelson, who had spent the years since his death in the cemetery's receiving vault. Following him were his mother, Elizabeth Neff Blocher, who died of pneumonia at age 78 on March 31, 1904, and John Blocher, who died of "old age" on June 30, 1911, at the age

of 85. But where exactly are the Blochers spending eternity? They are underneath a movable slab in the floor of the mausoleum. According to a Buffalo newspaper report published when the mausoleum was being built, there are six crypts. This story led to a rumor that in the safe of the cemetery office, there is a quitclaim deed stating that one of the other crypts is reserved for Margaret Katherine Sullivan—the maid. This story became fodder for romantic stories that often ran around Valentine's Day, suggesting that although the love-struck Nelson could not have Katherine in life, there was still a possibility he might spend eternity with her. Alas, Forest Lawn management tells us that there are only three crypts below the Blochers' marble likenesses. Poor Nelson is spending eternity just as he did in life—with his parents. The whereabouts of the maid is unknown.

Rock Star

Crouse Boulder
Oakwood Cemetery
Syracuse, New York
43° 1' 55.70" N 76° 7' 46.30" W (entrance)

Somewhere around 30,000 BC, a 95-ton glacier-propelled boulder parked just north of present-day Lake Ontario, Canada, started inching its way south toward modern-day Syracuse, New York. It ground its way progressing at a . . . well . . . glacial pace until it finally came to rest in what would become the tiny burg of Split Rock, New York. And there it stayed for the next 15,000 years, pushed no more by the now-retreating glacier. Thousands of years of continental glaciation had scarred the landscape of Upstate New York, leaving behind drumlins, terminal moraines, and one very large egg-shaped granite boulder.

Enter one Charles Crouse. For decades, the Crouse family had been among the prominent movers and shakers in Syracuse. They helped shape the city, and their legacy can be seen in buildings at Syracuse University adorned with the Crouse name, endowments, and civic improvements, and in Oakwood Cemetery. The grounds are peppered with graves, mausoleums, and monuments of fallen Crouses. It's fair to speculate that family members might have been a bit competitive about their monuments. The largest Crouse Mausoleum and most

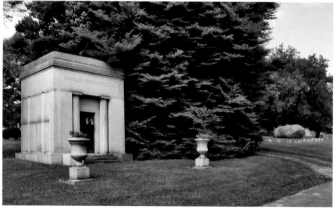

Charles Crouse Mausoleum and the Crouse boulder (far right).
Photo courtesy of John Thomas Grant.

The Crouse boulder. Photo courtesy of John Thomas Grant.

architecturally effervescent mausoleum was built for family patriarch John Crouse; but the most unique monument is the one that is the centerpiece of the Jacob Crouse plot.

In 1904, Charles Crouse decided to memorialize his father, Jacob Crouse, by placing a massive boulder emblazoned with the Crouse name at the center of the family plot. The landscape around Syracuse is awash with boulders, but Charles Crouse wanted just the right boulder. Driven by some sort of artistic vision, he finally found one that was just right, located at Wilbur Farm on Terry Road some six miles distant from Oakwood Cemetery. Crouse proposed to move the boulder by train but a crane large enough to lift it couldn't be found. After researching other options, Crouse turned the job over to a legendary granite-moving firm in Barre, Vermont. A few years prior, the firm of McDonald and Cutler had moved the largest slab of granite ever quarried in the United States. The slab was moved down the hill from Graniteville, Vermont, to the stone sheds in Barre, where it was carved into the massive pediments of the Stanford Mausoleum that was being erected on the campus of Stanford University near San Francisco.

Charles Crouse wound up paying the firm $4,500 to move the boulder. The job fell on company owner Fay Cutler, who first proposed to move the boulder with 40 teams of horses, but the road leading to the cemetery was too winding for the horses to get an even pull. After some head-scratching, Cutler hit on the idea of utilizing the Syracuse area's frozen winter landscape, using only one team of horses, six men, a sled, and a roller device known as a capstan. In the early spring of 1904, the boulder started making its way from Split Rock, New York, to its destination in Oakwood Cemetery. The massive bolder was pushed, pulled, pried, and nudged along its path, progressing about 900 feet per

The Crouse boulder in transit.

day. Apparently the boulder's progression was big news in Syracuse. The location of the boulder was noted in daily reports in the local paper. Indeed, it became somewhat of a spectator event as crowds gathered daily to watch the boulder's slow progress. The men and the boulder moved at a glacial pace for over a month before Charles Crouse was happy with the placement. The boulder is now surrounded by the graves of Crouse family members. A few steps away is the rather plain Classical Revival mausoleum of Charles Edward Crouse, who apparently elected to be memorialized in a more traditional way.

Escape Artist

Houdini's Crypt
Machpelah Cemetery
8230 Cypress Hills Street
Flushing, NY 11385
40° 41' 36.47" N 73° 53 '5.22" W (gravesite)

Harry Houdini (1874–1926) was the world's most famous escape artist, but he couldn't escape death. He was born Erik Weisz in Budapest, Hungary. His name was later changed to Ehrich Weiss. The family first lived in Appleton, Wisconsin, where his father served as a rabbi. The family later moved to New York City, and young Erich became a trapeze artist and later a magician. Not soon after, he changed his stage name to Harry Houdini (multiple theories exist about the name derivation). In fact, he registered for the selective service as Harry Handcuff Houdini.

His early career as a magician met with modest success. Seeking something to set him apart from others, he began to experiment with escape acts. It was a good fit as he was quite athletic and had a flexible physique. He was soon escaping handcuffs and shackles in a prison transport van, as well as being buried alive. One of his most popular escapes was from a straightjacket while suspended upside down. Another, called The Chinese Water Torture Cell, involved being suspended upside down in a tank of water. A variation had him escaping from an oversized milk can. As time went on, the escapes became more and more popular, and were often done in conjunction with advertising programs and promotions. He even starred in a few movies and started a movie production company.

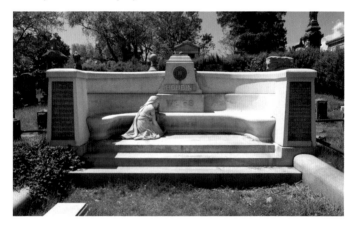

In the 1920s, Houdini went on a crusade to debunk the spiritualists, psychics, and mediums who claimed they could communicate with the dead. His training in magic enabled him to expose many of them as frauds. In fact, in collaboration with *Scientific American* magazine, he offered a cash reward to anyone who could truly exhibit supernatural abilities. However, he hedged his bets a bit by making a pact with his wife that, depending on whichever of them died first, the other would conduct a variety of séances and other ceremonies to communicate with the first to die.

It has been widely reported that Houdini died as a result of a series of unexpected abdominal blows he received from J. Gordon Whitehead,

a student at McGill University in Montreal. (Houdini had often stated that he could take punches above the waist with little effect.) While it is true that Whitehead delivered the blows before Houdini had time to prepare himself, the truth is that Houdini had been suffering from appendicitis, and he had been ignoring the pain. The blows just steeled Houdini more to ignore the pain. Unfortunately, his appendix ruptured, which led to peritonitis and death.

One of Houdini's tricks was to escape from a coffin, so that coffin was reportedly used as his final escape-proof vessel. Over 20,000 people attended his funeral in New York City on November 4, 1926. His grave is right at the entrance to Machpelah Cemetery. It is in the form of an exedra (bench). Centermost on the exedra is a bronze plaque of the Society of American Magicians (SAM). Harry Houdini served as its president from 1917 until his death. The grounds in front of the monument are peppered with the graves of a number of members of the Weiss family. His gravesite was a favorite gathering site for fans who assembled every year on the anniversary of his death. They would stand around his grave, read excerpts from his 1926 funeral service, and then break a magician's wand, symbolizing the loss of a magician's power when he dies. Unfortunately, all the publicity also led to vandalism and the theft of numerous busts of him that topped the monument. The original bust, installed in late 1926, was crafted by Irish sculptor John Cassidy in Manchester, England. It was crushed by a sledgehammer in 1975 (authorities speculated that someone thought Houdini's magic secrets were inside his head). A replacement polyethylene bust was installed, but it was stolen in 1983. It was subsequently found in a cardboard box in a closet in Queens in 2002. The last time a formal gathering was held on the anniversary of his death was 1995. The ceremony is now held from time-to-time on November 16, his death date on the Jewish calendar. In recent years, magician David Copperfield donated funds to aid in the restoration of the monument. Unfortunately, those wishing to visit Houdini's last earthly home will often find the gates of the cemetery locked.

In 2007, it was widely reported that Houdini's grave was going to be reopened at the request of his family, who believed he might have been poisoned by spiritualists who were angry with him for exposing their fraudulent ways. In truth, it was all a publicity stunt by a PR firm that was hired to promote the book *The Secret Life of Houdini*. Harry Houdini rests in peace.

Houdini's crypt is often covered with remembrances and magician's memorabilia. Note that the death date of his wife, Beatrice (Bess) Rahner, has not been entered. For 10 years after Houdini's death, she conducted séances on the day of his death to try to contact his spirit. The final séance was held on Halloween 1936 at the Hollywood Knickerbocker

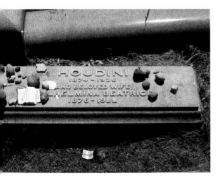

Hotel. After not being able to conjure up any essence of him, she abandoned the séances saying, "Ten years is long enough to wait for any man." She did express a desire to be buried with him, but reportedly, because she was Catholic, her family had her buried at the Gate of Heaven Cemetery in Westchester County because Machpelah Cemetery is a Jewish resting place.

INDEX

ACKNOWLEDGMENTS
AND REFERENCES

N o book is ever done alone. There are always those who have helped along the way. *Stories in Stone New York* would have been impossible to write and photograph without the generous help and support of Richard Moylan and Frank Morelli and Green-Wood Cemetery, John Toale and Susan Olsen at Woodlawn Cemetery, Dave and Jim Logan at Sleepy Hollow Cemetery, Chester Day, Judy Mitchell and Dorothy Williams at Kensico Cemetery, Edward C. Martin Jr. at Hartsdale Pet Cemetery and that anonymous nun who let me into the crypts at Saint Patrick's cathedral.

The books *Woodlawn Remembers* by Edward F. Bergman, *Brooklyn's Green-Wood Cemetery* by Jeffrey I. Richman, and *Dr. Johnson's Apple Orchard* (Hartsdale Canine Cemetery), by Edward C. Martin Jr. were extremely valuable resources.

Although there are many resources available on the Internet a good starting place is www.findagrave.com

D ouglas Keister is based in Chico, California, and has authored more than thirty-five critically acclaimed books. He also writes and illustrates magazine articles and contributes photographs and essays to dozens of magazines, newspapers, books, calendars, posters, and greeting cards worldwide. His wealth of books on architecture has earned him the title, "America's most noted photographer of historic architecture." His book on cemetery symbolism, *Stories in the Stone: A Field Guide to Cemetery Symbolism*, has garnered a number of glowing reviews. *Sunset* magazine said, "Keister has done for cemetery exploration what Audubon did for birding." Keister also edited a book of his collection of glass plate negatives titled *Lincoln in Black and White: 1910–1925.* He has also authored additional cemetery guides titled *Forever Dixie* and *Forever L.A.*, dealing with the those areas and their residents as well. You can visit him on the web at www.douglaskeister.com.